Adventures
of a
Dirty Blonde

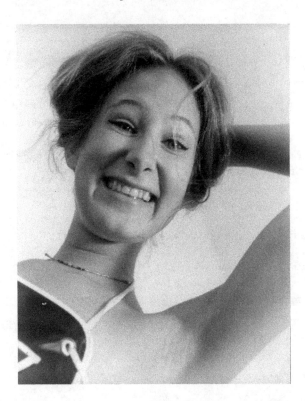

by A.L. Curtis

Front Cover: Ann in front of the Alamo, from a photo shoot for a short lived magazine, called "High Country", circa 1980.

Back Cover: Ann posing for a Funky Formal Foto, MDRF, 2012

This book contains ADULT CONTENT, SEXUAL IMAGERY & NUDITY

(In case the cover didn't clue you in to that.)

My disclaimer:

"If anything printed here is construed to be libelous and/or of slanderous intention, or if we offend and/or misrepresent you and/or the truth… oh well. We'll try harder next time!"

(stolen from the R.A.G.)

Perspective:

This is my story as I see it. You may find yourself in here, or someone that resembles you. It's my perspective, not yours. If you take umbrage, consider writing your own story.
Names have been changed where I was asked to change them.

"... This is dedicated to the ones I love ..."
(Ya'll know who you are, don't you?)

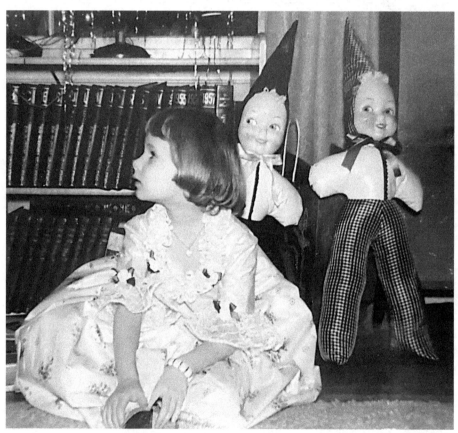

Little Ann playing dress up with two of her friends

Introduction

by Derek Weaver

I first met Ann in 1985, when she passed through a booth I was sharing with my dear friend Jon Schroeder at Scarborough Faire, a Renaissance Festival close to Waxahachie, Texas. She was on the arm of a man I had known since the late 1970's who could easily have been her father. I can still recall asking myself after they had left, "How does a crotchety old curmudgeon like Lucky De Taos, end up with all the cutest women?"

Ann was sporting her hand made buckskin pants and vest, as well as moccasins and a low cut blouse. Full Ann regalia.

It was a year later at the same show where she now had a booth, that she cast her net towards me. Not a very pretty catch at the time, mostly barefoot and living out of my VW Bug, I was also a dispensary of illicit commodities. She was well warned by those who knew of me, to keep her head about her regarding playing around with this marginally successful craftsman, who would probably never amount to much in life.

And I might not, if she had not made the frivolous choice of letting me into her life.

A life filled with friends and family, creators, artisans, actors, performance artists, musicians, and more artists, as well as those whose want to be around any and all of the above. Ann collected friends like some of us collect postage stamps. For her, creativity was brought on by stimulation, and the more the better. What could be more stimulating than talented friends?

Her house on Madison Street in San Antonio, Texas, was a hub of activity. A real change for someone who spent his formative years keeping people at arms length, as their Dr. Feelgood practitioner. The whirlwind of revolving faces was too much, and late one afternoon it came to a head, when what appeared to be a homeless man stumbled up the front walk and, as I was about to tell him I did not have any spare change, he asked if Ann was home. I hollered out, "Ann, you have company!", and walked out the front door and took a long tour through San Antonio to think about what I had gotten into with this budding relationship.

She might not have ever forgiven me for leaving her that evening, alone with a neér-do-well artist type that turned out to be quite drunk. Yet, she did, as she has forgiven me the myriad of peccadilloes I have performed throughout these 35 years of life together.

Ann's personal friends number in the hundreds. She knows how to bring you into her life, make you feel welcome and give you the help you need to get back up on your feet, from a good meal, to a place to stay. Whatever it took. You then became a part of her story.

She is still that woman today, perhaps it's the Cancerian in her, or maybe it is just that's the way she is built.

She has survived a fast paced life that many would find unbelievable.

As she wrote this, I would ask about the stories she was leaving out. Now and then she would add one of them. Her stories are of time periods many of us share, it's just some of us didn't live them with such vigor.

I hope you have as much fun getting to know Ann Lyneah Curtis, as I have. She is truly a work of art.

And, this is her story.

A Preface:

Over the years, my Mother took stock of my animated life and would frequently encourage me to write it all down, before I forgot. So finally I began collecting stories. I kept handwritten true tales and journals of my journeys. An old suitcase filled with letters has traveled with me since childhood. When letter writing waned, I began saving emails.

Then there are my photograph albums. I've counted 116. Most have over 200 pictures, some dating back to the Civil War.

A popular musician once said, "Every picture tells a story, don't it?"

Traveling back in time through these many resources, I often found myself tapping my friends for clarity on my memories. Frequently our recollections didn't jibe. The twists and turns of time are influenced by perspectives. I've collected and included fun photos and a variety of spirited tales, only to stumble over more as the brain opens to the past.

Within these pages, you'll find some nudity, (ALERT: ADULT CONTENT!), fashion, hordes of parties, and lots of sex. There are stories of sword swallowing and dalliances with drugs. Death masks of famous dead guys and life castings of random strangers. Renaissance Faires, Street Shows, and Bondage Conventions, are all part of the varied venues where an alternate lifestyle is presented in vivid vignettes. Throughout it all flow deep friendships, many loves and a passion for Art.

Thank you to those of you who are a part of my life and for making it so much fun!

As for the ones who don't know me, but find themselves reading my adventures, here's a view into one Artist's Life filled with fabulous friends and family in an amazing, beautiful and sometimes scary world.

I hope you enjoy!

Part 1

"In order to live free and happily you must sacrifice boredom.

It is not always an easy sacrifice."
– R. Bach

Chapter 1

Early life changing decisions

There was a brief window in 1983 when I was 27, that offered the chance to have your tubes tied for a mere $200 through Planned Parenthood. I took it. I did not have to be over thirty-five with at least two children, as one apparently does currently. I did have to wait a full month, after paying in advance, to ensure this decision wasn't flippant. The doctor grilled me in regards as to whether or not my parents, friends, and lover(s) knew of this decision. My mother was dead, my father approved - and yes, my friends and my lover knew. Not that it was up to anyone but me.

Having had numerous lovers and a semi-itinerant lifestyle since I was eighteen, I now knew with certainty that I would never have children. I didn't want to bring a small distraction into my chaotic self-employed life, nor did I see a need to add yet another taxpayer into an already overcrowded world.

When I awoke from anesthesia, an ex-boyfriend was there with a bouquet of flowers. Other friends offered a mix of everything from congratulations to bewildered condolences. My current beau was confused and oddly demanding. I found I had to escape him to heal. Not long after that, I escaped him for good.

One month later, while posing nude for a life drawing class at the San Antonio Art Institute, the final stitch from the operation popped out and wiggled free from my naval. A rather publicly disturbing bit of joy, finalizing my independency.

During the next few years, every man I dated seemed to want to encourage me to consider a 'reversal' of my tubal ligation. It appeared that I would make 'such a good mother.' These were all short-lived romances.

In 1986 at 30 years of age, I was dating a married man. We'll call him Scott. We had purchased adjoining booths at Scarborough Renaissance Faire, in Waxahachie, Texas. He and his wife had one side, I the other. His wife knew nothing of our clandestine union. I'd been his apprentice/assistant for a year, learning and creating production pottery and bopping him whenever I could get away with it. Already adept at wheel throwing, the talents in which he was instructing me added structure and technical skills

which would assist in the new artistic path I was about to embark upon.

Since 1st grade, I'd been making and selling my art. Everything from painting, sculpture, drawing, and portraiture, to jewelry, fashion, and costume design. Ceramic arts were always a big lure and I'd been dabbling in clay since I was a pre-teen.

Lifecasting was something I'd hit upon while attending college. With this ancient form of 'ultimate' portraiture, aka; "Death Masks," I'd perfected a way to cast a face in only ten minutes using medical grade plaster gauze bandage - with no straws. Quite the departure from the first time I did it where it took forty-five minutes with thick plaster on my face and straws up my nose in order to breathe. Almost broke my nose by having two girlfriends do my face casting while we were all getting plastered and getting plastered. Art students experimenting with something they really knew nothing about, while drinking ice cold Stolichnaya. Too much plaster around the fragile bridge bone between the eyes caused a triangular shaped bruise that could have easily gone further with dire consequences. Another girl didn't put on enough Vaseline and ended up ripping every hair off her face in order to remove the mold!

The plaster bandage used by the medical profession to cast broken limbs was far superior, lighter-weight and faster, with less muss and fuss.

My booth at Scarborough Faire was designed to encourage the public to buy my pre-made face castings, finished in clay. I was finding out that what they really wanted were their own faces. So, I began casting customers on faire weekends and taking custom orders. This event ran over the course of seven weekends. I was learning fast and furious!

Meanwhile, I had a problem with Scott (other than the fact that he was married): he wanted me to reverse my tubal ligation - I would make a 'perfect mother'. The wife he was planning on leaving was back home in the hill country with their two sons. He now sought to add to his lineage with me as the vessel.

Kinda put a damper on our relationship.

We were due to tryst at an art show he was vending at in a nearby town. He had hired help for his booth at the Ren Faire for that weekend and wanted me to run off to join him. I wasn't making enough money to hire an employee, and I was beginning to re-think the whole affair. I decided to stay on the festival site for a full two weeks and see what kind of fun and/or

trouble I could get into.

Chapter 2

Grateful for the Magic

In the daytime weekday Renfaire village, we pass in flowing colors. Fairytale cottages line the dirt and rock roadways. Flowers blossom everywhere, scenting the air. Children walk by, juggling balls and blowing bubbles, moving in rag-tag packs from grove to green in-between homeschooling and the freedom to roam. They live in a community of entertainers, musicians, and crafters. Dogs bark, geese honk, elephants trumpet, and somewhere there's a drum jam.

The "Monday Morning Bazaar" is where all who live on site gather for breakfast and a true 'renaissance faire'. Rennies bring carts and car loads of used costumes and clothing, crafts not approved for sale on the weekend, and garage sale type items. Bocce ball and croquet are happening in a field nearby. Massage tables are active, as is a hair cutting station. Fresh carrot juice is made to order. Game boards are in play, babies are toddling and there's even a bible study group - right next to the tarot card readings.

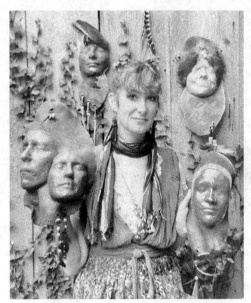

Ann with Raku Lifecastings, 1986,
Scarborough Renaissance Faire

This is a weekly social event, a sharing of fun before everyone heads out to do laundry and grocery shopping.

Chapter 3

"The heart has its reasons whereof reason knows nothing" – Pascal

Mid-week I went to a gin party at the 'Quayludes' (aka the 'Clayloons') booth. I wasn't a gin drinker back then and when I

loudly inquired as to whether or not anyone had any Mescal, a dusty looking barefoot fellow I'd seen around spoke up in the affirmative. Unbeknownst to me, as the guy went off to get his precious bottle of booze, he was thinking to himself that he'd be sharing this with some broad who'd drink it and be gone.

We sat down with his bottle and 2 shot glasses and proceeded to have a lively conversation about drugs we'd done. I mentioned that I'd never tried peyote. He proclaimed that he had some. We agreed on a date to partake on Tuesday after the coming weekend. When we parted that night, he was thinking to himself, yet again, that this Ren chick was gonna do his drugs and then split.

Over the rest of that week, Derek the Dusty Barefoot Boy inquired around as to what others knew of me. His friends all encouraged him. He was apprised of my relationship with Scott, the potter, but since Scott wasn't there, and I was, I appeared to be fair game. And, being new to the circuit, I was fresh meat.

Over the weekend, I cast Derek's face. We arranged a get-together Monday night for me to paint the mold in his likeness, as a potential prop for his gig collecting food orders at "Bernie's Breakfast" on Mondays at the Bazaar. The casting was to have the word balloon "Back o' the line, ya Grump!" attached to it.

Rennies Krista & Jon Schroeder, early proponents of our fledgling relationship

After a long weekend of selling to the public, rennies would line up for breakfast and, not yet coffeed up, could be pretty grumpy. This was Derek's standard line for those who were gruff with him.

Monday night came and the lure of pheromones had seven guys showing up at my door, along with Derek, whom I'd intended to have solely for myself. The attention was delicious, however, so I turned none away. It was an impromptu party - and I was the

5

desired female! Yay!

While Derek played guitar, another played the flute. A leather worker named "Lewd Lloyd" twisted cord using his toes as an anchor. Joints were liberally passed around. I worked on painting the mask I'd cast of Derek while we all visited, got stoned, and laughed into the night.

Slowly the partiers went home to their own beds, leaving myself, Derek, and one other. Knowing the fellow to be a loner whose sexual exploits were even more diminished than his own, Derek had decided to leave us to our devices … this man probably needed it more than he did.

I clamped my hand on Derek's knee, letting him know he was to stay. The other guy left.

This then was the most significant pivotal moment of my adult life.

I finished up painting his mask, whereupon Derek now thought to leave as well. After lip-locking him in the doorway of the booth in a manner which left no doubt in his mind, he returned inside and we continued our foray into a night of sexual frolic. We agreed that getting sex 'out of the way' prior to a day of peyote would be a good idea.

For me, there was another thing I wanted to get out of the way. I told him I could not get pregnant. He let out a WHOOP! Thrilled that there would be no babies, we proceeded into a prolific night of bliss, (sans condoms.)

On our first date the next day, I experienced two new things: the high that comes with the peyote cactus and getting to see projectile vomiting. Since that point, the years have offered up an abundance of new things for the two of us and it's never been dull.

Choosing not to have children gave us the freedom to move about

without constraints.

We've traveled to places not many consider venturing to. We've operated underground restaurants and hosted parties the likes of which few have ever seen. The art shows we've done have rivaled the most ribald and adventurous times of anyone I know, with some of the most amazing and talented people on the planet. With this man, I continue to seek out the preposterous and the absurd ...

Derek now has more than one pair of shoes, as well as a couple of suits, and is no longer dusty - at least not all the time.

He quit making leather luggage as a means of financial support, which was one of the things he was doing when we met. He's been the Bubbleman and the successful owner of a juice bar. He's built our home from the ground up.

My career in lifecasting has spanned 40 years, with Derek by my side for 35 of them. He's been my voice of encouragement, website designer, and schlepper extraordinaire. A few years ago we ventured forth into a whole new concept; Bone Art. It arrived with perfect timing. Life Casting had petered out and bones had become a 'thing' that the public seem to crave.

This, then, is the story of my life. It may twist and turn backwards and forwards. I will occasionally go down one rabbit hole or another. But it all leads back to here, where my heart is, with my sweet man.

Ren Fests became my way of making a living after that first year in 1986. We went to separate festivals over the next year, meeting up whenever possible. Encouraged to go to the seven weekend Michigan festival, I found a whole new family of folks that I formed a permanent bond with.

In Michigan, the Renaissance Festival was built on a swamp. The night before it opened in August of 1986, our intrepid crafts coordinator, Karen West, organized her minions to navigate the slime and mud with shovels and heavy equipment. The following morning a stage had magically appeared, right there next to my temporary lean-to of a booth. There is always a lot of magic involved in the creation of a Ren Fest. Never doubt it. Hokey? Sure, there's some of that. It's part of the charm, the humor. But the magic oozes out of it's very being, as does rebellion, unity, art, and entertainment. A tribe of creatures that are society's curious outcasts will weave a new world before your eyes. If you're willing, it will all open before you.

My Ren Faire neighbors in Michigan consisted of a palm reader, a leather craftsman, and a basket weaver. Other talented friends I discovered in that first year included a magician, 3 jugglers, jewelers, a weapons fabricator, a dulcimer maker, a flautist, clothiers, gamers, entertainers, glass-workers, and beyond.

I began painting signs for these rennies to augment my weekend gig of casting faces. To this day, it's one of the many art forms that still feeds me.

Chapter 4

"Ché Dereek"

The Michigan Ren Fest followed Scarborough Faire. The latter in spring, the former in late summer. There are many Ren Faires that happen all over the country. You just have to decide which ones you want to do, and get juried in. Derek didn't join me in Michigan full time until the next year as he was doing bubbles in a show near N.Y. City. I had gotten a booth partner, Jeff, to help defray costs. He was a young potter living in Rochester, Michigan. The boy subsisted totally on 'Stop n Go' fried pies, burgers, and Mountain

Dew. I've often wondered how his health is these days? Jeff had a large studio that I used to facilitate filling the orders for face castings that I garnered from each weekend's show.

Over time, Derek and I built a small bedroom atop the booth wrapped in bridal veil. Tulle, it seems, is the poor man's mosquito netting. Downstairs we had a very small kitchen with a blue and white 1940's vintage cook-stove. Out back we had the swamp, thick with long green and brown cattails, rooted deep in the murky bug-infested waters that circled around

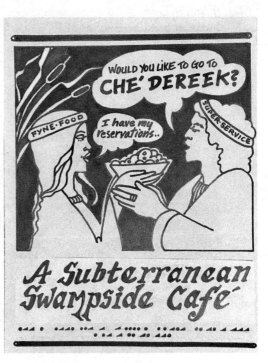

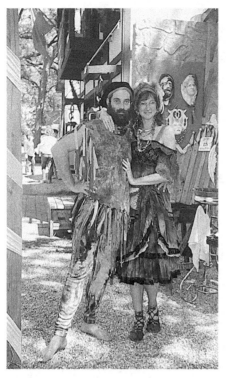

(Above) Christy Potter with The Burley
Minstrels: Jim Hancock & Bob Bielefeld
Scarborough Renaissance Faire

(Above) Ann & Derek the day they won
$500 for best booth upgrade at SRF

(Below) "Flaming Idiots" promotional poster

(Left) Ann's booth at the Michigan Renaissance Festival

(Below) Our first Champagne Croquet Formal & Erotic Food Contest on the Michigan Festival grounds.

(Bottom Left) Me with my friend Sandy Dunn

(Below Right) "The Flaming Idiots", Robbie Williams, Kevin Hunt & Jon O'Connor, with Crafts Coordinator Karen West

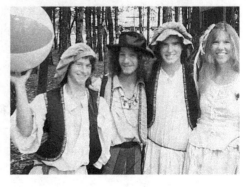

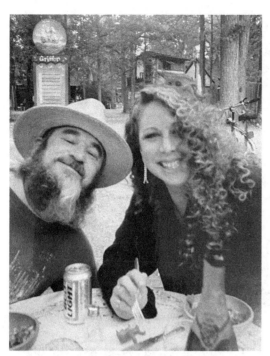

Metalsmith Dave Dardis & Face Painter
Tamara Norgaard at Ché Dereek

behind the festival site. The faire had paid a little 'extra money' on the side to fill in and build on DNR land, (Department of Natural Resources.)

In 1987, while we were constructing the booth, we had our first croquet party.

As the booth wasn't habitable yet, Derek and I were living with a friend of Jeff's in the upstairs of her barn in a town not too far from the site. For the party, Derek prepared a middle eastern feast of homemade dolmades, couscous, and lamb. He almost burnt the house down when the woman's stove caught on fire. Thankfully the owner wasn't there at that moment. We were able to mask the smoke effects from the fire. She was pretty oblivious anyway, so she never noticed. I don't think she actually ever used the stove. The food didn't suffer at all. One of the croquet mallet wielding revelers, musician Bob Bielefeld, proclaimed that Ché Dereek's cooking was the absolute best! The name stuck, and the following year when we were living on site, we decided to create the "Thursday Night Subterranean Swampside Cafe". "Ché Dereek" was born!

It started with 10 paid customers for a four-course, all-you-can-eat-til-it's-gone meal. $6. Desert was extra. Entertainment was divine! We had musicians, magic, and mayhem. One of my favs was a troupe of Rennie kids who rehearsed for a week. The "Funky Kidz" performed an incredible song and dance version of "Let Me See Your Michael Jackson, What's that You say-You say?" Little Stephanie had learned this clever ditty at camp prior to festival. Together, the kids performed a choreographed song and dance.

We had folding card tables covered with '40s tablecloths, wooden folding chairs, classic vintage plates and silverware. These were all purchased for dimes from thrift stores in Flint, where the economy was dismal. We

Front table: Jeff Thorpe, Jimmy Grant, Tamie Stewart, Dave Dardis &
Doug Gillespie, with your Host, Dereek, (standing)

scoured the local yard sales for animated kid's toys. (Some are now quite collectible.) If the entertainment wasn't to your liking, you could always play with the toys.

Living in primitive 3rd world conditions there meant no on site shower facilities. Many of us had temporary camp shower bags slung up behind our booths. The privies (portable johns) were often not cleaned until right before the next festival weekend. The only running water was across the way by hose, attached into the food booths. So, once our dog Toona had licked every plate clean, Dereek and I would haul the dishes over to this area and wash them. To this day I have no idea where we stored everything or how we cooked for that many in such an incredibly small space.

When the rains would come, we would lay out wooden palettes as walkways through the mud and set up tables in Doug's leather booth, Denzil's palmistry booth, and our own leaky structure. Any place with cover. We used

umbrellas to deliver the food. Folks came no matter what the menu. We made food up. Each flyer was hand illustrated and drawn by yours truly, with a different secret message in Morse code every week. It was 'spontaneous theatre' at it's finest.

The restaurant continued weekly, growing in size and cost. When we finally quit Michigan due to festival mismanagement, and a better offer to move to the more lucrative Maryland Renaissance Festival that over-lapped Michigan, we were up 30 people at $10 a seat.

Taking the modicum of profit from the season's take, we used it to feed folks we deemed 'worthy' at a restaurant of their choosing. Fine dining was encouraged. It was during one of these that Derek became an 'Honorary Lesbian' - but that's a story for another time ...

We also sponsored the yearly "Champagne Croquet Formal and Erotic Food Contest".

Having been inspired by an Erotic Food Contest at the Colorado Renaissance Festival, we decided to further amp up the competitive element by adding in Croquet - and Formal attire.

These events moved with us when we went to Maryland.

But I'm getting ahead of myself ...

Chapter 5

Rennie

Scarborough.

It ended for us after four fun years when an opportunity arose to vend at to the "Original Faire" - the Muther of them all - the California Renaissance Faire.

Scarbie was a party show. I got to really dig my fingers into the meat of this unique art of living with like-minded freaks off the grid. Okay, so not totally off the grid. We had TV. Saturday morning before faire, we would listen to PeeWee's Playhouse and shout out the word of the day. We had electricity. The intense North Texas storms were known to come inside and zap whatever was nearby into oblivion. And there were showers! Real ones! Even if the floorboards were rotten! So we weren't really off the grid.

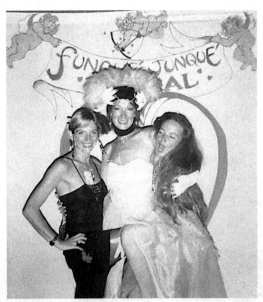

My first "Funky Formal" was there, in 1987, at Joanne's Junque. The Junque was a 'speakeasy' on the edge of the faire site that housed various events and was a general hangout.

The Funkys are themed dance parties. They started at Scarborough Faire in 1982 as a birthday party for my friend, the human puppet, Gabriel Quirk. Now all the faires have them. The 1987 Funky was the 'Lightening Bug Ball'. I decided

Katie, Ann, & Pamela, Funky Formal,
1987, Scarborough Renaissance Faire

that if I made a backdrop, I could use my new Polaroid camera to take photos for folks at the cost of $2 each! Can't remember how many photos I took that night, but I do remember having a blast dancing. There were dance cards, and mine was full. Finding the person who was due to dance for each number on the card became more challenging as the night wore on …

Derek was now with me most every night. Scott was distressed but

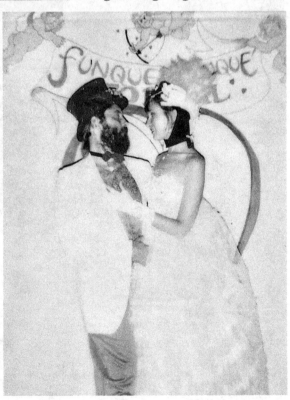

Ann & Derek, 1987, Funky Formal,
Scarborough Renaissance Faire

ultimately dealt with it. Somewhere towards the end of the season, his current apprentice/assistant made a pass at him. She knew about our affair and was attempting sexual blackmail. When he turned her down, she finked on him to his wife about us. The wife was plenty mad. What she never knew about were all the other women.

My friend Margie took over Scott's booth when his wife made him quit the faire.

Scott died several years later from a brain aneurysm caused by his recent addiction to methamphetamines.

I got better and better at lifecasting and eliciting from people what they wanted. By the time I got to the California Ren Faire, I was putting faces on goblets and teapots as well as doing body casting, hand castings, and shrinking heads and putting them on dolls.

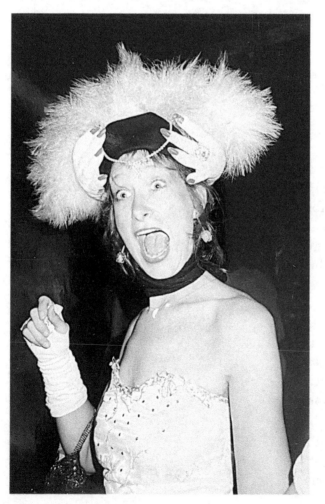

Part 2

Growing Up

Chapter 1

A figurative Artist

Faces had always been instrumental in my drawings and sculptures since I was very young. So had nudes. My brother, who was nine years older than me was always drawing nudes. If I snuck into his room, I could see them. They were everywhere! If I was caught, he gave me an "Indian Handshake" - grabbing my wrist in his two hands and twisting hard- until it burned.

Ahh, … siblings …

I would sketch/copy the Daisy Mae style drawings from my mother's "Fredericks of Hollywood" catalogs. Very risqué for the era. I focused on faces - and the bullet boobs.

In 1st grade, I drew 3 harem girls dancing around an umbrella - topless - and showed it off at school, offering it for sale for a dime. My teacher scooped it up and called in my mother. Mom said she'd deal with it. When we got home, she told me I was welcome to draw whatever I wished, but as the world didn't necessarily understand these things, it was best that I keep them here in the house.

She gave me a drawer of my own for keeping these illicit illustrations in.

Second grade. I was now known for my penchant for drawing nudes.

I was one of two in an elevated reading group. Mom had me reading from her elder sister's grade school 'readers' since I was a tot, (mom was born in 1916, to give this perspective). My teacher had to request that I not read from these currently as I was surpassing the other kids at too rapid a rate.

These 'Readers' were from the same grade, three and a half decades before.

The decent of a species. Thankfully, my mom ignored this request.

The boy and I who were the only two in advanced reading were given free time at our desks while the teacher instructed the rest of the class across the room. The boy presented me with the concept that we should draw each other's private 'things.' My hesitancy was short-lived, and we were soon covertly exposing ourselves to be sketched by each other. Once these masterpieces were complete, he suggested we paste each other's artwork on the front of our desks. Having already had an encounter involving nudity and scholastic red tape, I wasn't too sure. Being young and having as yet unformed mental capacities, I decided - what the heck!

I have zero memory of the upshot of this.

However, you can now begin to see the formation of my future.

Chapter 2

Getting naked

At sixteen, my fellow classmate Kathy, whose artwork I was inspired by, suggested that we take advantage of a life drawing class that was being offered Wednesday nights at a Unitarian church in downtown Rochester, about a 20-minute drive from our small rural town of Webster, NY.

For those in my reader audience that might not know, 'life drawing' indicates drawing from a live person, often nude.

Our parents agreed and took turns driving us there weekly.

The sketches we brought into our high school art class raised eyebrows. Thankfully, the painting teacher was avant guard and encouraged us. Kathy and I both made art the likes of which our little rural school had rarely seen.

One night, when the male model set to pose hadn't shown up, I told them that I would check with my mom and see if I could be available the next time that happened. I did, and mom said, "$10 for two hours is good money. It's an honorable profession. If you think you can actually pose nude, then you may." I was flabbergasted! Even more so a few weeks later when the model called in to say she wasn't going to make it. Class was assembled and waiting. The organizer asked me if I wanted to pose, as I'd expressed interest. Quietly I left my easel and changed out of my clothes in the dressing room.

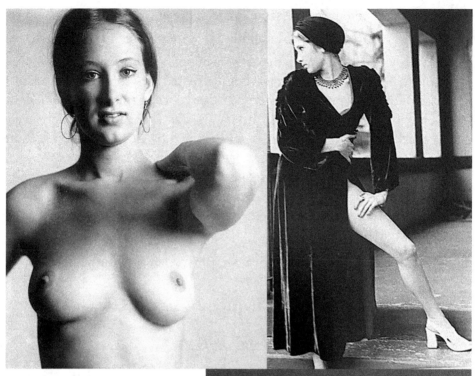

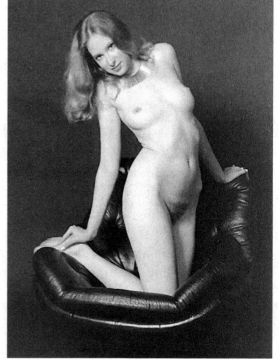

(Top Left) Ann at age 18

(Top Right) Ann at age 19

(Right) Test Shot for Penthouse
Magazine, age 19

I then walked bare-ass naked with very wobbly legs out in front of all these folks I'd become friends with, in the previous guise of a clothed person. My friend Kathy let out a way too audible "ANNIE!" I had taken a shaky pose where I leaned down onto my knee with one hand, the other hand on my hip, consciously creating desirable 'negative space'. I remember this clearly: a large (HUGE) drop of sweat s-l-o-w-l-y dripped down from my armpit to the tippy tip of my incredibly exposed nipple ...

At the end of class, I was applauded for my posing talents.

I was hooked.

This, then, became a source of employment that fed me and connected me into the art scene over the next 15 plus years.

Later, while in New Orleans, I posed nude for a potential Penthouse magazine spread. I never got published, as 'spread eagle' had just become a thing. Not my gig. Eroticism, for me, dwelled in a tongue tip touching partially parted mouth-lips. Or a drape of sheer cloth dipping down far

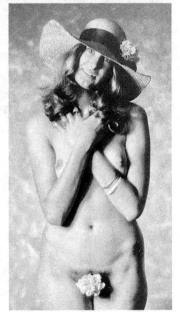

enough to show a nipple. Totally nude worked with the right poses, but a spread pussy lacked any mystery and creeped me out. Taking my 'spread-sheet' and the extra photos, I left.

I had thought when I got into Penthouse, I'd show the cool kids back home a thing or two! What I found out was that it didn't matter. I had attained a level of personal achievement and had walked away proud.

Nudity has never been a problem for me. Not since age 16 when I first stripped down in front of an entire classroom of artists who honored me for what my body could do in holding a pose that helped them on their way in creating art.

Chapter 3

Martian

My mom was an amazing woman. Every morning, when she woke, she

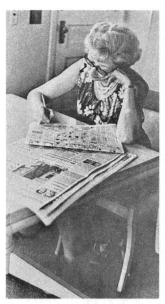
Mom's morning crossword, 1971

put on makeup and a nice colorful dress that had been perfectly ironed. She then went down to the kitchen, donned an apron, and proceeded to make my dad's lunch, as well as mine. She then cooked up a proper breakfast for the three of us. Very Doris Day.

She was a good wife and a fabulous mother. She was also my best friend. She allowed me liberties that no other mom would even consider during this era. We would discuss the options for moving forth in this world as an adult - with real concerns, love, and humor. She also fed my childhood fantasies of fairies and forts and dress-up. I had an honest to gawd metal and wood turn of the century trunk full of fabulous costumes, jewelry, and wigs. She let me use her sewing machine for making pieces to augment

whatever character I might need to be next. My friends and I played dolls and dress-up, well into my 14th year.

I was a geek. Think about that differently from the techno-geeks that are living in private worlds through their hand-held devices nowadays. I was one of those out-in-the-woods, climbing trees, building forts, and making mudpies in gowns kind of geeks. I had lots of friends and we had fun.

Then one day, the kids

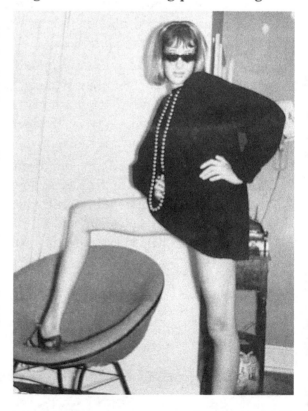

I'd grown up with in my neighborhood decided to 'ditch' me.

Small 'hood. We had two dead end streets off the main road of 'Five Mile Line' that led towards town. We were surrounded by woods and orchards. I lived on that main road right on the edge of these two short streets, Winifred and Gaywood.

Being a geek, I was often tortured by some of the boys. If captured, I might get snowballs shoved down inside my clothes, or be forced to sit in poison ivy. Like that.

Granted, I'd maintained for some time now that I was an alien and so was my aunt. She lived on Venus and would occasionally come to visit. She'd park her flying saucer in the hole in the concrete floor of our garage.

The hole was actually a deep pit that had been built in so my dad could get under our cars to work on them. But as it was empty, and no other homes in our neighborhood had one, I felt I was secure in my conviction. I also maintained that my Pippi Longstocking style pigtails were 'antennae.' You can perhaps see that as the neighborhood children aged, my sense of imagination became highly questioned ...

The gang of six girls I'd grown up with since we were toddlers came to visit one day in late summer. My yard was a favorite play place due to two treehouses, swings in the apple trees, pet rabbits, and a fort in the woods out back in our half acre lot.

I figured we were all going to play some game in the fort house. Mom gave us cookies and we stood out in the side yard by the fairytale white and purple hollyhocks that were taller than we were. While they munched on their snack, they told me they were quitting me. None of the local boys liked me. They, however, had started to like boys. Hence, they were not going to be my friends anymore. We were all about twelve to fourteen years old. Some had started to sprout breasts and had begun to age out of awkwardness. I was twelve years old and firmly rooted in this latter phase.

Confused, I thought it was a prank. Then they told me that not only were they going to ditch me, they were also going to make all my other girlfriends leave me as well.

And then they left. Cookies in hand.

It was real - and I was crushed.

I spent the rest of the summer mostly at home in my own yard. If I

wandered out beyond into the surrounding woods and orchards, I took my dog, Tippy, as protection. Now not only were there boys who would torture me, but creepy mean girls as well.

There were school friends I would go see if mom would drive me, or I could bike it if I felt like riding that far.

My new 'best girlfriend' Lynne, had moved in two years before. She was at the other end of the main road on the edge of where the houses ended and woods began. Lynne's mom restricted her playtime, as she had lots of chores. We spent as much time together as we could. Lynne and I never seemed to run out of fun things to do. She never developed friendships with the other girls in the neighborhood, so when they dumped me, it didn't affect our relationship.

Chapter 4

Pain

Summer ended and school began. A new high school was being built up the road and until it was done, all the kids in town were split off to two different educational facilities by the delineation of our street; Five Mile Line Rd.

Lynne and I were on opposite sides of this street. We took one bus together to her school and then I got taken on across town.

If you were smart, you didn't go anywhere near the back of the bus when you got on. That was where the 'cool' (ie: "cruel") kids sat. No real restrictions back in those days. The bus drivers mostly ignored what the kids did to each other.

Lynne and I always sat up front, facing forward, ignoring taunts.

Ever since the fall out with the neighbor kids, the old bus stop closer to home became an easy place for torture. I now walked down to Lynne's house every day to catch the school transport.

One morning we had fun playing with her one-eyed mouse-eating cat, Matilda, while waiting. We laughed and kidded around.

The bus arrived and we got on - and Lynne walked straight to the back.

I knew what had happened.

They'd promised her popularity, and she had believed them.

This time I was devastated.

Lynne and I didn't speak again.

It seemed their arms were far-reaching. Who knew what they were capable of?

My other school friends told me they would not allow these kids to come between us. They were steadfast and true.

However, now there was no one close enough to just go hang out with.

I was alone.

For two years I worked on trust issues. I built up my confidence and developed strength in solitude.

Mom was great during this time. We got involved in pottery classes together and spent many evenings playing board games while she drank her booze and smoked packs of cigarettes.

Chapter 5

Pot

Mom and Dad were chain smokers. Cocktails happened as soon as Dad got home from work around 5 p.m.

I sneaked both and found neither to be to my liking.

Two vices down.

At age fourteen my brother Danny got me stoned.

He was back from the University he'd been attending in Mexico City. I had 'grown-up' since he was last home.

We went out for a drive to one of the local beaches and he pulled out a joint. He was my cool older brother, so yeah! I was game! The beach we went to unfolded into a glorious vision. Soft winds wrapped around me. I laughed until I thought my cheeks would burst! We spoke of worldly things, and cosmically appreciated the beauty surrounding us. Then we went and got ice cream. Getting stoned was a wonderful way of finally making a connection to this person who had always been such a fabulous influence on me. ·

I thought pot stayed in the blood for a month, (childish rumors) - so

the next week during a routine visit when my doctor asked me in front of my mom if I'd ever smoked pot, I nervously fessed up. I figured the doc knew, so it was best to tell the truth.

In the car, mom grilled me. She wanted to know WHO? I fessed up again … with the caveat that I didn't want this to mess up a newly found friendship with my twenty-three year old brother. I promised I wouldn't smoke pot again until I felt I was old enough to 'handle' it. That turned out to be age sixteen.

Chapter 6

Both Sides Now

Shortly after my brother returned to Mexico, Lynne walked up to me in the hallway of our newly built high school - and just started talking, like maybe nothing had ever happened.

Fear and elation collided in me. I barely breathed. I certainly didn't trust it.

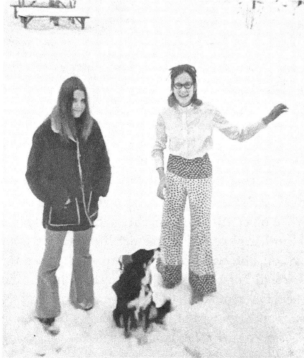

Over the next couple of weeks, she would meet and walk with me through the hallway. Light chatter.

I finally confronted her. She told me that the neighborhood girls came to her house and, as I suspected, offered her the grand prize of popularity if she would divorce me. She had always wanted to be popular. And at first, it was fun, she was invited 'in'.

Lynne, Tippy (in Santa hat) & Ann, Christmas 1969

As that waned, she

realized what she had done. That in me, she had a true friend, and she'd botched it. She couldn't just be 'given' popularity with the crowd these girls hung with. It was a whole different tribe. She and I would never be a part of that 'In Crowd', and truth was, we really didn't like them.

Trust did not come easy. It was a full year before I was willing to go hang out comfortably with her. Seeing how she recoiled every time she encountered one of those 'popular' girls finally convinced me that she was being honest.

Lynne and I became 'Best Friends' again, and have remained so to this day.

Chapter 7

"It's just a jump to the left!"
– Rocky Horror Picture Show

I continued to make art and my pieces won accolades. I got both Blue and White Ribbons in the Scholastic Art awards. I became the artist for the school newspaper. I got asked to be a part of a group known as 'The Freaks' who were a creative force that offered an alternative space for kids to hang out where movies and dances were held, (and where they could smoke pot). They called themselves "The People's Co-op" to have a more official sounding name, thus allowing for better credit in the local scene. Being their artist, I made their fliers, assisted in painting their billboards, and helped create floats for their spot in the local town parades.

I even participated in the local "Winter Snow Queen" Beauty Contest as the People's Co-op entrant, since I was the most 'normal' of their group. There were two of us out of the 6 contestants that were reasonably good looking. I was the tallest. Having been in the debate club, I was also adept at speaking and presented myself well. My folks had been teaching me how to walk with 3 books stacked on my head in order to help create proper posture and poise. Everyone was sure I was the shoo-in.

Who you know has always held sway. That, and money under the table. The dumpy schlub got the trophy. Her daddy was a hot shot in local politics and wanted his baby to get the crown.

But hey! - it was fun - and being told by one of the judges that I should have won made me feel good. It also made me realize that being the best at what you do doesn't necessarily mean you'll get the placement you deserve.

Kathy and I continued to attend the Life Drawing Class in downtown Rochester. I posed for class often. I got better at drawing nudes.

One day, an attractive older gentlemen in the class asked me if I would like to pose privately for him. I told him I'd have to ask my mom. He quietly stepped away, not having realized I was only sixteen.

In time, we found out this man, Dan Fuller, also lived in our town of Webster, over near the cemetery with his young wife. When our folks didn't want to give us rides, he'd come pick us up and bring us back home.

We became friends. At age seventeen, Dan asked me to pose again. This time, my mom said yes.

Sidestep:

I had lost my virginity at 16 to a boy I was SURE I was going to marry. After a year of a VERY active sex life with Peter, (parks, cars, church basements, bedrooms) Peter went off to college. He wrote from there to tell me all about girls he'd met and was dating. Spurned and devastated, I felt ready to commit suicide. I slogged around the hallways sobbing incoherently for days - for weeks.

(Don't forget him, we'll meet again ...)

All my friends tried to help. Lynne was awesome. She consoled me and encouraged me to "get up

Peter in my living room, 1971

27

Peter & Ann

and do something".

Mr. Anus - err - Annis, was our Science teacher. He looked like an iguana. One day he showed us how to freeze flies for 3 minutes, then separate their wings, and, placing the tip of a length of thread between them, you add a drop of hot wax so the thread adheres to the fly's back. When the fly thaws, you can walk it like a dog on a leash.

The halls were filled with kids walking their flies.

This was crucial in my high school shift from 1st love to creative balance.

Chapter 8

… Giving Birth …

We went to a very Avant Garde high school. Our administrators had decided that we were the 'Apathetic Generation'. We were the brothers and sisters of the sons that had gone off to Vietnam and had come back darkly altered. They figured many of us wouldn't be going to off to college.

So, as well as college prep classes, we were also given the option of 'life-prep' courses.

I took Sculpture, Fashion Design, Painting, Film making, Photography, Drama, 'Man and the Art of Society' (dual subbing for Social Studies and English), Poetry, and 'Zen and the Art of Mythology.' From this latter, Samuel Beckett's quote from Waiting for Godot stays with me to this day; "They give birth astride the grave, the light glimmers and instant and then it is night once more". You've got 'that!' (snaps fingers) long to live - so make it happen!

When Dan wanted more than just to draw me, I decided it was time to Live …

Thirty-five years later, I have a monogamous relationship and all of its vast stories to tell in regards to my "current" life. Nevertheless, this vivid segment from the past that I'm about to embark upon is intense and complex. The highlights are all here, and maybe it's best to focus on those, and not get too bogged down in the minutia. I've got so many dusty tomes in my head. I open one and, coughing and sneezing, edit it for the telling. I know its chapters well, but it feels like someone else's life I'm going on about. Gonna try to tell the truth. This is raw. These are the times that formed me, so there's no use in denying them.

Sometimes you make life choices and sometimes the choices make you.

Part 3

Portrait Artist, etc.

Chapter 1

The Golden Child

I spent four and a half years with Dan Fuller.

Dan was 25 years my senior.

He had four kids with his first wife, the eldest girl a year younger than me. He hooked up with the second wife when she threatened suicide if he wouldn't marry her.

He wasn't interested in marrying me (he was still married anyway) and we were not to discuss babies, (in retrospect - I gotta say, whew!)

He was a portrait artist and was willing to train me in all the ways of his world.

You can see why my mom was totally freaked when I told her we were involved. I truly thought, us being best friends and all, she probably already knew what was going on with me. Dumb 17 year old.

When I left home with this man, mom very nearly had a nervous breakdown - or perhaps she actually did.

My sister was worried about her. She watched over mom as best she could during this time. Born ten years prior to me, sister Dayna was out of the house already, married, with a kid.

Dayna let me know that mom gave all my stuff of value to her and to my two best friends with firm instructions that I was NEVER to get any of it.

Whatever else was left behind, my mother put into a big bonfire in the back yard, and ceremoniously torched.

I was the 'golden child'. Smart enough, talented, and more goal-driven than my older siblings. My folks were sure I'd be the one to make something of myself.

Dayna had been pulled out of college and brought home when she got mononucleosis, (the 'kissing disease'.) In order to get out of the house after that, she married. The guy she married was odd and pretty hard to deal with. She had one child before being stricken with Hodgkin's disease. It didn't kill her, but the radiation sterilized her and she was torn up over not being able

to have more kids. Searching for something, ANYthing, she ran the gamut from studies in Black Magic to Fairies. Through her husband, she landed on Christianity.

My brother Danny, who was nine years older than me, was off in college when I left home. He originally attended the "University of the Americas" in Mexico City. A couple years in when he knocked up a local girl, her relatives got their all their friends and went 'husband-hunting' with guns and machetes. Danny went and hid in the mountains until he could make his way back home to upstate New York. Once he returned, mom and dad got him back into college in Syracuse where he promptly discovered LSD and started growing marijuana in his dorm closet. He eventually got a degree in English, but somehow ended up working in a psych ward.

It was one of the toughest days of my life to pack my bags to leave home forever. I had graduated high school and just turned 18.

The shift of their 'golden child' into a renegade artist who was suddenly thinking of making a life with a married forty-two year old was absolutely flipping my parents out.

Due to the revelation of this illicit relationship I had embarked upon, they started enforcing tighter curfews. As Lynne said, I was now finally experiencing what she had been through during all her high school years.

Fights with my folks had gotten increasingly worse. They turned into shouting matches. Then one day, dad hit me. Real hard. Knocked my earring out and my right contact lens went to the back of my eyeball. Gave me a big bruise on my right cheek. Spankings and an occasional slap were peppered throughout my youth, but this was new and frightening.

The arguments with my mom tore me up. She had been my dearest friend and confidant, and I now had nowhere to turn except into the arms of the older man who'd been doing everything he could to lure me away.

The night my dad hit me, I went and stayed with a boy who'd been wanting me. This fellow wrote letters for months after I left. Mom would forward them to me, hoping maybe they'd help encourage me to come back home.

Dan was in Provincetown, Cape Cod, Massachusetts, doing portraits. I called him and he sent a female friend to come and get me from the

boy's apartment where I'd stayed over. She drove me to my house so I could pack my 6 tiny suitcases and leave to be with Dan. I'd asked Lynne to drive me over, but she refused. She loved my mother too much to watch her go through this.

Mom was a total wreck. She watched as I packed. Crying, not speaking, in the way of someone who has just seen the person closest to them die …

It was wretched.

I couldn't turn back now.

I left the next day for Provincetown.

Chapter 2

A Brand New World

P-Town was a hippie vacation paradise seaside burg with pubs and clubs, restaurants, and art galleries.

My first job was with an Italian Restaurant working for two lesbians as a prep-cook.

I'd met a lesbian growing up when one moved in across the street from my family. When she got the first color TV on the block, she invited me over to see 'The Wizard of Oz'. My folks wouldn't let me go.

One night a rich couple from Rochester that were sponsoring Dan's art came to visit us in Provincetown. The husband got toasted and passed out. Dan and the wife and I went dancing. The two convinced me that if I chose to frolic with them, the relationship between Dan and I would work much better than average relationships do.

We three went back to the cottage Dan and I lived in and had sex all night long, with the passed out husband in the corner.

I found out later, they'd slipped her husband a mickey.

Was I a lesbian now?

The town was filled with artists. I took painting classes from a premiere local master. I met two jewelers that were to feature prominently later in my life at Ren Faires; Wolfgang Lichter and Barry Chevalier. I honed my skills as a portrait artist under Dan's tutelage and got better at drawing.

The fashion choice on any given day would be tan short shorts and a white shirt unbuttoned to my navel, as per the 'scene' in P-town. I was blonde, lithe, and creative.

Men came on to me, but I was with Dan. I followed his lead. And lead me he did.

While I was working, Dan would have women to the house for sexual escapades. It took me months to discover that this was happening. When I found out and confronted him, he promised it would never happen again.

Winter came on, and we moved back to Rochester where Dan proceeded with portraits in the Mall, and I became an ecdysiast - (Read: professional stripper).

I saw mom when we returned home and we agreed to get together every now and then, but she didn't want to see Dan.

I kept my profession as a go-go dancer from her. I wore a black wig and false eyelashes to work. My stage name was Aubrey, after my favorite artist at the time, Aubrey Beardsley. I would take out my contacts so I couldn't see anyone in the audience clearly. It was easier to perform to a blurry crowd. There were two associated clubs I worked at in adjoining counties. One county allowed topless dancing. At the other one, I had to wear pasties. I learned to spin the tassels on my pasties as good as any professional.

An old high school friend came into the topless club one night. It was really nice to reconnect with him. We chatted, he bought me a drink and he said he'd come back to visit.

Brother Danny was home from college in Syracuse visiting with mom and dad for the weekend. He woke up and wandered sleepily into the kitchen, looking for coffee on Sunday morning, when mom came at him shouting, "Where's Ann Working?!?" At this point, one has to believe that fate has a sense of humor because when my friend couldn't remember where he'd run into me at my topless gig, unbelievably, he called my mother to ask what club it was.

Doh!

Danny knew but wanted to throw her off the scent, so he gave mom a made-up name for a club. It was actually the real name of a lesbian strip

joint in town.

Double Doh!

Mom now said we would not be seeing each other until I quit topless dancing. Didn't matter that it wasn't actually a gay joint.

Mom and I didn't see each other until several months later - right before Dan and I moved to New Orleans.

Chapter 3

"Panama Hattie's Whorehouse"

The apartment we got in NOLA was $25 a week. The entire interior of the place was covered floor to ceiling with 12-inch mirrors, except for sections where they had fallen off or were cracked or broken. Of course 'ladies of the evening' were no longer 'legal' (?) in NOLA, so "Panama Hattie's Whorehouse" had been out of commission for years. It was now a low-rent apartment complex.

By the time we'd made our trip cross-country, we had just enough money for rent. I got a job waitressing right away, so we could get the cash for Dan to get a license to do portraits on Jackson Square.

The Square is just that. A one square-block park surrounded by a wrought iron fence, real trees, and a statue of Andrew Jackson smack in

Me & Rosie the Skunk,
Jackson Square

the center. The Mississippi River bordered one side. The three other sides were beset with artists plying their trade, using the fence as their backdrop. The trees here were the only ones in the quarter. I would often go there and look up, pretending that I was back home, in my wooded childhood, which

was now distantly unobtainable.

I'd played around with portraiture my whole life. Watching Dan and learning some of the tools of the trade, I decided I would also make a cart and go out to the Square and do portraits. When times were rough, it was up to me to be the one to quit the square and go find employment in the 'real' world, since Dan was 'The Artist', and would not consider taking a job. That would be beneath him.

My jobs were mostly waitressing.

I did take a gig on Bourbon Street topless dancing Christmas 1974 when Dan needed to buy presents for his four kids back home. I quit one night when, during a table dance, some Armenian bit my leg. Walked away with my tips and never went back. The check was well below minimum wage and so piddly it wasn't worth returning to the sleazy joint.

Sometimes we were flush with cash, especially when business on Jackson Square was good. Often we were broke.

Money was an amorphous thing. If we made $400, we'd spend $399 at a restaurant that night, with friends, food, and drinks. Lots of drinks. The legal drinking age was 18 at this time, so I was good to go.

Chapter 4

Sex in the '70s

Dan groomed me in the 'lifestyle' concept that if a woman was willing to share her man, she'd be more likely to keep him.

We would both scout out women that he might like to share our bed with. Every now and then it might be another couple.

The local bars and clubs were perfect for this, as was the tourist trade that came through Jackson Square.

Condoms weren't considered at this time (this being the early

Curly, Ann, Dan & 2 friends, NOLA, 1975

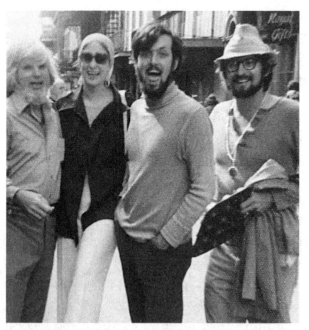

Dan, Ann, Mike, & Robbie, NOLA

swingin''70s) and besides, I was on the pill.

Dan was still having women in when I was off working. I found this out after a high school friend came to visit and he'd come on to her when she discovered him at the apartment fucking some waitress. Dan convinced her to not tell me, but a few months later during a phone call, she decided to.

As usual, when confronted, he promised to stop. Yeah. Right. He told me that if I found someone I wanted to have sex with on my own, without him, I could.

So, finally, I did.

Mike and his wife Penny were part of the crowd we hung out with. Penny was a Bunny at the Playboy Club. Mike was a potter. I was wanting further clay instruction from the guidance I'd gotten in high school. Remember the erotic scene with the wet clay and the potter's wheel from the movie "Ghost"? I think they took their cue from us.

I finally had my first orgasms!!

Life snapped its fingers again, and I took 6 jumps ahead on the game board.

Chapter 5

$12 a Day for a Street Role
$50 to Play the Whore

An acquaintance of ours was the local casting director for movie

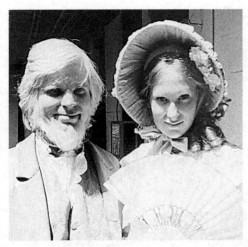

Dan & Ann in the movie "Mandingo"

roles that landed in New Orleans. Dan was a true 'character' and the movies wanted him until his looks upstaged the actors, after which his scenes would get deleted. Me - I was young, cute and the casting director and I got along great, so I got a bunch of bit parts.

Mostly these were background gigs at $12 a day. You'd sit around for 10 hours waiting until you got called, playing cards, and listening to the stories of bit actors that were higher up the food chain.

For the Charles Bronson movie, "Hard Times" I got a cool role as one of three whores. That gig paid $50 a day! I wore a pink satin striped vintage short slip and 'fuck me' pumps- (strappy open-toe shoes). No lines. If you watch the movie, don't blink or you'll miss me. We were all told not to speak to Bronson. If you did, you'd get fired. James Coburn was a sweetie.

This led to a gig in a television pilot for a "New Orleans PD" series that bombed. If it had taken off, I'd have had a role as a police station secretary full time.

Actor Peter Graves was the original "Mission Impossible" Tom Cruise character. A few years past his prime, he was the star of this potential new series. It was one of many freshly launched cop themed concepts being touted for every large city in the country at the time. He invited me into his trailer one day during a break in filming, put his hand on my knee, and let me know that we could have a 'thing'. My skin crawled, I demurely bowed out and left. Eww.

Ann in "Hard Times"

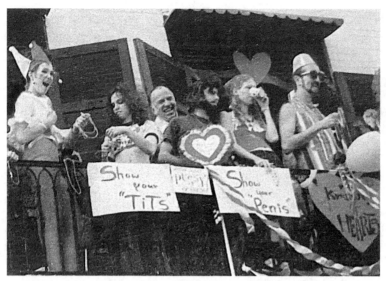

Ann, far left, in joker hat, 933 Royal Street, 1976

Chapter 6

"Show Us Your Tits"

Mardi Gras 1976! A non-stop drunken costume party extraordinaire!

Dan and I were part of the "Krewe of Hearts". There were around 15 us. I was the Joker.

I'd discovered that in going to Canal Street to watch the big float parades, if you climbed up onto someone's shoulders and pulled your shirt out, exposing your bare breasts, you'd get the best beads tossed down to you from the masked men on the floats. They'd aim for my boobs with gobs of necklaces. The local street urchins caught on fast and would sneak around and leap up, literally snatching them off my chest! Dodging these kids, I'd salvage the ones that fell into my shirt and pass them down to my

Robbie exchanging beads for boobs

Krewe members who stuffed them into bags.

When the Canal Street Parades end, the revelers swarm the French Quarter.

Dan and I lived in an upstairs apartment on Royal Street in the Vieux Carré with a long stretch of balcony overlooking the street below.

4 gents comply with our signage

Our Krewe having now garnered hundreds of strands of colored plastic beads, gathered in my apartment and plotted as to how we might get the hordes below to entertain us. I made some signs. One of them said, "Show Your Penis," another said, "Show Your Tits". The latter became the biggest hit! We tossed beads down to any that offered up their body parts for review.

Years later, I received a letter from a Professor of Sociology, teaching at Louisiana State University, researching the social phenomenon of "Show Your Tits". He had traced its origins back to our balcony on Royal Street. Foolishly, I decided not to follow up on it. The letter got lost in the shuffle of life.

TIME WARP:

In the final stages of getting this book ready for print, information came to light regarding "Show Your Tits". It would seem that in 1983 a fellow by the name of Wesley Shrum began inquiring with French Quarter locals regarding this growing fad. He was told that it was a Mardi Gras "Tradition". In less than 10 years, something we had done one day from our balcony on a lark, had become a "Tradition" that had been happening "forever" in the minds of the locals! His long search for the origin ultimately led him to my fellow Krewe of Hearts member, Robbie

Anderson. Mr. Shrum found Robbie selling his artwork on Jackson Square. In interviewing Robbie, he was able to trace our balcony party back to the original inception of this particular form of titilating public nudity in exchange for beads. Robbie gave him my address in Texas. I received the letter from Mr. Shrum in 1990, which I ignored.

Here are some excerpts from Professor of Sociology, Wesley M. Shrum's academic papers on the subject:

"In the mid 1970s a new phenomenon began to occur in New Orleans' French Quarter during Mardi Gras. That phenomenon may be described simply as an exchange of beads for nudity.

With parades now banned in the French Quarter, and most tourists on their way to Bourbon Street, a group of revelers engaged in innovative exhibitionism. This group on Royal Street determined, sometime during the 1975[sic] festival, to stop passersby and try to prolong the interaction.

The ... source was an annual gathering at a second-story apartment on Royal Street.

One female artist designed a sign with the bold letters "SHOW YOUR PENIS" ... [A] second sign was displayed: "SHOW YOUR TITS," soon to be commercialized on t-shirts, buttons, and a variety of French Quarter paraphernalia. By the late 1970s, it had become a chant and a slogan."

Finding an email address for Professor Shrum at LSU led to a flurry of excitement. "Do you know how many LSU students since 1990 have heard the story of your balcony? Thousands, maybe 10,000!" Professor Shrum told me.

I filled him in on some of the back story as I knew it, sent him the photo you see here, with me costumed as the joker on the balcony and the aforementioned signage. Further documentation on both our sides passed between us. A serious slice of history confirmed and 'fleshed out' (as it were.)

More research revealed a paper by Professor Laurie Wilkie called "Beads and Breasts" documenting the uptick on sales after the Mardi Gras event on the balcony at 933 Royal. In our email correspondence she stated:

"I think its worth considering the tremendous economic impact on Mardi Gras that the escalation of the throwing game through displays of nudity had

--- you are part of a group who increased bead sales dramatically as well as facilitated the expansion of bead throwing and exchanges at football games, uses at philanthropic events etc., because nothing gave national attention to the ability to quickly communicate meaning through beads faster than "show your tits".

This then, is one of my many Warholian '15 Minutes of Fame.'

Chapter 7

Fast Friends

Standing on the deck overlooking our section of the French Quarter, I saw Leslie for the first time. Dressed in a pure white ankle-length halter dress, with a matching snow-colored dog at her heels, she flipped her long blonde hair as they both came prancing into the courtyard. She'd come to stay with our friend and neighbor, Jerry, who had once dated her mother. Lost suitcases on the in-flight from Monterey, California had left with her with naught but evening gowns for a week.

She was 17, I was 19. The men we were living with were both in their 40's.

In yet another New Orleans reality warp, Leslie's mom Phylis had shipped her daughter to NOLA to get her away from Phylis's lover, - who had a contract out on Leslie.

It happened like this: Leslie's beloved dad died when she was just 13. Phylis took up with a black jazz musician named Ace.

Leslie had a body and demeanor beyond her years. By the time she was 14, Ace was slipping into Leslie's bedroom nightly after putting Phylis into a deep alcoholic sleep. With threats of lies to Leslie's mom, or worse, physical violence to Leslie, Ace would abuse this little girl as often as he wished.

Fearing that her mother would believe that she had been the one to lure Ace into her bed, Leslie allowed these nightly raids.

Finally, at 17, she made the executive decision to address the situation and told her mom about the three year 'affair'.

Phylis instantly approached Ace who tried unsuccessfully to switch

the scene around. In his anger, he put out a contract on Leslie's life. New Orleans became her safe harbor.

As so often happens, Phylis ended up staying with Ace. After working it out in Calif., they came to visit NOLA. They were the ones who told this story to me, with Leslie by their side - in some sort of mediation therapy. Leslie and I became fast friends and often went out dancing and partying into the night, at all the clubs the Quarter had to offer.

Due to the number of animals Leslie acquired while living in the tiny apartment of our downstairs courtyard, the landlady said she had to get rid

Leslie & Rosie the Skunk

of some. I adored Rosie the skunk, so she became mine. Rosie would sit happily draped over my shoulder and we'd walk through the Quarter. One day a couple of sightseers stopped me wanting to know what kind of a creature I had there. I smiled and told the two older women that it was my pet merkin. They were thrilled. One turned to the other and said, "I can't wait to go home and tell uncle Harry! I just knew it! I haven't seen a merkin since I was a kid!"

(A merkin is a 15th century pubic wig, employed when one had to shave due to lice or syphilis.)

Another time when I was walking out to the Square to go see Dan, a couple stopped me to ask if Jackson Square was "still over there?" pointing in that general direction. Amazingly, these exact words often came out of tourist's mouths. This time I said no, that they'd moved it and it was now over there - pointing in the opposite direction. The two wandered off, most assuredly to have an unexpected adventure.

Leslie met a boy and moved away.

Another friend who also came into play during this time was Deann.

Chapter 8

Deann

One of the locals was a bouncer Dan and I befriended named James.

St. Patrick's Day was yet another HUGE party scene in the Vieux Carré. Dan had to go take care of some family business in Rochester during this time. He asked James to be my 'go-to' should I need anything.

I'd gotten totally wasted and turned around from the friends I was partying with on that St. Patty's Day during the Bourbon Street revelry, and ended up at the street-front bar where James was working below his apartment. I walked up and said, "Hi!" then promptly passed out. James got his girlfriend to carry me up four flights on a spiral staircase to their top floor bedroom. He instructed her to take care of me. She didn't like me very much as James and I always flirted with each other, and she was jealous. Passing out on their bed didn't help to endear me to her.

I had ditched the couple I'd gone out drinking with the night before as I had concerns about their level of 'Pleasure through Pain'. Knowing how drunk I was getting and fearing what might happen if I passed out in their bed, I decided to leave them at the club where we'd been drinking and dancing. What I didn't find out until many months later was that they went looking for me. Shouting out in the street in a near panic, the girl began freaking out when they couldn't find me. She started to hyperventilate in a drunken stupor. Her boyfriend slapped her to get her to snap out of it. A cop saw this scene and approached, baton out. They both started screaming at him (bad move) and the cop ended up beating both of them! It only escalated - the more they got beat, the more they freaked out; repeat. The guy's face was badly damaged and the girl's back and arms were bruised. They were released from jail the next day and had friends take pictures of the injuries inflicted. When next we spoke, they were still pursuing a lawsuit against the New Orleans Police Department.

In the morning I woke up in between James and his 17 year old girlfriend, Deann. Wondering what we'd gotten up to the night before, turning, I saw the look on Deann's face and realized that nothing had happened - not on her watch!

Then I threw up.

Somehow, over time, she and I became friends. Then we became better friends.

She ditched James and became lovers with Dan and I. James was none too happy with this.

He put a contract out on Dan's life.

In 1987, years of nightmares ended when I finally asked Deann to fill in the blanks. I knew something happened that was bad, but I simply couldn't remember anything until she told me all the stories that linked the flashes in my memory together ...

Chapter 9

The "River Square" Galleries, etc.

A couple of friends on Jackson Square had invited us to come work the mall circuit doing portraits with them in Texas. Now seemed like the right time to get the heck outta Dodge! Five of us portrait artists worked the malls in Corpus Christi and McAllen.

There were 2 'Bobs' in this group. The younger one (41) was married to a sweet 17 year old named Regan. In Texas at during time, if a 'guardian' bought a drink at the bar and then handed it to an under aged person, it was not illegal for the kid to have that drink. We'd buy cocktails for Regan all the time. She is the reason I wear a thumb ring. She gave it to me at the bar one day when I complimented her on it. Her life was not an easy one, but she bore it well. I wear this ring as a reminder of her and her tenacity.

The elder Bob was a total lush - and rather obnoxious.

One day in McAllen, older-Bob (63?) proposed that we all go over to Mexico for the day. Everyone agreed, then slowly they all declined until it was down to Dan, the other female portrait artist and Bob and I. Dan and the other woman decided to stay behind as well and encouraged me to go on. There was no way I wanted to go to a foreign country alone with this drunk. I tried to back out and Dan wouldn't let me. (He'd already secured a

liaison with the other female portrait artist for that afternoon.) He insisted I go, and basically shoved me out the door.

Bob and I drove down into Matamoros, across the river from Brownsville, Tx. No need for a passport at that time. First thing we did was go to a bar. Bob began putting the moves on me right away. I kept shoving his probing hands off of me. He was creepy, and I became more than a little nervous.

We went to a shop where they had cowboy boots and he insisted on buying me a pair. Wouldn't take no for an answer. Of course then, I "owed" him. We went to another bar, more booze. I was staying sober. He was trying to slobber kiss me and I had to fight him off. He then drove to a motel, with his hand coursing up my thigh as I swiped it away. Bob was telling me that Dan knew what he had planned and that it was okay.

No … It was not!

He was so drunk by now that he ran into the motel fence, and promptly passed out.

Swarms of small children gathered about the crashed car, watching me dissolve into a shaking puddle of sobbing tears.

I didn't yet know how to drive. I also had no clue as to where we were. What I did know was that if I stayed there, I'd very likely end up in jail with him. That, I was quite sure, was NOT a pretty picture.

I ran.

A tall, blonde American, 20 year old girl, wearing skimpy clothes, alone on the back streets of Matamoros, Mexico. I was *very* scared.

I ran until I found a shop with a phone. A mile? Two? They were kind and despite not speaking any English, helped me to figure out how to make a collect call to the U.S.

In between frantic tears, I told Dan what had happened. He told me to get to the border where he and the other Bob would meet me.

It was now dark out.

I flagged a taxi. Told him I needed to get to the border. No comprende.

"Rio Grande?" (referencing the river that separates our two countries at this juncture) No comprende. "Rio Bravo?!" - now hoping to tap the Mexican term for the river. I really believe he was messing with me and that he knew what I wanted and was hoping to get more money. I was totally

spazzing out by now.

The taxi driver finally took me to the border, where Dan and the other Bob were waiting.

Inquiries were made with the local constabulary. Yes, they knew about the car and drunk man found lodged in the destroyed fence. He was being held at the jail.

I wanted out of there.

Instead, we went to the 'jail' to spring old Bob.

Old Bob was in a dirt pit that had an open metal barred ceiling we could see down through. The entire place smelled like urine. He was starting to sober up and knew his dire situation depended on how much money we had to purchase his release.

The cops also knew I had fled the scene. Dan and younger Bob began pulling money out of their wallets.

I have no further recollections from this horrific night.

I do know I spent the next week on Valium, thinking I would never go out of doors again.

Dan and I had been told about the charming town of San Antonio by one of the friends we'd made from the Corpus Christi Mall. We left McAllen as soon as I was functional and headed there.

We immediately located a spot where we could do portraits at the "Syzygy" gallery owned by a strange little ectomorph named Gaylord Stevens. Gaylord sold hokey art sketches that were matted and framed, each with the BIC pen he'd drawn them with.

This gallery was located under one of the overpasses right on the charming Lilliputian Venice called the "Riverwalk", making it a perfect place for us to do portraits for the tourist trade.

Deann now joined us after a trip back home to her native California, and we three with my pet skunk, Rosie, got an apartment above the Schneider Printing company across from the Hertzberg Circus Collection, in downtown San Antonio.

A couple of jewelers who were also selling at Gaylord's had decided to take the leap and move into the new indoor "River Square Gallery" opening

up nearby on street level. Gail and her husband Kevin encouraged us to rent the shop available next to theirs. So we did.

"River Square" gave me a place where I could finally showcase some of my better drawings. Dan got to show his "Treehouse" fantasy series he'd been working on. We also brought in another artist named Kim who did lovely landscapes. I began designing t-shirts as well as signs and menus for businesses around town.

At twenty years old, I was now making all kinds of art for a living. The world was my oyster.

I had a woman I loved and a man whose love I'd learned to distrust.

Dan named our gallery at River Square Mall, "To the Woods To the Woods" - called thus due to Snidely Whiplash's response to Nell regarding that she "Must pay the rent", (google the "Rocky and Bullwinkle Show".) In an obvious fall out to our namesake we had hit hard times and Dan knew he could make fast cash on Jackson Square. He also knew that returning there he might run amuck of the supposed 'contract' that was out on him. He left me to run the gallery with Kim and went to NOLA. He hired a black bodyguard and returned to the lucrative portrait work on the Square.

Deann had left her car in the French Quarter, so she drove along with Dan in order to retrieve it and then come back to SA, and me.

Dan had sent a message to James, letting him know that should he, Dan, meet an untimely demise, James' nine year old daughter would encounter a similar fate. The situation was reaching a critical peak.

When Deann disappeared after arriving in NOLA, Dan called me, frantic.

I flew to New Orleans and began to search for her.

James had been linked to gun-runners and the mafia, hence his connection to even being able to possibly put out a contract on Dan. Knowing all I do now, if there'd been a real contract, Dan would be dead, bodyguard or no. Nonetheless, James was a dangerous man. I was very worried about my sweet Deann.

I tracked down where James was living. It seems he had held my girlfriend at gunpoint for the last 3 days, raping her repeatedly and threatening to kill her if she left. On the 3rd day, she was over it and told him, "just shoot me!" and walked out the door - to find me standing there. The gate opened and

Deann came out, slowly, with a gun pointed at her back. We walked away, down the street, got in her car, and left New Orleans, - for good.

Chapter 10

The Resiliency of Youth
and How I Started Wearing Contact Lenses Full Time

You'd think Deann would be over ever wanting sex again. You'd be wrong. With Dan temporarily out of the picture, still in NOLA, we found another lover as soon as we returned to SA. He was an enchanting artist type who knew where all the gallery openings were.

We were pretty broke, despite what money Dan deigned to send, and what little we were making off the shop in River Square. We'd go to the galleries that had openings Thursdays through Sundays to get free eats. Cheese, crackers, fruit, and wine. Lots of wine.

A regular hangout was the River's Edge, where Deann and I could always get free drinks from the men who thought they might have a chance. We learned the bar trick of tying a cherry stem with your tongue. Crafting a papier-mâché' cherry on a stand as an award, we held a contest! It became a favorite past time after that, and tho we never made awards again, Deann and I held the contest often. We were good at it. It got us complimentary booze.

Dan finally returned to S.A. He figured he would take up where he had left off, but I was done, as was Deann. I told him it was over. He didn't take it well. As though sex was going to mend it, he insisted that he and I go at it 'one last time'. In the process, he crushed my mom's vintage eyeglasses that she'd had lenses put in for me when I was 16. I was now forced to wear contacts full time. Not being able to afford a new pair of glasses, this prospect affected me more than splitting up with Dan did.

He left, a broken wreck. More so than I would've thought, considering his sexually rapacious ways.

My gallery mate, Kim, asked if I minded if she went after him? Hell no I don't mind! Go for it.

The gallery closed and I went to waitressing, my old standby.

Deann moved back to her home in California. I was really sad to see her go, but I had our 'boy-toy' and continued to play with him, until, he too, became tedious.

Deann and I have remained dear friends, and that's forever.

Poor Kim had a wretched time as Dan bemoaned the loss of love between he and I, to the detriment of their doomed relationship. She ultimately left him and in a twisted turns of events, took off with Old Bob. No idea whatever happened to her. Dan continued doing portraits and drawing Treehouses, living between NOLA and Rochester until his demise a few years ago. I understand he carried a torch for me 'til his dying day.

Sweet Deann

Part 4

There and back again

(with apologies to Tolkien)

Chapter 1

Greyhound and Westbound

By this point, I'd already had numerous lovers, both male and female. I'd been trained in the art of being polyamorous, (a word I didn't know at this time). This didn't stop jealousy from rearing its ugly head, but it was how Dan had instructed me. I'd found that if lovers were going to cheat anyway, why not beat them to it?

I had "long-term" relationships (one to two years) with little affairs during and in-between. Some meager attempts at monogamy. A lot of the men I hooked up with had control issues, which I didn't do well with at all. The men would be attracted to my art and freedom, and then want to own it, cage it and put clamps on the very thing they'd fallen in love with. By then, I'd be gone.

The man I was seeing when Dan returned to New Orleans let me know at one point that I would 'never be anything but a glorified waitress'. It was a cruel taunt, but it worked. I left him and began creating a new artistic role for my life that exploded me onto the San Antonio art scene.

But first, let's go on a Sexcapade!

Journal Entries from The Trip West;

Leaving San Antonio, 2-9-77
Greyhound Bus

She wore a black glove on her left hand, folded neatly over her naked right hand. By the time we departed the bus depot at 8:27 am, I knew all about her sin in not serving the lord while she worked as a cable repair woman at Kelly air force base for twelve years. People had been tormenting her with the devil ever since she found where her duty to the Lord lay. Thanks to Bezilina Schlink and her audio tapes with the 'Word of the Lord,' this woman had been able to ward off vile spirits. Like, for instance, the time she was on a half-filled bus and the devil sat a negro right next to her! By the time she finally reached home, negroes by the dozens were dancing to Lucifer's drums. Thankfully she remembered what the audio tapes had told her and she repeated the holy words over and over, "Let the blood of Jesus

wash over my brain". Soon the black people were all gone.

After the telling of that story, I noticed her staring at all the rings and bracelets I wore - and then, bug-eyed, she noticed I wasn't wearing a bra. She prayed, folding the bare hand into the clothed one, mumbling about blood and her brain for 20 minutes.

She got off in Comfort, Texas, and all I could think was, "Thank Heaven!"

That was the first leg of my journey west. I was 21 years old. My friend Samantha, that I'd met in New Orleans, two years before had invited me to come visit her and her new hubby in San Francisco. She offered to pay half my bus fare! Greyhound had a $50 one-way as far as you can go deal. I planned each stop all the way out to California and back again. I was to be gone a month.

West Texas:

I awake fuzzy from a nap in the afternoon light and all around me are mounds of brown sugar speckled with chocolate chips. I feel like I'm in a mixing bowl but for the occasional windmill that passes by.

That evening as the last color disappears off the bellies of the clouds, the dark comes on quickly. Soon the whole sky looks like a sheet of carbon paper through which someone has poked thousands of tiny pinholes and then shone a great lamp from behind. The very vastness of this land, now flat and barren, exaggerates this magnificent star-studded sky even more.

How I met Samantha:

Kansas City was the first place I'd been to visit Sammie. It was there that I learned that she had to "Nair" her entire body ... tits and all! Black fur grew in lush curls everywhere. She'd been my lover on numerous occasions and it had never occurred to me that the black hair grew past

My portrait of Samantha

the mound between her legs.

Samantha and I had met when she and her friend Phil came to New Orleans for vacation. While visiting Jackson Square, she had her portrait done by Dan Fuller. He brought the two of them home for Fun and Frolic, '70s style.

Phil didn't last long, but Sammie liked playing with us and stayed on for an extra few days. She returned several times to visit during our two years in the Crescent City.

Sex held no restraints for me now. I believed that anything goes as long as there's consent. The more frivolous it was, the more tempting.

Feb 10th, '77

There I was with an apple stuffed down my shirt. It was cold. I'd pulled it from my backpack when the bus driver said the Agricultural Inspectors would be stopping us and taking all fruit. After we passed through, I pulled it out from between my breasts, polished it on my shirt, and bit into it - enjoying the forbidden sweetness. I contemplated my immediate future.

Albuquerque was to be my first stop. An ex cook from my previous waitressing job in San Antone had invited me to stay at his place on my way west. Jimmy was tall, of medium build, and had receding orange hair and a beard. He met me at the depot and took me on a tour of the town.

The Sandia mountains were an old west stage set backdrop to the adobe huts of Old Town. Straw stuck out from the mud walls like spirit whiskers from a jaguar nose, twitching in the turquoise daylight. From the shade of a saltillo tiled roof, an Indian woman wrapped in a desert rainbow blanket leaned into a red dirt corner of a dusty antelope-colored building. She had a babe in a woven basket on her left, and a palette with silver and coral jewelry laid out for sale in front of her.

Shops hawked t-shirts and trinkets as well as handmade goods from the pueblos.

We found a cafe' to our liking, had a good meal, a few drinks, and went back to his place. We had sex. It was okay.

I took a bus out of town the next morning.

Driving through the Arizona desert, the sun-parched grasses glowing in golden amber clumps sparkled next to lavender flowering sage and tiny green juniper. A woven carpet, incongruously scattered with cotton, lost

from a truck with a loose bundle.

5:30 a.m. The color on the mountains as we enter southern California is very songish, "Purple Mountains Majesty," etc.

Chapter 2

Tales from a second-hand romance

On the 12th of February, I arrived in Fresno, Calif. Frank was there to greet me. Frank and I had been sweethearts when I was fourteen and he was seventeen. We met in Mrs. Cooper's dance class ("Swoop! 2,3,4!")

Mrs. Cooper was a diminutive powerhouse. Her grip was like a vice. If her giant of a husband caught you dancing too close, he'd come and physically separate you (making room for Jesus). Both my siblings had taken her class 10 years before. She knew I was a 'Curtis' and was put on alert. My brother, Danny, had dressed like a woman (really effectively!) one Halloween. All the boys wanted to dance with him. Mrs. Cooper found this distasteful.

I got permanently kicked out when I wore a mini skirt. Other girls wore mini skirts - I was the one that got ousted.

Frank and I continued to see each other.

He was from a boy's school in Rochester, which added mystery to his 6'4" frame and his baby-faced charm. His daddy was a neurosurgeon and his mother a nouveau riche snob. She would sneer at me when we would visit his house. So we avoided it.

My mother loved Frank. She had a bond with him that I'd only ever seen her exhibit with our immediate family and my friend Lynne. Psychically, she

Frank & Ann

knew when one of us was about to call or visit - or was in trouble.

I don't know that she was prepared, however, for the doozy of a concussion that I got the day Frank and I were running down a hill in Webster Park. The heels on the tan pumps I was wearing snapped off, and I tumbled ass over teacup, fifteen feet down a majorly steep grassy knoll. Although I was complaining about a headache, I was also being quite amorous ... in ways unlike ever before. Repressed sexuality come forth in concussion? Frank decided it would be best to take advantage of this, despite my dilated pupils and delirious speech. Not being cognizant until several weeks later, I have no clear idea of what really happened. Frank led me to believe that my virginity was still intact. I'll never know for sure. When I finally had sex a couple of years later at age 16, there was no pain or blood. I always attributed this to riding a boy's bike and slipping or falling on outstretched limbs while climbing trees. The 'slip and fall' that comes with childhood actions could easily have broken my hymen.

His parents feared a lawsuit from the severity of this concussion. To exacerbate the situation, his bitch mother referred to me as a 'slut' in a phone conversation with my mom. I'm sure mom straightened her out. Later, I found out that word didn't bother me. If guys could have sexual encounters without retribution, why not girls?

The head warp from the concussion put me out of school for the last full month. I apparently repeated the same things over and over. I remember feeling quite nauseous for a very long time. Lynne would bring me homework from school and I did what I could. My grades were good enough that I had no problem passing.

Frank and I ultimately separated as sweethearts but remained good friends. He would come visit whenever he was home from college. It was during this time that he hooked up with my dear friend Lori.

Lori was there for me when Lynne had left me high and dry back when we were twelve. She was mom's 'other kid' besides Lynne. When I left home with Dan Fuller, Lori was the other recipient of the 'treasures' I'd left behind, along with Lynne and my sister Dayna.

It was in 6th grade that I met Lori. I needed a partner for the talent show act I had in mind. Dressed in matching white and yellow checked foam polyester dresses with black shiny patent leather shoes, we looked like the female kid versions of Laurel and Hardy. Me tall and skinny, Lori short and round. We sang "Raindrops on Roses" from the "Sound of Music" to rave reviews from all our classmates! We became fast friends.

Now engaged to each other, Frank and Lori attended universities on opposite coasts.

Here in Fresno, I was seeing this grown man/boy with fresh eyes. As Frank and I wandered his campus, we discussed how he hadn't been able to settle on a major. He was vacillating between doctor and abalone farmer. As we talked, I looked at how strong and handsome he'd become. He held my hand, just like he always had, but this time it stirred something in me that I was pretty sure I shouldn't be feeling.

Over coffee, he told me that he and Lori had been having it rough. He wasn't sure if they would stay engaged that much longer. If this was the bait, I bit.

Smuggled into his dorm room, we finished what we'd begun in Webster Park in a state of delirium induced lust years before.

When I left the next day, I felt frisky and fine. Little did I know that his honesty would lend hazard to our antics. He told Lori. This ended their long distance relationship. I never spoke to Frank again. Lori, bless her, has remained my friend, despite this seriously obvious infraction.

Journal entry #6; Leaving Fresno

I've never been so enraptured! The sensuousness of the soft misty moss covered rolling hills; the sun being sucked down in among them- 'til the whole sky delights in orgasms of rich color!!

So majestic a fornication - only I don't feel a voyeur - much rather a

part of the act.

Chapter 3

Here's to those you never see again ...

Arriving in San Francisco was awesome. The bus came in at dusk across the Bay Bridge. I've never seen a city so beautiful at night! It even rivaled the Maxfield Parrish skies of San Antonio.

The glowing evening mountains melted down into the bay, sprouting up on the other side into the proud man-made brilliance of city-scape.

It had been a year since I'd seen Samantha in Kansas City, where she was living at that time. We eagerly embraced, I changed clothes and we dashed off to a party to feast, imbibe, and 'heighten our senses'. Leaving the party early, we met her husband Bill back at their home. This was a turn of the century three-story abode in the very heart of the city. Lush with rich dark wood and arched doorways, room after room was filled with the photographs these two professionals had been successfully selling for the past year.

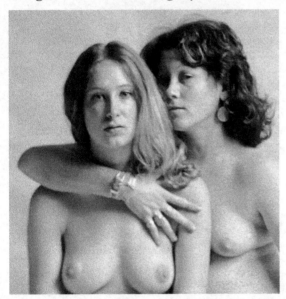
Ann and Samantha posing

Bill was slightly shorter than me and about fifteen years older. Stocky and well built with sharp eyes that looked me over approvingly, knowing the plans in store for the evening.

After a 'get-acquainted' glass of wine and a doobie, we three began our evening of sensual delights. Somehow, although memory doesn't serve as to why, we ended up in the laundry room to consummate our activities.

Morning found us on the living room floor in a tangle of pillows and

body parts.

Bill had to leave early for a week's work out of town. This left us two girls to go frolic on our own. The beach was a couple of blocks down the street. I saw the Pacific Ocean for the first time! To pique the excitement even more, Seal Rock was just down the way! Live water slick seals 'orking' and splashing, sliding, and jumping!

One of my planned intentions in visiting San Fran was to see Peter Magee, the old high school boyfriend who'd broken my heart. Rationalizing that this was the man I would marry, I had 'lost' my virginity to him at 16. Once we'd accomplished this task, we found great pleasure in doing the act again and again, wherever and whenever we could. How I kept from getting pregnant remains a happy enigma. At barely 16 my sweet mother agreed that going on the pill was a good idea to 'reduce the monthly excessive cramping issues'. She knew what was going on and wisely thought avoiding a package from the stork at my tender age would be well advised. When Peter went off to college and discovered other poking pleasures, my dream of True Love was shattered. The pain had left a deep scar.

Now I had a chance to get back at him. Sexy at 22, my body had filled out from its scrawny form into a 5'10", 125 lb. babe. My 'dirty blonde' hair had become honey-colored from the sun, and it rolled down to just past my shoulders. The pimpled skin that plagued my teen years had given way to radiant flesh. I was ripe.

Living in the Haight-Ashbury section of town, Peter had gotten work in construction. I met him for lunch while he was on break. We conversed about my artist's life and the freedom it offered. I taunted him, displaying my proud nipples in a tightly knit top. Pretty dark-haired Sammie met up with us on Fisherman's Wharf. She and I greeted each other with a deep kiss. Girl tongues. Peter, who was already squirming, was almost hopping from foot to foot. He was sure he had two live ones - which I hadn't discouraged … until now. Sam and I said we had a date. I promised to call before I left town. When I did call him, he told me how cruel I was to lead him on so. Mission accomplished.

I saw him one more time, but I found him irritating now. He wasn't happy and I was. No reason to ever see him again, and I never did.

San Francisco provided ten days filled with fun. I saw Alcatraz and San Quentin. We drove down the 'Crookedest Street' and took trolleys all over

town. A horseback riding mishap had me cleaning dirt out of my eyes, nose, and ears. It also snapped my (new) glasses. Thankfully I had my contacts with me. We toured town and went to a lot of parties. In the evenings we snuggled and did the rub-munch.

My favorite memory of that town was one day on our way back from Sausalito. Approaching the Golden Gate Bridge, the famous fog rolled in. Unlike the settling of impenetrable mist I remember from upstate NY in childhood, this was a roiling fog storm, as though the earth had gone on a dry ice binge. Thick and shaped like a more solid idea of a sculptured cloud, the fog just kept pouring and rushing over everything. So vast and immense that the city beyond became a toy town, and finally became cloaked and disappeared altogether under the voluminous billowing whiteness.

This then was a beautifully fitting finale to our relationship. Although I heard from Samantha a few more times, we ultimately drifted and lost touch. Like Peter, I was never to see her again.

Chapter 4

Leslie and Larry

Body still sore from the horse spill, I got on another leg of my Greyhound bus tour and headed south to Monterey to see Leslie. Over the past few years, she had become a high-priced call girl. When you consider her time growing up, I suppose this wasn't a big surprise. She had a nice apartment with her female lover. Her life was complicated and full. She was currently involved in a lawsuit against the Monterey police department. One night about five weeks prior, a local cop broke into their apartment and, putting a pillowcase over both the girl's heads, proceeded to rape them. Leslie saw him before he covered her head, and knew him. He figured she'd never go after him, due to her profession. She and her girlfriend were fighting this, against all odds.

Despite having known for a month of my arrival, she'd made little space for me. She pawned me off on a friend. The fellow graciously took me on a tour of Big Sur. The giant redwoods were full of amazing and magical things. He introduced me to a colorful creature called a 'banana slug'. Bright orange/yellow these large gastropods have 4 retractable antennae and their slime is an edible protein. The critters are said to be delectable when BBQed.

We scrambled around the rocks and hiking paths for two days. At the end of the second day, we came across a migration of monarch butterflies in a grove of fragrant eucalyptus. Pulsing orange and black against the silver gum nuts, gentle and unafraid, the butterflies would lift, then fall back around us, swallowing us in the sound of 'one hand clapping'. They were on their way to Mexico. It was new to me that such a migration existed. I was awed beyond measure.

Ann, Leslie & Lucky

Back in the world of twisted human foibles, Leslie, her sweetie and I, went with her mom, Phylis, to go see Ace perform at a local jazz club. Leslie's mom and her daughter's rapist from Leslie's teen years were still an item. It seemed all had been forgiven.

I'd become acquainted with a great fellow named Larry B. through my waitressing job at the mall in San Antonio, Texas. He'd helped me out several times when the jerk I was dating didn't show to pick me up from work. (I still didn't drive). Despite his obvious desire for me, I'd remained faithful to the turd I was seeing and thus had refused to have sex with Larry. During this adventure west, I was still with that same boyfriend back in SA, but in accordance with one of the 'rules' set in place during my previous relationship with Dan, when you're on vacation, all bets are off.

Larry had come to Monterey where we

now fell instantly into bed with one another, consummating a long overdue desire.

Bidding adieu to Leslie and her entourage, Larry and I headed down the Pacific Coast Highway. The first stop was Jade Beach, where we found sand-washed jade stones in varying shapes and sizes dotting the sandy shore. Larry had one of these set into a silver pendant for me upon our return home by my jeweler friends Gail and Kevin.

My first visit to Disneyland was a great and wondrous joy! The special effects spurred my imagination, putting ideas there to be worked upon at a later date. We toured the exotic San Diego Wildlife Park. We went to Black's Beach to watch the hang-gliders. After days of fun and frolic, he dropped me off at a bus station in San Diego, where I began my trek home.

Unlike Peter and Samantha, Leslie and I stayed in close contact over the years. The birth of a baby boy caused her to re-evaluate her vocation, whereupon she became a hairstylist. Years later she became a meth addict. I've not heard anything since that time. I wish her well and hope she has found her way back to the land of the living.

Larry also dwindled into the distance shortly after my return to S.A. We'd had fun and now it was time to move on.

I also left the man I'd been seeing back in San Antonio. He was a talented artist, but his relationship skills weren't ever going to be something I could work with. Nor mine for him.

A series of romances ensued. I never could be faithful. It meant giving away a part of me that was held sacred. I could not allow myself to ever be that vulnerable. Never again …

Part 5

Chapter 1

Life as Art

Advanced schooling began in Corpus Christi, Texas, at Del Mar College in 1979. There, I was approached by the teacher on my first day in Drawing One. He asked me what I was doing there. Figuring this was a trick question, I stuttered out, "G-g-etting a degree??" He took me out of class to go see the Dean of the Art Department, with

In Corpus Christi with my polka-dot bug

the sketch I'd just made of the live model. We discussed my art history and the Dean decided there was no reason to have me go through these classes where I wouldn't be learning anything. He had to requisition a CLEP test form for this, as none had ever been applied for in this category. I was moved into Drawing 4. In my year at Del Mar College, I was an 4.0 student.

San Antonio College was the next leg in my process to get a degree. I didn't work as hard but maintained about a 3.7 average.

Over the next few years, I taught kids art classes at various facilities such as the Montessori School and the San Antonio Art Institute. I never completed my degree at San Antonio College, so the classes I taught were obtained on my achievements alone. It was while I was teaching a LifeCasting Workshop at Sul Ross University in Alpine, Texas that a professor freaked out when she discovered I had no credentials! It had never stopped me before. I replied that if they could find someone more capable than me, they should. I continued teaching at various art institutions all over the state and subbing locally when someone couldn't make it.

My designs for menus, t-shirts, and business cards had gotten more professional.

I continued modeling for art classes around town. Due to my modeling abilities and my knowledge of the arts, I was allowed to sit in on any class I

Modeling in Texas, circa 1980

Sunday MAGAZINE

San Antonio Chic

Local fashion designers split their seams to dress up S.A.

(Top) Modeling my leather fashions for the "Ritz", with shop owner Carol Lee Wirth

(Above) Face painting at King William Fair

(Right) Performance Art at a local club

(Top Right & Left) Fashion shots

(Right) Self Portrait

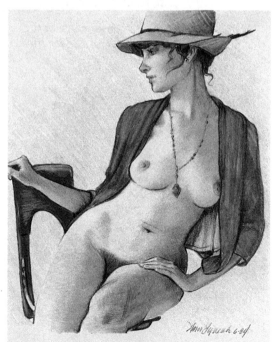

wanted, any time. I often was given the dual role of instructing the class I was modeling for when the teacher wanted to slack off, which was surprisingly often.

I took classes in pottery and clay sculpture whenever I could. I knew how to make glazes, pug (mix) clay, and throw pots on the wheel. I also knew how to load and fire gas kilns, so I had added value.

Scholarships were available when I needed them.

Modeling my own designs at SAMA

I had a gig doing faux painting with a gay brother duo. We worked in rich folk's homes all over south Texas until the boys gave each other AIDS and both died from it.

I designed Texas traditional wall fabric, creating silk-screened hill country images. Informed that we were all part of a team and no one person's name would be put on any of the artwork, I was shocked when a full-page ad came out in Texas Monthly magazine with the name of the head bitch as the sole artist for these high-end fabrics.

I called in 'well' and quit.

The San Antonio Museum of Art hosted a Fashion Show featuring my clothing designs, which I sold in a few quirky shops around town.

San Antonio art icon Gene Elder invited me to be a part of SAMA's 1984 "Time Capsule", which will

open on March 1st, 2181, during the museum's bicentennial celebration. Included with another 99 local artists works are two of my finished life-cast faces. (Another 15 minutes of fame!) My friend Gail was working at SAMA at this time and while the Time Capsule was being filled, she surreptitiously slipped in a piece of her handmade paper art with a little note, - making it 101 artists. This now is the documentation of her particularly delicious illicit act, right here.

Making costumes for various theater groups became a constant sideline.

There were Gallery shows and Art Walks. I painted faces during Fiesta and at the King William Faire.

I was a regular in local Performance Art.

When someone wanted to know what was happening in the art scene in San Antonio currently, they called me. My finger was on the pulse.

Chapter 2

The Mad House

Photo shoot, Tower of the Americas, 1980

In 1983 I moved into a small mansion on Madison Street in the King William district on the south side of downtown San Antonio. This hip turn-of-the-century neighborhood is known for it's gloriously restored mansions. Elegant and charming, the district was edged by the San Antonio River, the "Tower of the Americas" and Hemisfair Plaza (1968 World's Fair), as well as the "Victoria Courts', a notorious barrio. The 'courts' were later torn down and replaced with upscale condos.

The house on Madison was three stories including two porches, an

Ann & Sandy

attic, and a basement. It was haunted. Two dear friends lived upstairs. One was Holly. She was also part of the art scene in SA. I fell in love her work and her spunky attitude. A unique friendship evolved. I had met her through her mom who owned one of the shops that carried my fashion designs. Holly's roommate, Sandy was a dancer that I'd met back in the late '70s. I watched Sandy walk into an art workshop one day and thought I'd never seen anyone more beautiful. It radiated from her very soul. She touched my heart and has stayed there ever since.

My apartment had thirteen foot tall ceilings, four different kinds of wood in the parquet floors and two mahogany and marble carved fireplaces. There was leaded glass in the front door that shed prisms of rainbows into the house every sunny afternoon. All the heavy interior doors slid easily into wall pockets that opened into double-walled rooms. I punched one of these panels in a rage one day, and found that the popped out square had a floored receptacle in it! Who says there's no upside to anger? A couple of my current boy toys showed me how I could make a secret compartment there by using a small nail as a key. I used this as a hidie-hole for various treasures, such as my tiny vile of cocaine that I'd save for art performances or gallery openings. This was handy, as Holly would often sneak downstairs to try to find my stash when she ran out. I'd leave a little pot around for her, but she never could find the coke.

Despite my early years of

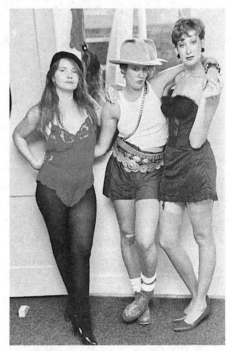

Gail, Holly & Ann in Party Mode, '83

excessive drinking - (to the point of blacking out) - I've never had an addictive nature. (Unless you included sex or potato chips). I'd save a little bit of coke for special occasions. The only drag was that it brought on herpes. No one I knew could save cocaine. Everybody thought that if you had it, you did it all.

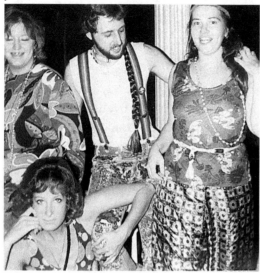

Kelly Dyal, Randy Wilson, Gail Pollock & Ann

The "Mad House", as it became known, was a fabulous party place.

The art scene of San Antonio gathered here. We had music, wild dinners, and themed events on a regular basis. The neighbors joined in. We were close to the art hub of the "Friendly Spot", a local ice house hangout of renown. This fab slice of Americana finally got shut down due to the dancing in the street that thwarted traffic, as well as the plates and glasses that would literally crash to the floor in nearby homes, due to the vibration of the REALLY loud live music.

The Mad House was also a short walk to downtown, - the Riverwalk, the Alamo, great restaurants, and a hotel who's top floor key I'd obtained. This is where the pool was. All summer long I'd invite various friends to come use this refreshing outlet as a source of cooling off in the Texas heat. I also held the secret to the top floor of the classic Tower Life building, built in 1929. This was once the tallest building west of the Mississippi. There is an outside "balcony" rimming the exterior at the very top where the gargoyles lean out into space. Once achieving the proper floor, you'd go into the ladies room and crawl out the window to access this precarious perch. My favorite time was going out there with the "Flaming Idiots", a juggling and comedy troupe. They proceeded to climb out onto the concrete creatures and do a balancing act. Somehow, we never got caught.

The garage at 105 Madison was not ever going to house a car. It was

on the verge of collapse. We all kept our cars in the driveway. One day the "Dance Art SA" crowd filled the tiny back yard parking area to brimming with their vehicles while gathering upstairs for a meeting. When they went to leave, there was a spontaneous collective 'break-dance' that happened in, around and on top of the cluster of cars! Fifteen people in unplanned choreographic perfection! One of the more magical performances I've ever had a chance to witness.

The crumbling garage became my clay studio. Not burning it down with the intense heat of firing my kilns was sheer luck.

In 1984 a drug dealer I knew needed a source for laundering his money and chose me. I had my concerns about borrowing $5,000 from him, but my dad refused me the loan, and I had a business I wanted to get off the ground. I needed the cash. Figuring $5K would do it, I went for it. I paid that loan off in three years! Right before the dealer went to prison.

My 30th birthday in 1985 was a blow out bash at the Mad House! A local band played in the driveway. There was also a stilt walker that made balloon toys, and a magician doing card tricks and sleight-of-hand. At least seven lovers past and present were there, some with current sweethearts. As an added treat, my old high school friend, Patty,

Ann, Patty & Feather at my 30th b-day party

came in from Rochester, NY. It was great to see her.

As teens, Patty and I had spent long afternoons playing hooky and drinking Southern Comfort out in the woods behind the school.

(Many years later in the late 1990s, she discovered that her husband, a high school mate of ours and the father of her two children, had been visiting the seedier gay bathhouses outside their Houston neighborhood. They divorced. He found a man that suited his lifestyle. Shortly thereafter, my childhood friend took her own life.)

For me, this birthday was also a celebration of moving forward. I was going to segue out of the gallery scene and start doing street shows, where hopefully more of the money I made from my art would find it's way into my pocket.

I had taken that $5K loan and built up the garage studio with shelving (that I use to this day) and art supplies. Casting people I knew gave me a variety of faces to work with. Raku became my main art form at this time. This is a firing process whereby you take the piece out of the kiln when it's at its hottest - glowing red. A kiln is an oven of sorts that cooks the clay to a very high heat, around 1,800 to 2,400 degrees. Grabbing the piece with long tongs, you then thrust it

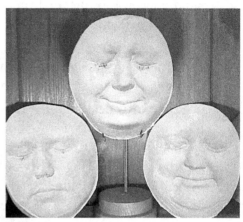

Illusion created by lighting the interior of the initial casting of the face

into a barrel filled with hay, newspaper, or wood shavings, and cover it. The combustibles catch fire and smoke the ceramic piece. This process makes the glazed areas luminous and crackly, with the unglazed areas a dark, dusky gray/black. When done properly, this style of clay work is stunning. Gallery shows became street shows. Street shows became Ren Faires.

Eventually, I moved away from the raku pieces all together and began

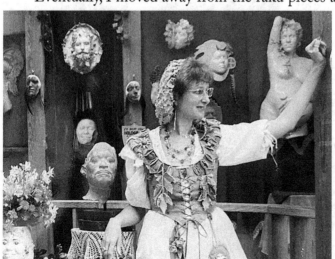

working with white stoneware. This process was more amiable to creating a wider variety of fantasy for one's features.

I then became "Masquerade Life Casting".

73

Part 6

*"To the Absurd
and the Preposterous,
May They Never Desert Us"*

Chapter 1

Starting a life together

Derek moved into the house on Madison with me in late 1986.

Holly became irritated. Someone had moved in that was taking me away from hanging out with her.

It was apparent to everyone but me that I'd finally found someone that was my perfect mate.

I thought I was merely having fun. Really, what I wanted was a nicely dressed man with a good job. This hippie freak owned one pair of shoes (sandals from Mexico) and was living in his mechanically challenged VW Bug with his dog. Although he was trained as a fine leather craftsman, currently being a gamer at the renfest was easier and more profitable. That and selling pot. A "Gamer" was a lackey who ran the various games for someone else at ren faires. Derek ran the 'Knife Throw', a level of business enterprise right in there with being a Carny (one who works the carnival circuit).

Derek also made and sold Bubble Wands. This was a joint business venture with his friend, Stephen Bennett. Until we met, Derek and Stephen had only worked together at the New York Ren Faire. Now my sweetie had decided to take off on his own to do street shows with the bubble wands around the country.

We were in bed one night when we heard the sound of his wonky VW Bug being started up. Looking out the front window slack-jawed, we watched it being driven off. Derek ran onto the front porch and started jumping up and down screaming; "I hope you take it on the highway!!" The Bug had what appeared to be an unrepairable shimmy that got worse at higher speeds. After retrieving it from the impound lot where it went once it was found abandoned on the southside, Derek sold it to a friend for $150, as

is. We found out that all it needed was new tires ...

It was after that he bought a used Toyota truck. We now had matching yellow trucks.

Traveling to various shows together over the next year was a new adventure - for both of us.

I worked his bubble wand shows with him, and he worked my life casting gigs with me.

Bubble Wands are made from coated copper wire bent around a jig and inserted into a wooden dowel rod to create a contraption that looks like an old-timey rug beater. When dipped into a soapy solution and waved about, there's a

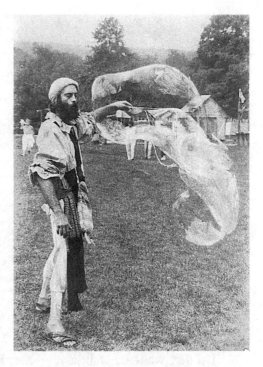

fairy tale world of bee-u-ti-ful bubbles that encompass you! Derek had a whole rap and a constant demo he would do while I took the money. We did shows from California to NY. Sometimes we did shows simultaneously, where we would each have our product there and hence needed to hire an employee or two. Unlike many other craft couples, we managed to stay together and not do shows that would separate us. Around each other 24/7, to this day, we still like each other!

This type of being together can wear on you. But somehow the determination to stay together has outweighed any drama. That, and a deep abiding love for each other.

Chapter 2

"Communication, Honesty and Responsibility"

In my second year at the Colorado Ren Fest, 1987, our first full year together, Derek proposed a concept that verged on monogamy; forthwith, he wanted to know ahead of time if I'd had sex with someone else before he'd

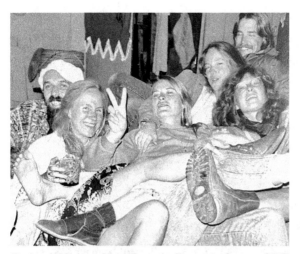

Richard, Nadine, Kate, Pamela, Doug & Ann at CRF

have sex with me again … AND he wanted to know who it was. Prior to this, it was 'don't ask, don't tell'. Although there'd been no one so far, it always loomed as a potential, due to the 'rules' I'd set in place.

'Opting out' if sex happened was his current take on other partners. He also didn't want to play the jealousy game. In essence, he wanted us to be monogamous.

I was freaked. Giving myself over to this meant giving all of me to one man. I'd reserved that piece of my heart so that it couldn't be broken.

I didn't want to walk away - neither did I want to give all of myself away. I spent weeks in turmoil trying to figure out what to do.

I liked being with this fun and irreverent man. He'd quit smoking cigarettes for me! We had grand adventures together … and Great Sex! He didn't try to squash or control the creative artistic energy that was me. He encouraged it.

Ultimately, I decided to give it a try. I agreed.

Marriage was never on the table. There was no need. No children and no reason to involve the church or state in our relationship.

A few friends were concerned that I had 'settled' for

77

this fellow. I got a letter from an ex-lover telling me that I should 'fall in lust, not in love'. Another couple of guys I knew told me that I could do better. Later, they recanted. All of them ended up telling us what a great relationship we had, and that they, too, hoped to one day have something that good. (They've now all been married numerous times.)

Holly quit art and became a caterer. She married and had a couple of kids with a man who was an addict. Already having a propensity for coke, the move to meth was an easy one. When it got bad, her kids were removed from her custody. She was wise enough to want to change her life and so she moved forward with counseling. I'm so very proud of her for all she's done to make peace with her world. She now enjoys a grandkid and a good life making and delivering gourmet meals for families in San Antonio. We visit and laugh often!

Sandy met the man she was to marry and moved from San Antonio. She remains one of my closest friends as does her handsome husband, Paul. Sandy continues to be involved with the performance arts and is also a massage therapist. Paul is a pulmonologist (lung doc) and the director of a Critical Care Unit in Austin. Two of the sweetest people I've ever known. Both of them have always been proponents for the two of us - from the very beginning.

Chapter 3

One last King William party

We had one last fling at the Mad House.

The place was going on the market and my friend Dian was the last remaining resident, living upstairs. She was due to move out in a week. Derek and I were now renting a defunct old gas station in downtown Harper (seven churches, one blinking light, a stop-n-go, and a post office) while working on building our house in the country, ten miles west, outside of town.

"Spring Magic Festival" was happening at "La Villita", the original Old Town of San Antonio. Derek was selling bubble wands and I was painting faces. We knew virtually everyone that was doing the show.

We also knew that most were too poor to do anything other than sleep in their vehicles for the weekend. So we decided to open up the downstairs at 105 Madison and have a Saturday night party!! The old codger that owned the place was too decrepit to drive out on a whim. He hadn't been to SA in years. He lived south of Dallas and was fat and sickly. We were golden!

Dian let us in. We went through the house to the now empty downstairs and opened up the front doors.

Colorful entertainers and crafters swarmed in, bringing their sleeping bags and whatever food and booze

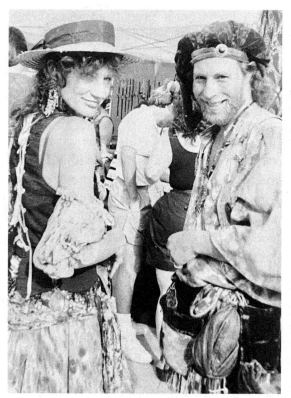

Gaila & Magical Mystical Michael

they had handy. Instruments came out and those that didn't play, danced! A few of the locals that had known this as a party house heard about the celebration going on and came to see what was happening. They invited their friends - and soon the place was over-flowing! It was a fabulous bash!

Sunday after the Festival, most folks left and headed back to Austin, or wherever they came from. Those that didn't, stayed overnight with us one last time at 105 Madison.

The next morning, Derek and I took off, leaving instructions with the last two revelers as to how to climb through the downstairs kitchen window after locking the doors from the inside. Dian had gone to work, so this was their only way out.

Just as they'd shut the window and were headed to their cars, a big fat man with a wad of chaw in his mouth came up moistly asking them who they were and what were they doing there? It was the landlord! They faked

it well, saying they were friends of Dian's and were just leaving. He side-eyed them, but there wasn't anything he could do. He spat a stream of brown goo and let them go on, their hearts thudding. I heard the story many times after that.

A fitting end to a grand old party house.

It sold, but to this day, no one lives there. I think the old bat that haunts the place never really wanted anybody else but us there.

Don, Anne, John & Randy

A Side Story to San Antonio with the Maxfield Parrish skies ...

1998

On a sunny Monday, November 9th I went to say goodbye to an old friend. I hadn't seen Don Davenport much in the nine years since having moved to the Texas Hill Country. One of the last parties I held while still living there at 105 was the final straw as far as Don's increased alcoholic ravings were concerned. Burning a fellow guest with his cigarette while hooting and flailing about, he fell over backward in his chair. He also broke my toilet seat - and then, several days later, I discovered his soiled undies in my laundry hamper. It had simply gotten to be too much.

Derek had given him the "bum's rush" that night at the party. No one would take responsibility for the old fart. Don didn't drive (wisely) and the guys who'd brought him had left. Derek muscle-fucked him into his VW bug and took him home. He'd never been in one of Don's homes before. Despite his aggravation at having to deal with this old sot, Derek found himself looking about in awe at the vibrant hand-painted columns, cupboards, and cupolas. Paintings everywhere, and on everything. And Books! In the years since his gallery had closed, Don had been working at 'Half Price Books' on Broadway near Brackenridge Park. He had the most awesome collection of

art books that he'd bought for a tuppence due to his employment there.

For nine years, the book store is where I would go see Don. We'd chat two or three times a year. He'd be sober at work.

As my business kept me out of town more and more, I'd see him less and less.

A mutual friend called to say Don was dying. A fast moving cancer had him bedridden in three weeks. Lung to liver, liver to bones. The doctors had now given him a week. Apparently, the previous December, he'd quit drinking when a headlong dive took him down the stairs at his apartment complex.

I went in with Derek and our friend Randy Wilson. Randy loved Don too - for the same reasons we did. He was a mentor and an amazing soul.

Another friend, Anne Alexander, was there doing a 'maintenance watch', making sure Don got the necessary drugs and Gatorade - all he was currently taking in. She hadn't seen Don for the last couple of years for the same reason - an over the top drunken incident. Now she was here to help and say goodbye to a man who'd been her friend first - and a drunk later.

As I came in, boisterously greeting Anne, I heard from the back bedroom, "Oh My Stars! I can't believe my ears!"

Thin but alert, he grabbed my hand as I sat on the bed next to him. I dutifully apologized for my long absence. Tho his eyes weren't focusing real well, he gazed at me and smiled, and said how much he'd missed me.

We discussed his situation. Being both atheist and artist, he had no morbid thoughts. He was 70 and ready to go. Any blood family he had wasn't going to get there and despite this making

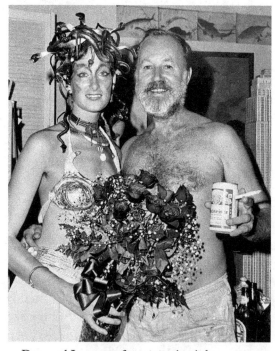

Don and I at one of our joint birthday parties

him a little sad, the last week's parade of friends had stirred him deeply. The constant party was his greatest happiness. His real family was right here.

During the hour we stayed, people came and went. I remained perched on his bed, with him holding tight to my hand.

We laughed and told stories. Don and I were B.P.s (birth partners) and we had held joint birthday parties yearly for so long … There were the 'male and female' cakes, the "Greek Toga" party, as well as the Fiesta events, etc …

We talked about how he was Father to so many of us fledgling artists, getting us off the ground with encouragement and our own shows at the "Shown Davenport Gallery". That place fed me physically and artistically for years in the early '80s, when I was learning so much about the arts so very fast, and I was often too poor to feed myself. Don's weekend gallery shows always had wine, cheese, meat, and fruit, - dinner!

John Shown, Don's lover at that time, had been in Mexico for over a decade now. Don had been refusing to answer his letters for years. Their relationship had ended long before their living arrangement had. Don was bitter about John and where his life had taken him.

The last time I saw John he was marveling at the sheep enzyme he'd obtained down in Mexico, claiming it would help control his AIDS virus, while at the same time remarking that those "young married Hispanic boys loved his dick". Repulsed at his uncaring attitude, I vowed to have nothing more to do with this man who was perpetrating a vile virus on an unsuspecting community.

Don finally fell asleep while we were all conversing. We slipped into the living room.

On the walls were numerous photos with me. I was touched beyond words.

Anne's shift was over and another friend had taken up the station. As we prepared to go, I went back to look in on him one last time. Don was curled up peacefully sleeping. I blew him a kiss. He whispered that he loved me. I told him if he ever returned, he should wink if he saw me. As we smiled at each other, I couldn't believe how blessed I was to have this opportunity.

Downstairs, Anne, Randy, Derek, and I agreed to go sit in the nearby Whole Foods parking lot and have a beer and reminisce further. Picking up a six-pack and some chips and salsa in the store, we dropped the tailgate on the truck. Derek and I had two chairs in the back. One was a broken

vintage '40s affair, suitable enough to still hold a person, and the other was my mom's round back rattan "Princess" chair that I was taking to my brother who lived across town. Randy dug out a music stand from his car trunk, a baritone ukulele, and some Patsy Cline sheet music! Derek regaled us. Our dog Toona sat at our feet, grinning. Under an overcast sky with an Indian summer breeze, we had our very own tailgate party.

After an hour and a half, we all went our separate ways.

In the middle of the asphalt expanse between 'Blood, Bath & Beyond' and Holy Phoods, we left some 'found art:' one multicolored metal scallop chair with six spent beer bottles and a hand-painted note saying,

"To Honor the Queen Dad, We Love You."

Chapter 4

Our Fuckaversary

We celebrate the day we first had sex as our "Fuckaversary". This is always nine weeks and a Tuesday after Easter - making it a "Moveable

Feast". This was Derek's idea. (Now that I've written it down, maybe I'll remember.)

The first one was during a weekday at Scarborough Faire in Waxahachie, outside of Dallas, Texas, where we had gotten together the year before.

I told Derek to dress up, that we were going out to dinner. I met him in a see-thru floor-length lace dress, with nothing on underneath - and yet he still thought we were leaving the site to dine.

I'd planned a catered feast all made and served by Ren-friends. I led Derek to a little island in the creek that runs behind the booths. Margie made the stuffed chicken and veggies. Jill was the salad girl. Stephen Bennett served the food, Ken Carter was the steward who offered joints all around.

Our servers were dressed in formal tie-dye. Jim Nelson and Bob Bielefeld played the accordion and violin. The glassblowers in the booth above lit sparklers.

Derek turned to me during one of the solitary moments, lifted his glass, and said, "To the absurd and the preposterous, may they never desert us!"

Part 7

The Californication Segment

Chapter 1

No such thing as a Hollywood Ending;

Settled into "Paradise," our view overlooks Elmo's banana, persimmon and fig trees, all ripe and ready. There's a forever blooming Bird of Paradise and a poinsettia as tall as our balcony. The drone of 'the 5' pulses in and out as constant background noise. The highway will take you to your dream's desire. It's California, where you can get anything you want, - for a price.

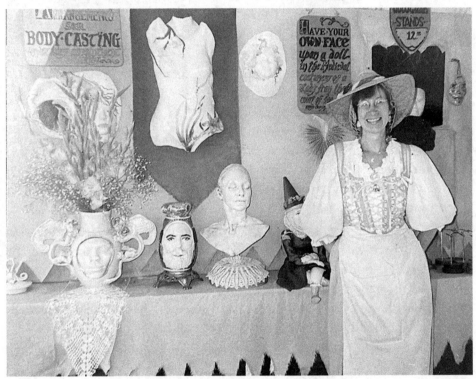

At the California Renaissance Pleasure Faire

Derek and I had been coming here to Elmo and Dell's handcrafted furnished apartments in Oceanside since 1988. The first three years we were at the Southern California Renaissance Pleasure Faire; a hedonistic venture borne of one woman's quest for control. It was an amazing event, especially when you got to know the underbelly. The after-hour parties had unparalleled costumes, the most amazing music, and the very best drugs. However, when it came to the show itself, we decided early on that the

women in control were burning black candles late into the night in order to see into our very souls, (and tap into what our percentage to them should be.) Despite outward appearances, their way of running the faire had vicious undertones, as well as a strict regiment.

I knew the faire was using pieces of Christo's "Running Fence" for some of their structures. Christo's art installation was claimed to have been removed after 2 weeks with 'no visible trace' left behind, however huge sections of the fabric found in the desert had been salvaged and were now being used by maintenance crew members. The heavy woven white nylon was perfect for all kinds of temporary construction.

Our fabulous landlord, Elmo Fries

Derek and I had found a small boat during Big Garbage Day in Pasadena where we were staying. We brought it to the worker's shed and asked if they'd trade for a piece of the famous artist's fabric. There was a pirate ship show on a small lake during the faire weekends and the boats were always in various states of disrepair. I figured I was doing them a really big favor. The trade was made, everyone seemed happy.

The following weekend, one of the management goons came and reprimanded us for going directly to maintenance instead of to the office. I had given them a boat for a piece of fabric for chrissakes!

When I told my friends there that we were quitting the show, the comment across the board was, "Where will you ever make this much money?!" I laughed and told them it was time to get out of California and experience a little more of the rest of the country. The wool had been securely cinched over their eyes.

Our search for better bosses with longer leashes in the pulsing, vibrating

lower half of the state known as California, landed us in Laguna Beach. I still had a good clientele base and decided not to leave Californialand altogether just yet.

At the outset, ignorance is bliss. The Laguna Beach Sawdust Winter Fantasy Festival was only a year old when we got in on the "10% outsider" rule. Letting in crafters from outside their elite burg was a new and necessary concept. Many of the long-timers didn't actually live there anymore (as was the festival 'requirement') but still held post office boxes, so they could maintain the resident status as crafters for the original two month long, 12 hours a day, grueling Sawdust Festival that happens in the summer. Consequently, fill-ins for this revised venue were needed. Once the summer Sawdust Festival was over, the participants went hither and yon, off to enjoy their profits from this renowned event.

They'd never seen anything like us. We weren't boringly jaded like the rest of the locals who'd worked this venue for decades. This new show was in the same locale as a continuation of the three month long Laguna Beach Sawdust Festival that happens in the summers. The Sawdust Festival is an elitist arts event so tightly juried that no one got in unless you knew someone high up and had been on a list for 10 years.

Coming from the entertainment edge of crafts events, Derek and I knew how to put on a show! Always dressed to the nines with smiles as big as Catalina on a clear day, we knew how to make people feel welcome. The customers flocked to our color and our crafts. New Blood! New Art!

Derek's bubble wands caused quite a stir the first few years. "Fine" artists hollered that crap like that had no place in an art show. Someone even reported us, saying they knew we had these made off-shore. Derek got a map and circled an island off of Fiji, then added a doctored photo of a GM plant in Flint, Michigan, and sent it to them, saying this was where the wands were made. A week later, this bit of sideways humor was followed by letters of recommendation from crafts coordinators that knew him, as well as real photos of him making the wands. They conceded and allowed that he could stay. After all, it was the sole children's toy at a show geared for families that only had a Santa and an imported snowfield.

They also wanted me and my life casting demo and they knew Derek and his bubble wands were part of the package.

Chapter 2

California; The Indians called this the "Valley of Smoke".
I wonder what they'd think
if they saw it now.

Nov. 18th, 1993

Stuck in rush hour traffic, I resort to one of my favorite California pastimes; reading vanity license plates. The one that remains top o' the list is, NDNIAL. There's also KTNBEAR and OKHOWRU. Another good one was CITOLDU.

On our second year out to this three weekend Thanksgiving/Xmas event, we found we were headed to the "Lagoona Sawdust, Ash and Pollution Winter Fantasy Fest." There'd been a massive 2-week fire happening in the Laguna hills. No one was answering the phones. When we left for the show, we didn't even know if there was going to be one. Rumor was that a couple of the locals had stayed behind, despite being told to evacuate. They spent

their days hosing down the festival site and the hills and homes above it.

We entered the area through a post-apocalyptic valley of blackened trees, charred hillsides, and mudslide remnants pooling in the streets.

On the Sawdust grounds, busy bees were making white sandbag islands; "California Snowballs".

Opening day didn't. It seems the advertising committee forgot to include this day in the show schedule.

The next day was better until the rains came. General freak-out commenced with sandbags flying. Plywood was screwed to the stairways creating a funnel to the street, in case of mudslide. I took my stock down

and crated it back to the apartment in Oceanside.

The following Thursday we nabbed a nice spot on TV that brought great business.

By the 3rd and last weekend, we were all packing early due to the Santa Ana winds beating us with dust, ash, fried refrigerator tidbits, and other crisped appliances, whipping us until we couldn't see ...

Chapter 3

California: the only state
whose entire southern tip glows
through your night window, like a 1950's tube TV
after it's been turned off ...

Laguna again, one last time; 3 weekends, November/December, 1996.

The neighborhood in this old army-based community had gradually gone downhill. Gangs were beginning to ooze through the periphery. Elmo and Dell often couldn't tell if they were renting to a family of four, or if there'd be 20 living there in a week.

This year when we arrived, we could tell it had gotten worse. There were obvious 'spotters' scoping out the next mark. Makes one uneasy knowing you're being looked at like a backyard dog eyeing the squirrel that jumps from branch to branch.

The morning after we settled into our small apartment, Derek came back in from taking some things down to the truck and said I'd best come see what was missing. The passenger side vent window had been busted in and the glove box was open. My prescription drugs were still there, but a tin of candy was gone. Then I noticed that my spankin' new leather fringed coat, made by a friend, was no longer gracing the back of my car seat! Dammit!!

Derek and I shortly realized our true luck; $380 remained tucked in the glove box as did the spare truck keys - and hence the truck.

On our way to Laguna later that day after making the police report, I realized what else was missing from the glove box; my Preparation H.

Early Thursday morning, after setting up the bare bones of the booth

at the festival, Derek went to a Ford dealership to get the window fixed and I went about researching car alarms.

That evening we returned to our freshly flea-bombed apartment. Apparently, the fellow who'd lived here before us (he'd gone off to prison) had a dog on the sly. It was obvious almost immediately that one bombing was not going to do.

While airing the place out, we got a call from the grounds manager at the Fantasy Fest. It seems our Craft Hut booth didn't pass inspection by the fire marshal. The tent would need to come down and we would have to build. Build?!? Tomorrow!

I hung up and had a small nervous breakdown.

Dell was so kind. She brought us squash, persimmon cookies, and concord grape juice made from her own grapes.

The next day:

After doing some research on the life and feeding habits of fire marshals via Elmo's connections, we went directly to the head honcho in Laguna central. We presented him with the code patch mounted on all three panels of the offending tent, as well as a spare test burn swatch of said tent. It seemed the drawback to my flameproof certificate was not the code, which was in accordance, it was that the design didn't have the same scrolliolios with circles and hoo-haas like the particular one he had in front of him. His right eye twitched, in that ex-Vietnam vet way, as he called his superior to see if we could pass. We did.

Later that day this twitchy control freak returned to the festival site with his minions to cut actual pieces of tents from their moorings for testing. As we were setting up for the weekend, I saw more than a few friends sobbing over the destruction of their costly show pavilions …

Three weekends, Thursday - Sunday.

On the first Sunday, my festival neighbor whom we face while casting, was really angry with us because when we demonstrate we effectively block one of his displays by the crowds we draw. He has four counters. Each with the exact same stock. We must now call security every time we cast so that they can regulate traffic flow.

One of our favorite artist friends wasn't there this year and we finally found out why; he'd gotten a gig doing a wedding 'stage set' for the crown prince of Saudi Arabia!

Chapter 4

California mountains of such majesty,
they named them the Angels.
On a clear day, you can almost see them ...

On Tuesday we set off another flea bomb.

From Hollywood that afternoon, we went out on the "Graveline Tours" with two friends, Steve and Laura.

We met these folks last year when they came to get a body casting of Laura. Despite their 'normal' day jobs as a cop and a bank official, we discovered we had much in common, and became fast friends.

The hearse driver of the tour company was fun and we found ourselves sharing stories as he told us tales of life - and death in Beverly Hills. The winner of the day was pin-up model and film actress Lana Turner's house. She lived with her daughter and the gangster, Johnny Stompanado. The general story goes that after one of their many fights, the daughter knifed Stompanado in defense of her mother, killing him. Our friend Steve then told the story about his dad who was in the police force at that time in the organized crime division. He happened to be there that night. It seems the real story, which has never been told, is that the gangster boyfriend had taken the teenage daughter on holiday to Europe. When they returned home, the kid confessed to Lana that they'd been 'doin' the nasty.' Lana killed Johnny and the daughter took the rap to save her mother's career, which was at its high point. The cops all agreed to the faked ruse as they wanted Stompanado out of their hair anyway.

We saw where Janis Joplin did her final needle, where the Ronald Reagans had their street address changed from 666 to 668, and where Errol Flynn had sex with under aged girls. We went by where Jane Mansfield was decapitated and heard tales of Raymond Burr's massive feather boa collection.

What was supposed to be a 2-hour tour went to 3! It was a blast!

Chapter 5

Botox and Frankie in Palm Springs

We were in limbo for Thanksgiving, and as I'd always wanted to know what hatched Derek's friend, Stephen Bennett, I begged him to invite us over to his mom's place in Palm Springs for this feasting day. Stephen lives in Hawaii when he's not doing shows at Ren Faires on the mainland. I convinced him to come 'home' for this holiday.

Mr. Bennett is known for his button-pushing curmudgeonly ways. His ex-girlfriend used to call his mother "The Dragon Lady" - and she'd never even met her.

Derek and I arrived at the front door of his mom's gated community

Stephen Bennett

house around noon. The door was answered by a tightly botoxed woman of about 75 in pristine attire.

"Look! It's Santa Claus!", she said as a greeting, looking Derek up and down. Turning then to Stephen who was standing behind her, she said, in perfect American/Jewish dialect, "Why doncha get a facelift? You look older than your father did when he died!"

I had decided prior to arriving that I would play up to her as much as possible. I wanted to get whatever insight I could into this mother of one of Derek's best friends. That went twisting off in a different direction with her taking me to the bedroom multiple times to interrogate me on why her son with the 160 IQ who at the age of fifteen had learned chess (at the library mind you!) and had come in top in a tournament, was making the same tired old pots he'd been doing for years since he'd dropped out of school where he could have gone on to become a nuclear physicist or a doctor at least … (Whew!)

Okay, so maybe I learned something.

Thanksgiving meal was good. She did complain about having to cook the whole meal herself, while Derek and Stephen sat on the back porch playing guitar and ukulele. Truth is, Derek and Stephen prepared all the side dishes during those special moments where she'd drag me off to the bedroom to quiz me about Stephen and the two boys he had fathered that she'd never seen. She did make a separate stuffing for her son the vegetarian, in which she put a can of chicken stock. He had the runs for three days and didn't know why until I told him later.

We all sat down and ate our meal, serenaded by "Frankie" (Sinatra) on the stereo.

Croquet and other lawn options were thwarted by 'the rules of the gated community,' so we walked off dinner, touring the incredibly pastoral, 'Rancho Mirage'. Grass the perfect shade of green, trimmed tight. Disney bright flowers nestled around the base of each manicured tree, with a pretty pond and babbling waterfall that kept turning on and off. Purple-blue mountains rose on the horizon framed in by waving palms gracing a clear azure sky.

As Derek and I were getting ready to leave, she began in on Stephen again about how he should color his hair.

Chapter 6

Newport Beach drag, where Christmas topiaries sport leaping leafy green dolphins with reindeer style antlers and red & white Santa hats.

That weekend at the festival was dismal. Normally the biggest shopping day of the year would be slammin'. Not so much. The festival's advertising seemed to be in question - yet again. Apparently, they fired the media manager three days before the show began. The board members weren't talking to one another and no one was in charge of supplemental ads.

We finally got our first double body casting of the show!

I'd started body casting in Michigan when a young woman with a

shaved crotch insisted that she could be my first subject. It was fabulous! Then I cast someone with crotch hair. Oops. Not like facial hair. It takes about 25 minutes to do a body casting with the wetted down strips of plaster gauze bandages applied to the form. This is two times longer than a face cast and the plaster in the mold has more time to grab a-hold of those short and curlys as it dries. Scissors and a lot of squealing were employed to remove that cast. From then on I used 1-ply kleenex as an additional release agent in furry areas. Later I found that Spray Pam works just as well for this, as it does for frying eggs.

Another learning curve was the issue with 'locked knees'. If someone locks their knees while being cast, they can pass out. Yes, indeed they can.

My first male body casting was done on a professional track runner. Stunning body. He wanted to be cast from the neck onto his upper thigh. This meant casting the ~ you know ~.

Due to complications we'd discovered that could feasibly occur while casting someone nude, Derek now came with me and would be in an adjacent room if I needed him. Both as an agent and as an assistant.

Derek was in the dining room, reading the newspaper, while I cast the athlete in the bathroom, where he could see the pose he was holding in the mirror.

Having done the upper torso, I was now poised at his crotch. I had already announced, as a point of fact, that I would, "Drape, drape, drape, because if you touch it, it changes shape" (really - I said this out loud), when the studly young man told me he was feeling a tad dizzy. Really? How dizzy? He believed he might faint … I urgently called for Derek.

My poor boyfriend had to squat behind this fellow, perched on the toilet, and hold him up by his ass, while I finished the privates.

Derek swore he'd never do this again. He was very wrong about that. He's done ever so much more since then.

The folks we did the double body casting for lived in a nice gated community. In their late 50s, these two were unselfconscious about their sagging parts. A double body cast includes two people from head to just above the waist, holding each other in a sweet caress. We propped the woman's tits with a rolled up washcloth and went to work. They had great

smiles!

It was obvious they would've invited us for other pleasures, were we so inclined. As we weren't, Derek discussed cooking and it's joys with the wife, while the man and I pondered the difficulties in casting a couple making love.

Back at the festival, I had a woman who wanted her body cast, but had no openings in the days I had left to have us make a home visit. We decided to do it then and there behind the closed door of the wheelchair accessible stall of the ladies' room. She was 49 and quite attractive. Her daughter was with us, assisting where necessary. Later she laughed about how our conversation must've sounded to others using the facilities; "How does that feel … do you have enough Vaseline there?" "You really DO have big nipples!" "I won't be covering your face 'til after I've done your body, so you can watch." "Here, you can clean that up with these baby wipes …", etc. etc. Ahh, well. All those nervous mothers who rushed their children from the bathroom will just have to chalk it up to the "California Mystique".

Derek and I had now placed a mirror in Feng Shui style, facing the ever glaring jeweler neighbor. It seemed to be working.

Sunday before the last weekend we were all given a handout. It stated that in accordance with 'contractual agreement' we were all supposed to be dressed in a "Gay and Festive" manner. We were to comply for this upcoming final weekend.

Well now. Derek and I ALWAYS dress Festive …

The Bubble Boy we had hired for the show to run Derek's booth was a professional juggler and a

real good sport. When we asked him to dress like Carmen Miranda, he went for it. I'd picked up a vintage Mexican lime green dress with black and silver ric-rack at the AIDS thrift store in town the week before. It fit him perfectly. He wore a Dr. Seuss hat I'd festooned in plastic fruit. Large pearls at the throat were the piece de resistance. Derek dressed as an 'outted' Hugh Hefner in maroon silk pants, and a 1940s maroon smoking jacket with matching ascot and pin. He sported a pink felt tam and had maroon patent leather shoes with tassels. Makeup and nail polish topped it off. I wore Derek's black tails, a bowler, a cummerbund, and his necktie with a nekkid lady. We had us some Fun!

The general consensus was that the Winter Fantasy show was purposely being sabotaged by the summer Sawdust Festival, a tired 30-year-old show that was once known for its excellence in the arts. The biggest drawback was you had to be local. Even then, it was all about seniority, and who knew who. Newcomers were rare. The Winter Fantasy concept was born to use the pre-existing show space during the holiday season. When this new event opened up to outsiders, patrons began coming out again to see new arts and crafts. Jealousy ensued.

It had been decided that all booths the following year must be built out of plywood, as a semi-permanent structure. This meant either hauling it or

Dell & Elmo Fries, our beloved landlords

storing it locally. Neither was going to happen in our world. We were done.

As I sat in my rented kitchen that final morning, watching the sun come over the distant mountains, past the trees and the rooftops, moving through the low staccato on the expressway, another noise in my brain ached like the blinding sunlight on the concrete sidewalk when you stare at it too long. I wouldn't be coming back here. "Good-Bye" this year meant something completely different. Elmo and Dell sent us off with a big bag of persimmon cookies, homemade grape juice, canned apricots, and pineapple guava jelly - all grown in their garden. We would never see them again.

The winds from the Santa Ana's knocked us through the pass. Trucks were pulled off everywhere on the sides of the road. The gusts arrived suddenly and then ended 64 miles away.

We drove into the "Mountains of Mordor", as Derek calls them. I said they looked Disneyesque. Either way, we were now on the other side of Paradise.

Part 8

"The truth." Dumbledore sighed.
*"It is a beautiful and terrible thing,
and should therefore be treated
with great caution."* – *J.K. Rowling*

Chapter 1

"Trust is like a mirror, you can fix it if it's broken, but you can still see the crack in that mother fucker's reflection." – Lady Gaga

What is it about the popular kids and how the teachers cater to them? Cool teachers or teachers who want to be cool, seem to love to play to the cool kids, much to the detriment of the rest of the class, whose struggles include torturing inadequacies and fear of being teased relentlessly.

I ultimately developed my own agenda, but I also wanted to understand the machinations of the power structure.

It started early on, in 4th Grade, with our teacher, Mrs. Miller. There was already a class system; those who were the prettiest, the snottiest, the bullies, the athletes, the whiz kids, and the dweebs.

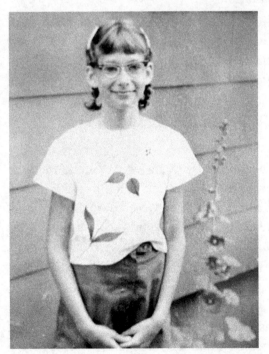

Scrawny and gangly, sorta goofy with horn-rimmed glasses, I was not as swift as some, more so than others. I really sucked at math. Staring outside held ever so much more interest. Failing that, the patterns on a fellow classmate's outfit or the scrawlings on my wooden desk could hold me rapt for hours.

When Mrs. Miller went to get some coffee in the teacher's break room, we were instructed to all remain seated.

Haa!

As soon as she was deemed safely down the hall, all the 'cool' kids began giggling, passing notes, and jumping up to peek out the door. This had happened before, and no one was ever punished. Cool kids rule.

It seemed like everyone in the classroom had gotten up but me. So, I did too. First time ever. I was one of four that got caught. However, I was the only one that got punished.

Everyone ran back to their desks, and not all were sitting when Mrs. Miller came straight for me. I was seated, with my hands folded on my desk. She shook me, rather violently, shouting that I needed to be studying my math. I sat there in shock at the intensity of her attack. And then she struck me across the face. Very, Very, Hard. My classmate friend Donna tried to speak up for me, saying that all the kids had done it, but the teacher would hear none of it.

I arrived home in tears. There were visible red finger marks on my face where I'd been smacked. My mother was furious. Icepack and words of comfort were employed for that evening, with the assurance that I wouldn't return to school until the principal was involved. She promptly called his office the next morning. He was on vacation. Instructions were given that she was to keep me at home until the end of that week when he was back and could properly mediate the situation.

When we all gathered, I still had a bruise. It was my mother, Mrs. Miller, Principle Johns, and me. He heard both sides and was appalled by my teacher's actions. She was reprimanded in front of me (Score!) and was warned to never again strike another student.

She quit after that year around a buzz of controversy that rumored alcohol as the culprit. She died of a heart attack shortly thereafter.

Sixth grade. 1963. A pretty new teacher with an Amy Winehouse (who wasn't born yet) hairdo came to our 4-story red brick schoolhouse. She was married to the hot new gymnastics teacher. They were automatically cool. The cool kids flocked to them. The jocks, the babes, and the ones who never got caught, or if they did, were told not to get caught doing it again, (wink, wink).

One afternoon there was a bubblegum contest as a fun time treat. The prize for the biggest bubble was the popular Sonny and Cher "I Got you Babe" on a 45 record. Everyone was to pick a single piece of brightly wrapped bubblegum from a bowl that was passed around. Some grabbed two. I blew a fabulous bubble. It was a winner! Everyone said so. That is, until a couple of girls who'd grabbed two pieces of gum blew bigger ones. I loudly proclaimed

these two as being fakers. They always won by cheating and I simply didn't wanna take it anymore. The teacher called me a 'fink' and gave the record to the cool chick with the biggest wad.

Later that year when the loudspeaker announced that Kennedy had just been shot, this beehive babe sobbed the loudest of all the teachers who gathered in the hall.

I was beginning to get a greater grasp of power and how it worked.

Nonetheless, in eighth grade, I played into it yet again.

Our cute English teacher - think Gilderoy Lockhart from the Harry Potter series - was teaching Satire. Wanting to be on his good side, I offered to bring in my brother's fab collection of the satire comic/magazine, "Mad." Some of the issues dated back into the '50s. Brother Dan was away in college, so as long as these came back, he'd never know they'd been gone.

The stipulation of full return understood, the comix were let out among this suave teacher's classes. Kids slipped them into books and bags and tore pages out. The teacher turned a blind eye.

When I came for the box of 'zines the next week, there was naught but a smattering of bits and pieces.

I broke down into tears. Shuffling his feet, the teacher mumbled a sort of an apology. Too little too late. He was diminished in my eyes forever after.

"Trust" now firmly embedded as a concept no longer trustworthy, I moved into young adulthood with many questions - and a new way of wheedling what I needed to get from my teachers. If they were going to abuse me without concern, I could certainly perfect a way to use them.

I'd been told by an upper-classman that if you approach a teacher on the side with a desire to know more and a sincere sounding, "I want to understand this, but I'm having a difficult time …," the teacher will give you all the answers you need to pass. Dang if he wasn't right!

I skated through the harder classes by winning over the teachers and getting (sometimes just barely) passing grades. Of course I aced Art and English.

Regarding the 'cool kids,' mom had always said to 'just ignore them and they'll go away.' Dang if she wasn't right!

Hard won lessons in hand, I became a member of the Student Council, a prime actor in the theatre group, a part of the school newspaper and an artist of some renown.

The "Freaks" had taken me into their fold. Dope smoking long hairs, they were known for their shabby clothes, bellbottoms, and rebellious ways.

My best friend Lynne was one of these 'freaks'. I remember when she got kicked out of social studies for wearing 'flag pants'. This concept in clothing was still considered desecration and disrespectful, despite now being marketed in popular stores. Abby Hoffman had only recently scoffed at America with similar attire and some of the teachers were offended by this slap in the face regarding the symbol of our country. Lynne was told to never wear them to school again, or risk being expelled. She was my hero!

Despite the fact that I was still a dweeb and involved in some of the more 'Republican' elements, I was freaky enough to be one of the Freaks, especially

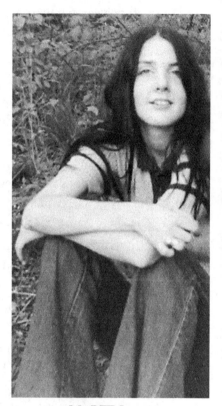

My BFF, Lynne

as I now had connections as well as abilities. They used me to get their words heard through the paper and in school politics. My art was a handy medium as well. I now had most all the various factions of the school under my thumb. Except for gym class. I sucked at sports. Always chosen last for any team. Embarrassing. I even fainted smack in the middle of the 50-yard dash. Anemia. Didn't know it. Sprawled out, legs akimbo, with my eyeglasses scattered in several places. Lynne was there and she told the teacher (who was busy chatting up the cool kids instead of timing my run) that she might want to see if I was okay. There's a scar on my knee as a reminder of this moment in my youth.

I've retained a cautious nature all my life. I smile and nod in a perfect facade while listening very carefully to what's being presented. Often, I'm wondering what is it this person wants from me, and what level of 'cool' do I need to present, and - do I care? Who can I trust? What IS trust? If I could not trust a teacher, what did that mean? I've many, many friends all over the country. I am heedful about who I totally trust.

Chapter 2

"We Have Art in Order not to Die From the Truth" – Nietzsche

I'm an Artist. I've never been famous, tho I've had my Andy Warhol "15 Minutes of Fame" numerous times over the years. I've made much of my living by making art since I was 12. Okay, so I didn't really begin to support myself with art until I was 18. Even then it was supplemented by art modeling and waitressing as needed.

Right before I hit age 30 I made the leap full time into craft shows selling the art I was making. From there I segued into Renaissance Faires and lifecasting workshops. Ren Faires offered a gig of duration running 7-9 weekends long, where you stay in one place for the entire run. This is ever so much easier than the set up/break down that happens at the average weekend street show. At a Ren Faire, if you're lucky, you have a comfy booth to stay in that's not a tent. There's rarely a shower of worth, and no running water in your booth. Privies are pretty much all that's available as a place of excremental relief if you're living on site. Basically, you're camping for however long it takes to do the show. Part of that show is wearing a decent looking costume, (many shows have strict restrictions) and, you must speak, as best you can, in a funny foreign accent of your choice. Anything but American, mostly Ye Old English.

I'd been selling in art galleries for many years before discovering that street shows made me more money. Yes, it's a little more work, and you're a slave to the weather. You pay the booth fee and are stuck with whatever the situation is. If there's a big sports game nearby, (or even on TV) the crowds can diminish. Numerous other events can interfere, such as the State Fair or a Tractor Pull. If this happens and draws away your potential clientele, you may be S.O.L. (shit outta luck) for that weekend. Same with rain, snow or

wind storms. The latter generally being the most devastating. Especially for me as a ceramicist. Face painting was another easy-peasy way of garnering some quick cash at events. I did both across Texas from 1981 until 1986. That's when I entered the "Ren World" and my life changed in major ways.

I discovered that my portrait talents, honed on Jackson Square in New Orleans, could now be expanded into an actual face mold of the customer that I would then complete. This was a 'true' portrait. Undeniably them. A ten-minute casting process of the face with a one to six month turn-around while they wait for a custom-finished sculptural clay piece. Risky business. They had to trust me. Having learned about trust through personal experiences and my parents instilling the worth of one's word, I was rarely late. If there was a chance it would take longer than the due date, the customer was informed and given options.

Historical research helped in creating the perfect patter. This was an ancient form of portraiture that dated back to Death Masks. Life-casting became a documented art form in 1392. Perfect for tapping the Renaissance theme. You can find the process written up in "The Craftsman's Handbook" by Cennino Cennini, (Dover books), wherein he describes how to cast faces, "using a mixture of plaster and rose water. If, however, you are doing a simple commoner, tepid river water will do."

After numerous mistakes regarding this very same plaster casting process, I happened upon medical grade plaster gauze bandages. The discovery occurred when I went to assist a boyfriend's mother who'd gone to the hospital after she'd tripped and given herself a decent sized hematoma of concern on her noggin. There was a supply closet in the room where she'd been told to wait. After being ignored for over an hour, I began poking about. I found plastic-wrapped rolls of plaster impregnated gauze bandages. I knew of these by virtue of numerous broken limbs friends had endured. This was what they'd been cast with!

I stole 4 rolls.

Feeling guilty for stealing, these potential art supplies lay fallow, hiding in a cabinet beside my bed for about three years. When I finally broke them out and began working with them, my art was revolutionized.

As time went on, my patrons would feed me their desires. I learned it was all about whatever their fantasies were. Despite my search for Truth in Art, my customers didn't want to see wrinkles and double chins. Moles and imperfections were now smoothed and made lovely. I turned people into kings and fairies, adding spirit animals and ornamenting them with flowers and butterflies. Hand castings started off as two hands, then became 3 and then 4 and then families of 5 and 6. Body castings morphed into whole paintings that would tell fables and personal stories. Dolls with my customer's shrunken heads were finished out as satyrs, imps, royalty, and one of Pocahontas's great-great-granddaughters, resplendent in full squaw regalia.

Somehow, I trusted this was what I'd be doing for the rest of my life.

Part 9

*"Anything for a
weird life" – Zaphod Beeblebrox*

Chapter 1

Lifecasting.

The stories have been deliciously endless.

I had a woman who begged me to cast her pet rabbit. Despite my obvious hesitations, she insisted the rabbit would do her bidding. I mentioned the complications of using sedation and that animal's eyes never fully close, even with the hazardous drug. She responded that she was going to fashion goggles for him …

There was a double body cast where they passed out while in process (too much booze) and then there was the woman that threw up INSIDE her face casting (too much booze).

There were nipple casts and body casts in wheelchair accessible bathroom stalls at various indoor venues, utilized when the customer was on a limited time schedule. Again, I can only imagine what the others entering the restroom thought of our conversations.

Stories come from people who've tried this on their own with limited knowledge of the process. A young man who cast his entire head with Plaster of Paris, at home - alone. Think about that. You can't see to make a phone call, nor can you talk …

Two girls told me the tale of doing a cast of their pregnant friend's belly with plaster of Paris and no Vaseline. Plaster adheres to body hair - which we're all covered with, and it also shrinks - and heats up intensely.

My fav is the story of a young man I was acquainted with that wanted a more 'personal' casting. He was well aware of my work but decided he had all the info he needed to do this at home. His parents had been ceramic doll makers, so he had a rudimentary knowledge of the process. Putting the mixed plaster in an empty coffee can, he inserted his penis. To ensure proper size management, he'd taken Viagra. EXTRA Viagra. And no Vaseline to boot. Not only couldn't he get himself out of the plaster, but the plaster was also stuck in the coffee can due to the ridges in the metal. Hoo-Boy.

After an hour in burning pain, alone, out in the country, he contacted a medical technician he knew a few towns over. The fellow said that, yes, he had the appropriate saw for carefully removing the contraption. My friend hopped in his car with naught but a shirt on and the can of hardened and hot plaster attached to his crotch - and drove.

It was past midnight by now.

His left rear taillight was out.

He got pulled over by a cop. The cop wanted him to get out of the car.

Hilarity ensued, (on the cop's end.)

The officer offered to forfeit the ticket for the option of a visual chuckle for a few of his buddies on the force. After more cops and more giggles, they gave him an escort. Around 4 a.m. the body part was finally freed.

Another friend of some renown had enough pull in the world of adult entertainment, that after having watched me cast numerous times, did further research and began molding famous porn star's pussies for paperweights and soap.

This then leads me to my own weird segue involving casting at BondCon, a Bondage Convention, Vegas style.

Chapter 2

We are all. Free. To do. Whatever. We want. To do. – R. Bach

Okay - so this is how the story goes: Renaissance Faires have been much of my life. I suppose if I lived in New York City or L.A. I could triple my prices, (but then I'd have to live there), and maybe then I wouldn't have to work so hard. Don't get me wrong, I love my work. But I also live in a much nicer place than L.A. or N.Y.C.

Really remote with vast skies, creek and canyon, hidden from our neighbors in this valley off a dirt road, we build on our home as we make money. My bathtub was outside for eight years (on-demand water heaters work through hoses even in zero degrees!!) and it took longer than that to get a living room. We eat well and sleep deep. No kids. Normally a dog and cat, which often travel with us to our shows.

Waiting to be 'discovered' is a cartoon dream. I've got a killer press packet that's landed me numerous TV spots, radio shows, and newspaper articles. However, my work, although honored by the ancients and well crafted, is apparently 'creepy'. In an era of intense self-examination, self-mutilation, and self-denial, the true meaning of 'Know Thyself' has become lost in psychoanalysis. A casting of one's real features is a force to reckon with. It's a luxury for the self-assured.

Searching for the next tide, we began to notice a shift at the Ren Faires. Bondage and Discipline gear moved from the closet to the wall in numerous leather booths. One shop previously selling just belts incorporated $110 leather harnesses, sold out by every Sunday afternoon.

So, Derek shaved his leg, tied it up and we cast it using the plaster gauze bandages. The finished clay piece got lots of response and led to the knowledge that a huge culture, less underground than I had previously believed, existed on what appeared to be a very marketable level.

I made friends with a woman who had started modeling for our weekly drawing class on the faire site. She'd worked various booths at the Maryland festival since she was a teen. She married an old flame from those teen years that struck it rich when he invented Internet Firewalls. A semi-profitable sideline for him was taking fetish photos.

In a seedy DC hotel, he was doing a photo shoot of Elkie Cooper, one of the top fetish models in the world at this time. He mentioned our desire to locate a venue to market our bondage castings. Elkie suggested "BondCon8", in Las Vegas. After all, if you're experimenting, why not choose Vegas?

He offered to fly her there with some of his free air miles if she'd pose for us in public. She agreed.

We booked the event, not knowing it was a first time show. BC8 was eight people putting it on - not a time honored 8 year old event.

Chapter 3

"Republicans understand the importance of bondage between a mother and child" – Dan Quayle

Jan 7th, 2003

Having barely recuperated from the grueling 12 hours a day, 13 daze straight, Armadillo X-mas Bazaar, we drove to BondCon in Las Vegas, Nevada, (from one form of bondage to another, as it were.)

Derek drives. He also builds my booths and carries the crates. Derek makes the coffee, he does the dishes and half the cooking. He'll talk to every person that comes within earshot of the booth. He can cast faces, tie ropes when needed, and clean plaster out of people's eyes, ears, and teeth. It's my job to make the finished art pieces, do the other half of the cooking, and to keep him awake when he drives.

The desert is lovely. We go through the barrenness of a "Joshua Tree Forest". Distant mountains are painted in light and rainbows. We listen to books on tape and tell each other stories. We laugh at each other's jokes.

On the Arizona side of the Hoover Dam, we're stopped at an inspection station. Security due to possible 'terrorist activity'. An interesting side effect of 911. No tractor-trailer trucks allowed over. They must go all the way around and into California and back to get into Vegas.

Already booked by Halloween, we couldn't get a room at the Stardust where BondCon was being held. CircusCircus motor lodge was close enough and affordable and had vacancies. Two beds; one for Derek and I and the other for our friends who were joining us there, Theon and Hildy. Housekeeping hauled in an extra table for our cookware and coffee pot. It was a truly cheesy room, but the staff was accommodating, so we pretty much got everything we needed.

We used a method contrived of clamps and cable ties to secure the wall

panels of the booth in order to avoid the use of tools that might otherwise necessitate having to hire Union Labor. Muslin curtains were attached behind the panels and swagged across the front to drop down for privacy during casting, should it be needed, which it was. Although most of the women that were cast here allowed their bodies to be shown, one fetish model who

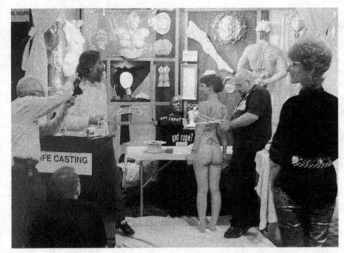

wanted a roped up chest casting would not allow her breasts to be seen without pay-per-view, wherein your credit card can buy you a gander at her globes.

The booth was filled with bondage shibari life cast samples I had made from numerous willing friends. My boyfriend had shaved his own muscular leg up to his crotch. He's a very hairy guy and this freshly naked (and oddly greenish) large patch of bare hairless flesh was highly erotic! After taking advantage of this sensual moment, we roped him up in designs we'd found in one of the places where you find that sort of thing. The piece was exquisite! Plaster gauze bandage works great to capture the rope and knots in perfect detail.

Derek learned the hard way about various pressure points and where not to tie ropes too tightly. A tall muscular male friend we'd trussed up nicely, crumpled on us. Quickly, using scissors, we sawed through the binding at his wrists. The casting still turned out very well, though now in two parts; butt and back.

Before opening, I'd already made my first purchase. A few booths down there was a darling man with a joyous childlike quality.

VOLUME NUMBER TWO
BETTY PAGE IN BONDAGE

ILLUSTRATED WITH 32
Actual Bondage Poses of Betty Page

BONDCON™
presents
An Evening of
BURLESQUE & BONDAGE
Stardust Conference Center
Friday January 10, 2003
11pm

STARRING

Playboy Holiday
2002 Covergirl
Dita Von Teese

Stripping Sensation
Catherine D'lish

Gothic Queen
Persephone

The Erotic Duo
Summer Cummings
& Skye Blue

Since the age of 16 he'd been collecting fetish 'zines. I bought numbers 2 and 7 of the original Irving Klaw's "Betty Page Bondage" mini-books!

Dita Von Teese postcards were another purchase. Touted as the new Bettie Page, she was the current fetish rage. She was also shock-rocker Marilyn Manson's girlfriend. Rumor is they've both had four ribs removed. Corset Fetishists. Dita was one of the headliners for the convention. I got her to autograph my '02 Playboy magazine as she was the cover model.

AVN (Adult Video News) was in another hall in the same convention center. This provided additional interesting attendees to our venue. Hildy chatted up anybody that walked by our display, consequently, she met numerous porn stars. One was "Dick Smothers". He was so enamored of her that he gave her all his contact info. And yes, he's Dickie's son, of the Smothers Brothers, the famous musical comedy duo from the '60s and '70s.

At one point, I ran up to Derek and eagerly asked him to take a picture of me with the man coming down our aisle. The man posed with me and my boyfriend snapped the shot. After the guy walked on, Derek asked who the porn star was. I informed him that he wasn't an XXX-rated actor, but Penn Gillette, of Penn and Teller fame.

Most booths in the convention hall were featuring models promoting themselves. Beautiful girls with great, albeit augmented, bodies. There were also vendors selling videos,

Ann with Penn Gillette

books, and toys. I loved the horse and whale phallus's cast from the actual animal's erect members - in realistic pink rubber! A snooty California jeweler

had white and magenta velvet boxes in which were displayed rose quartz and crystal dildos rimmed with gems and finished with Versace fur tails. These were a mere $3 grand.

Booths had leather and latex clothes, electro stimulus tools, paddles, whips, clips, and clamps. There were pony boys and pony girls. Masters and Mistresses. Theon went up to one of the 'pony girls' and asked her if she knew what kind of underwear pony girls wore. When she shook her pretty little blonde head no, he said, in a whinny, "Kniiiickers!" Looking dumbfounded, she walked off. We all laughed.

"The Cutest Kink" provided the best humor. Encased in festive rubber, girls from 'The House of Gord' would be bound into all sorts of shapes, such as chairs, tables, lamps, and best of all, cars! Manipulating a lever with teeth and lips, the subject 'drove' the 'car'. An appropriately inserted electroshock 'egg' operated by Gord would spur her on to keep her moving up and down the convention hall aisles.

Footwear was another extreme. I remember my years as a slave to fashion, but these stilettos were downright scary! Every color and height. Belled, chained, strapped, and hobbled. Pony people often wore hooves. Magnificently crafted, these had a brace of metal for balance. Equestrian effects included bits or ball-gags.

Having gone into intensive research before entering this realm, I felt prepared for most of my encounters. I was pleased to find humor and beauty in much of what I saw. Hildy had numerous moments of concern in the first two days, often arriving back at the booth horribly distressed regarding some Master/Slave treatment she'd observed. By the end of that second day, however, she was delighted to announce that on Sunday she was going to be trussed up in suspension and whipped on stage!

Saturday several friends came to visit, from as far away as Maryland! One was the very same fellow who later would make paperweights from pussy castings. It was from him that'd we'd found out about this event through one of his models, the famous Miss Elkie.

The buzz that this fetish model of renown was going to be there had gone through the event like wildfire. When I announced she was coming there to pose for me, - the new kid on the block, - they (all the old pros) scoffed. What a surprise for them to discover this fresh face on the scene had connections!

While wearing naught but a piece of duct tape on her nether region, a Rope Master tied her up in our booth. The crowd went wild!

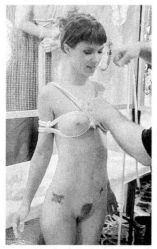 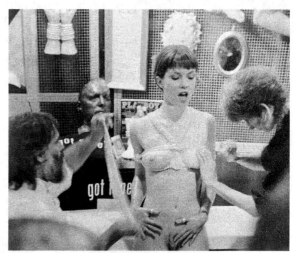

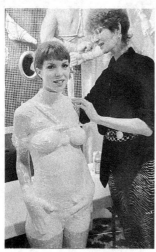 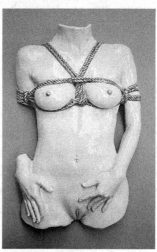

After smearing her flesh with Vaseline and putting spray "Pam" on the ropes, we proceeded with the casting, thus making a mold for yet another bondage sample. And getting a modicum of fame in the B&D world as well.

Chapter 4

"It's knot what you think" – Midori, Rope Mistress

*Sticks and stones may break my bones,
but whips will only please me.*

The boy next door was '80s retro in his white make-up and orange mohawk. Conversation revealed he knew me from my three years at the California Renaissance Faire, where he'd worked for a sword maker. He and his betrothed had gotten together at a Hollywood Dungeon. She was now a part of his 'act'. A real cutie in a baby doll dress and pigtails, she was almost vibrating as she told me that the famous Midori was due to tie her up later that hour.

Using some of our duct tape, she affixed some cotton to a wound on her back, so that the ropes Midori would use on her wouldn't cause further injury. The day before, during their stage show, Mohawk Boy flayed open a section of her shoulder while whipping her body. Falling on her in tears, he apologized. In the ecstasy that pain brings to pleasure, she told him she was higher than she ever knew she could go. They both agreed that the blood as it dripped, was exquisite ...

"Free your Mind, Bind Your Flesh" – Nawa Shibari

We were highly unfamiliar with the B&D scene, so prior to going on this adventure, we'd inquired with friends who had some knowledge. Their stories had put us on alert. It all sounded frightening. Ball-gags and nipple clamps horrified me - not to mention the bruised beatings.

Originally hired as our buff Bodyguard/Assistant, Theon was fired within the same week when we were informed that a bodyguard was ridiculously unnecessary.

Side story:

(1997)

Derek and I had tenuously visited a dungeon in California several years before. Although we trusted this return customer on the level of being a patron/friend, we didn't know what going to this place might incur. And we hadn't told anyone where we were going. What if we 'disappeared'??

A couple of blocks from Disneyland, this dungeon was a joint venture between friends. Well turned out, it had a lavish "Hollywood Set" quality to it. Dimly lit, the color scheme was done up in silver and black and rich reds. The walls were filled with chains, straps, and two full racks of whips and floggers. There was a "Catherine's Cross" as well as another lashing station named after some other saint. A large pipe frame supporting a leather sling chair with ankle straps and an overhead mirror was nearby. Slung from the ceiling was a metal bar that one could be cinched into by the wrists and hoisted off the floor. In the corner upstairs was

an 'Electric Chair' as well as a chain suspended bed with leather sheets. Framed "Tom of Finland" drawings covered the walls, - superhero style disproportioned muscle-men in various compromising positions.

The partners would let movie crews film here. During one of these, a whip was used and it broke the skin, causing blood to get into the braiding. This was a matter of great concern in these days of AIDS, and the expensive whip would now need to be discarded.

Return to original story:

Reminded that this was a Convention and that no one would do anything to us that we didn't want to have done, we had released Theon from his bodyguard status. Not to be thwarted, he and his wife, Hildy, came anyway. Having their insight, humor and friendship on this adventure made it all the more delightful!

On Sunday afternoon, Hildy masked her face and stripped down to her black thong on the main stage. Short in stature but strong in limb, her calf muscles flexed as she stood on tiptoe while a beefy rope master with a devilish grin bound her to a tripod. Creating a rope harness to support her while suspended, he lashed her arms and legs spread-eagled, whip-teasing her as she spun in rope ecstasy. My understanding is that the ropes take the subject to a 'zone' - a place of mental orgasm. Clips and spankings can heighten this. Many of the models in truss would flush raspberry from torso to forehead, exhibitionist, and voyeur each achieving pleasure from the moment. The voyeurs here were mostly behind cameras.

Late Sunday night, we took Theon and Hildy to the airport where they could return to their young children and their normal lifestyle in their small East Coast village.

Forever after I'll be asking, "What is normal?"

Pick of the Week

In keeping with the newly established *CityLife* tradition of listing at least one bondage-related event on the CityPicks page, we give you ... **BondCon 2003**, "the ultimate bondage and fetish exposition." That's right: It's moved from New York to Las Vegas this year. After all, Sin City is *the* adult playground of the world, so it's sure to prove the perfect location.

There's a lot to hotly anticipate: 140 models will be attending (including the Empress of Erotica), as are 72 exhibitors and vendors (including the good folks at GaggedTorment.com). The schedule of events is breathtaking: hands-on bondage workshops, bondage demos, Internet copyright and trademark protection discussions, prize giveaways and meet-and-greet pre-show cocktail parties — with hor d'oeuvres!

It's not a free-for-all, though; make sure to read the event rules at www.bondcon.com. The exposition goes from Jan. 9 through Jan. 12 at the Stardust Resort & Casino. It's $20 per day for exhibit access; $35 for the "Burlesque & Bondage" show inside the convention center ballroom on Jan. 10 at 10 p.m. For more info, check the website.

Get thee to a rubber nunnery!

Marcus J. Ranum www.ranum.com

Chapter 5

"Nakedness makes us democratic, Adornment makes us individuals." – Liberace

Leaving CircusCircus, we moved into the much more luxurious Venetian. Our dear friend Sandy Dunn had come to town on a whim and offered to share her swank lodgings. We spent several days touring the Vegas sights and eating amazing food.

One of our favorites was the Liberace Museum. The famous entertainer was known for his lavish costumes and wildly adorned pianos. Glass cases filled with floor-length rhinestoned furs in every color and design imaginable. He would change numerous times during each performance, rarely repeating an outfit.

He was certainly one of the innovators of the modern Art Car! A

crystal studded Rolls Royce was among the more delightfully garish vehicles presented.

Bizarre artifacts from a bygone era filled the final room of the museum. Framed black and white photos detailed the early Vegas culture when the "Rat Pack" still ran the "Sands" before being ousted by the new owner - a degenerating Howard Hughes. This showed a time before the Sands imploded, only to rise from the ashes, like a brilliant theme park phoenix, into the hotel we were currently residing in, the Venetian. These were photos from the strip before the high rise went higher and the lights went Disney.

Behind a gaudy white and black rhinestone encrusted piano with matching candelabra, was a solitary shot of the first puffs of an atomic mushroom cloud over the Vegas Strip. Curious if postcards of this momentous event were available in the gift shop, we inquired with the docent. She told us with a snigger, "That's a time the investors would like to forget about. People here abouts sat out in their lawn chairs to watch. They thought it was free fireworks." Derek lifted his wrist, looking at an imaginary time piece. "Oh," he said, "Has it been twenty thousand years yet?" The museum matron replied glibly, "Why do you think Vegas has so many oncology labs?"

Chapter 6

BonCon, 2nd round: 2004

Code Orange; Hoover Dam Diversion.

On the Arizona side of the Hoover Dam, Wackenhut Security pulled us aside requesting to see the inside of the covered camper shell section of the truck. No problem. Derek opened it up while explaining that we were headed to Vegas for a craft show. "My wife'll be telling' me about that one! She makes it to all those shows", the guard said.

I doubted it.

Construction was underway for substantial bridgework for a by-pass of the dam. 911 precautions now being implemented.

Polo Towers was a timeshare owned by some patron/friends we knew from Maryland. They'd heard the previous year's stories of our Vegas adventures and decided now was a great time for vacation fun. They offered

us their spare bedroom.

Superior to CircusCircus, here there was a full kitchen and a jacuzzi.

We'd met Dave and Laine six years before when we did a double body cast for them. Dave works for the National Security Agency (NSA), a profession shrouded in secrecy - and of great curiosity to Derek and I. Unable to wheedle very much info from him in regards to this branch of the government, the one bit that lingers is that yes, our fearless leaders can recreate and implant any illness you can imagine, thus putting "undesirables" out of commission - often permanently.

BONDCON™ 2004

The World's Premiere Bondage and Fetish Exposition

Official Program Booklet

Las Vegas Sports Center
Jan 8th-11th, Las Vegas, NV

Show set-up wasn't until noon, so Derek and I exited the city and went to see "Red Rocks". Although a brown haze of pollution lingered deep into the horizon, we did get a great view of the calico colors of the petrified "Dunes of the Desert." Sandstone boulders painted by nature in graphic sweeps of red, pink, white, and black. Nice escape into mother earth's naked majesty before entering into the realm of the mistress's naked mastery.

BondCon this year was held off the strip at a Sports Center. Since signing the contract for the event, the center had changed hands five times. The last owner failed to purchase a cabaret license. That means any nakedness (exposed breasts, butts or genitals) will cause the city to revoke the Sports Center's liquor license. Liquor in a Sports Center?! Ahh! Vegas! This mandate changed the whole bouncy flavor that punctuated last year's event.

"Fantasy" still played out. Colorful latex garb stretched tightly over the tiniest titties to the biggest bazoombahs. Rope suspension and trussed thwacking were still available around every corner. The 'rules' were posted for Safe

Words: "Green" was to keep going, "Yellow" means you might be getting close to the stopping point and "RED!" was for WHOA! NELLIE!

There amongst the batting cages and climbing walls of the Sports Center, the shrieks and cries of bound babes being tortured gave a whole new meaning to the term, 'playground'.

Chapter 7

Christmas 2003;

The US Government sent 5 squadrons of men to 5 U.S. cities, Las Vegas being one of them. Each squadron had radioactivity monitors disguised as golf bags. They're worried about nuclear bombs being planted here, and yet they have a freak out if you show a nipple?

Tank Girls.

'House of Gord' returned again, to the delight of the crowds, with numerous female powered machines. Most superior was a camouflaged tank flanked by Desert Storm style guerrillas carrying rifles with bayonets, spearheaded by copper-colored rubber dildos. Sporting a ball-gagged female centerpiece, the tank pulled a strapped up "trailer hitch" chick. Powered by pedaling female feet, this feisty bit of bondage transport faded away into the sea of human encased latex on the next aisle.

Friday brought out more attendees than all three days from last year's event combined. Everyone was very excited we'd returned. We were led to believe we were about to have a Great Show!

Doh!

On Saturday we set up a demo to drum up business. A couple of friends had come in from California to visit. Lee agreed to let us do her head, neck, and upper torso casting with her hands clutching her boobs. Ultimately, I added horns and nipples to the finished piece. With the great snarl she did, it was an awesome piece of art! It sold immediately.

Lee and Bevan were veteran Rennies. We knew them both from the California Ren Faire. Bevan had become an entertainer of renown with his "Troll" character - (Hairy Guy with Big Teeth). He was also a "Henna Tattoo" mogul, owning numerous booths at faires around the country.

Associated with the B&D, S&M scene (Bondage and Discipline/Sado-Masochism), Bevan decided to take this opportunity to promote videos for Doms. (Abbreviation for Dominatrix; noun; a dominating woman, often one who takes the sadistic role, especially in sadomasochistic activities.)

By Sunday he was already filming.

Sunday for us was a total bust.

Derek hung out with our neighbor "B".

On a dare from a friend a few years back, B created a whip in his machine shop. These items hit the big time. He sold well from his simple display case here. At the side of the case was a metal hinged prosthetic leg in a high heeled shoe. He'd made this in hopes that Dita Von Teese would return to this year's event and purchase it for her boyfriend, Marilyn Manson. Rumor has it that Manson has quite the collection of prosthetic

limbs. Just below the wooden fit that would go over the stump, there was a small door. If you pushed a button on the base, the door opened and a petite amputee dom-doll with a whip slid out onto a platform … and then slid back in. (Manson did purchase this piece at a later date from B.) Collaborating on ideas, Derek and B came up with a cuckoo-bird butt-plug.

I wandered around with my camera shooting some close-ups and visiting some of the booths I'd avoided the year before. Lulling, Texas, (famous for the 'Watermelon Thump Festival') had a representative here that was thumping regions more resonant than watermelons. Displayed on the table before her, were various sizes of silver rods. Thinner than your pinkie to thicker than your thumb, eight in each set. Okay. I'll bite. "What are these used for?" I inquired, (with one foot prepped to flee.) These were "Urethral Sounds". Google it. If it doesn't make your skin crawl right out from under you, then you might want to order some! Medically designed to clear obstructions from the male urethra, these metal rods are also used for pleasure. Yuppers! According to the lovely lady behind the counter, you choose one the proper size, nothing too large, as you don't want to stretch the opening past the ripping point (YIKES!) - and you insert it to the very tippy tip. At eight inches long, this is a daunting concept to my way of thinking. Then the Lulling lass tells me that to heighten the effects, you can attach these little electrodes right here …

I'd managed to get over nipple clamps and ball gags the previous year, but this one skeeved me right out.

Back at the condo that night we all decided the answer to the question, "What is a Urethral Sound?" "EEEEEEEEE!!!!!!!"

Having helped us set up, Dave and Laine already 'knew the ropes'. Show over, we were packed and outta there in less than an hour after close.

Wanting to catch the new titillating "Treasure Island" show, the four of us drove out to the strip. Constant entertainment is offered free on the Vegas strip. At night they astound with light shows. Designed to lure you in to gamble at their establishments, each one is uniquely amazing. Last year, outside Treasure Island Casino it was pirates battling it out with the British. Ships, cannons, explosions, all set in an outdoor lagoon with a moat that surrounds the casino. The new, less 'family friendly' venue this year was Sirens and Pirates. The sirens were scantily clad buxom babes led by Cinnamon, otherwise known as 'Sin'. Sin ties up and tortures 'Eros', a pirate who falls for the call of the sirens. Chaos, cannons, whips, and flames ensue as the leather garbed pirates battle to regain their bound mate from the lusty wenches. They lose.

We feel like we've just seen another segment at BondCon. Or maybe a stage act at a Ren Faire?

"We don't need no
stinking badges"
(Treasure of the Sierra Madre)

Oh yes, we do!

At the Hoover Dam, the guard demanded proof that we'd been exhibitors at a 'crafts show'. We presented our BondCon badges. He told us that if we'd still been in "Orange Code Alert" they'd have emptied out the back of our truck.

That's right in there between the 'yellow' and 'red' safe words, right?

Later in this same year, we went further into the realm of darkness …

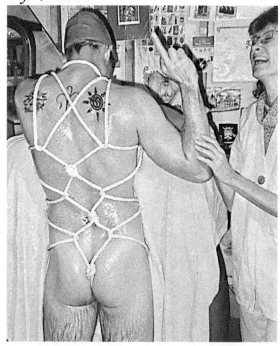

(Now entering the 'danger zone'. You may want to consider not reading any further. If the previous chapter on B&D disturbed you, move thee forward to Part 10.)

Chapter 8

The Black Rose, Maryland

A number of years back a UN Munitions inspector in Iraq was outed on the front page of the Washington Post as one of the primary founders of a major pansexual club. That club was the "Black Rose". He didn't lose his job and Hans Blick (chairman of the International Atomic Energy Agency) publicly endorsed him.

Crisp fall weather. Naked trees and crunchy leaves. We've never stayed north this late into the fall season. Residing on the faire site was free and close to our daily Washington DC destination. The only folks remaining on the Ren Faire grounds at this late date were the site manager and a rennie family planning the first leg on their journey as missionaries for Christ, - and us. We were about to embark on our next phase of fetish offerings.

Wednesday night we set up for Black Rose. This is our first Bondage and Discipline/Sado-Masochism Convention. The S&M adds a whole different flavor to the B&D.

Everyone was really nice and helpful. While working the kinks out of our booth display (how to fit a 10-foot booth into an 8-foot space), we watched as tables began to emerge with the requisite leather and latex clothing, bondage accouterments, whips, and butt plugs.

Over morning coffee, Derek and I had perused the vendor packet. Amazing information! An impressive 92 classes over three days. You

could be educated in such areas as; "Temporary Body Modification-Saline Infusion", or "I Didn't Know You Could do that with Wax." And then there's "The Joy of Duct Tape" and "Sharp Pointy Things". But my personal fave was "Extreme Medical Play; Stapling and Suturing". Our paperwork packet came complete with treats. We received "Silk Lube", "Churn Style Boy Butter", a note pad and … a flashlight.

Friday afternoon, our first customers were a delightful lesbian couple whom we'd met previously at the Maryland Ren Fest. The 'Mam' was requiring her 'Sub', (a lovely statuesque redhead named Phoenix,) to be cast in my "Roman Slave" Style, with her hands tied behind her back. It was essential this casting be done today, as at 11 pm tonight in the dungeon, Mam would be doing a picture 'cutting' on Phoenix's back.

Class description: "Fun with Fear and Pain"

"What do you do when you get bored with spanking and bondage? The synopsis began, "Here is a chance to recharge your creative batteries

by exploring the darker side of S&M. Explore what makes something frightening. Learn how to safely scare the crap out of someone. How to push boundaries and have fun at the same time. Included topics: interrogation, self-administered pain, creating 'difficult' situations. We will attempt to create some of those situations so you can learn and enjoy some new ideas in play"

At one point, I wandered into a class on peeing, where a naked slave was instructed to piss on her hand and wipe it all over her body …

Chapter 9

The Dungeon Rules: "No Fucking, No Sucking, No Cameras"

Descending into the bowels of the earth, one arrives at a landing where your 'vanilla' clothes are left on a coat rack. From there a random gamut of latex/leather/harnessed to various stages of nudity sally forth into the darkened environs.

The cavernous convention hall had been transformed into separate themed areas, creatively using black plastic to cordon off the play spaces. Spotty lighting helps with the ominous feel of impending doom. To your left is the Medical Area, set up for cutting and body modifications. Straight ahead is the school room stage set of the "'Littles". The Wax Room is to the right. The remaining hall space is mostly devoted to the hanging racks and flogging crosses so popular for restraining one's prey.

Throughout, 'doms' roamed with their black bags, stuffed with the necessary implements to create the perfect 'scene'. Subs followed meekly at their heels, awaiting whatever punishment the night had to offer, palms sweaty in anticipation.

"No cameras" is equivalent to total freedom. Anyone can be here and play to their fantasy - within the restrictions of the other two limitations. Entering the immense play space, we hooked up with our friend Larry who knew dungeons well. Strolling through the initial stages of people being hoisted, manacled, and gagged, we struck up a conversation with one of the security personnel. In front of us, a stately looking man with a comb-over

was hitched to the X style wooden St. Anthony's Cross. He was getting whacked by two babes in cowboy hats and leather corsets. Discussing body castings, the conversation came around to "picture cutting" on flesh. Security called over another guard who lifted her shirt to expose a whimsical Arthur Rackham style elf. The carving filled her entire back! This is done by shallow (up to 1/4 inch) scalpel cuts into the surface of the skin. The woman described the incredible endorphin rush that still lingered from this relatively recent work.

"- In a nutshell - err, nut clamp -"

Other views of interest included the use of zip ties and various penis clamps. These included zipper clips that would be ripped off testicles that had just been so fastidiously adorned; (pull, scream, reclamp and repeat, ad infinitum).

There were Violet Wands. (I own two turn-of-the-century plug in medical versions that I am fascinated with, but refuse to allow near my flesh.) These modern ones look like something out of a Lord of the Rings fantasy segment. Bejeweled and glowing a rich violet hue, these wicked looking electrified daggers make a vibrating humming noise. Reminiscent of that elementary school lesson on electricity, the person being shocked is in control of the circuit, with their body as part of the series.

In another room, there were copious MOUNDS of naked flesh getting dripped with hot wax. While Derek and I stared wide-eyed, Larry idly clipped his nails and drolly commented on "the torture of manatees".

Having left prior to the 11 p.m. "cutting," we did not see the design carved into the lovely red-haired Phoenix by her dom lover until the next day. She came into the vendor hall in a stunning iridescent green-blue evening gown that was cut low to expose her back - now decorated with a stupendous dragon whose wings flapped when Phoenix flexed her shoulder blades! Mam was beaming with pride.

Saturday's only casting was of the vendor coordinator and her husband in a hand-on-breast design.

Chapter 10

From the History of the Black Rose, by Chris M.:

"Real estate was a problem from the start. Our stay at a Unitarian Church ended abruptly when a church member showed up for what happened to be a presentation on fisting.

When we had told them we were a support group into dominance and submission, they just assumed we were a 12-Step Program. Oops."

The second night in the dungeon:

Derek ran into an old high school chum from Houston as soon as we got there. The fellow told us he comes to these events to 'leer'. I suppose we were pretty much doing that as well. Larry had told me yesterday that I looked like I had a spring-loaded neck ...

So much to see!

Phoenix and Mam came bouncing up to show off Phoenix's flapper outfit. She sported a sequined headband with a feathered frontispiece and a dress of sassy fringe to just below the crotch. Mam revealed that this was sewn on. The fringe was several layers of trim. Closer inspection proved this to be even more complex. It was a hook and eye affair. Hooks in the fringe trim with eye loops that were sutured onto her flesh.

Chapter 11

"I've traveled the world and the seven seas,
everybody's looking for something,
some of them want to abuse you,
some of them want to be abused ..."

— Sweet Dreams, Annie Lennox

The "Littles." You were probably thinking these were midgets or dwarfs. Nope. These are dudes and broads who have 'little people' inside of them. In this nursery setting, there was a man dressed in white and pale blue latex baby clothes with a diaper on, shuffling about in fuzzy slippers. Women skipped or sulked in polka dots or tacky flower prints, toting teddies or dolls. Bottles

and bibs. There were messes that needed cleaning up. There was also a guy on all fours in a leather pig mask with a curly tail stuck in his butt hole that he was wagging. Great muscle control.

I finally got to see the 'bad girl' Derek had been telling me about. In a schoolgirl frock with white ankle socks and black strap patent leather shoes, she had knelt with her nose pressed against the wall for 2 days/nights. While being collar-led to a new wall by a tiaraed dom, it was soon revealed that this little girl was actually a mustachioed male with a 5 o'clock shadow.

A skinny man wearing fairy wings was slugging away on the fat ass of an incredibly huge female that was chained to a St. Anthony's Cross.

A lovely dark-haired masked girl had been hung naked to a post and lintel system, arms splayed. She was being tortured by an average looking fellow wielding two tasers. Laughing and screaming, she twitched in an effort to "escape" undeniable electric shock.

On a similar rack, two men were bound facing each other, their penises tied with rope and attached to one another. Blindfolded and whipped, if they jerked away, it would - well - you get the picture... like a Chinese finger-cuff/push-me-pull-you.

Flesh billowing densely, a thick bosomed woman was being caned until bruised.

Screaming, crying and giggling filled the air.

On one of the swinging rack tables, a man encased in black latex, complete with zipper mask, had naught but his nose and penis exposed. The latter was being coaxed by a female dominatrix to receive a 'urethral sound'. I'd been curious about this, (once I'd gotten over the initial horror), ever since

discovering them at last year's BondCon in Vegas. Derek was now pointing this scene out to me, then he sort of gurgled and fled. I watched in rapt awe as the muscle in the penile shaft released and the metal rod dropped! The dominatrix pulled it out - and proceeded to do it all over again.

I decided my only remaining desire (?) was to see 'fisting'.

Careful what you ask for.

Mounded on a padded table, an extremely overweight woman, (who only half an hour earlier was having her ass slugged), was now being drilled with a vibrator in one hole as she was being fisted in the other. This is where one inserts an entire fist into a southerly oriented orifice, sometimes with great vigor. Telling you just in case you didn't already know.

Due to sensory overload, we decided to exit the dark annals of the Ramada Inn Convention Hall and go find more 'vanilla' things to do ...

Chapter 12

"I'd rather be depraved than deprived" – J.L. Brooks

Sunday brought three castings. One of the many times Derek was retrieving fresh casting water, someone stopped him, wanting to know if "carrying around pans of water was his thing" ...

My favorite casting of the show was on the Sabbath. A butt-casting of a woman with her husband's hand holding a leather strap-paddle to it. It was their first paddle from years earlier in their relationship and they wanted to immortalize it in a casting. Older folks, they told us they were traveling on a diplomatic passport. Government employees.

Phoenix and Mam stopped by again before the vendor area closed for the weekend. I asked Phoenix what she did for a living. With a PhD. in physics, she said she worked for NASA.

> *"Bondage for the body is much better*
> *than bondage of the mind" – Sigmund Freud*

I've never been into pain or restraint. In another life, I might've made a great dominatrix, but then I have to ask myself, how much of this would've actually been for the fashion? Latex costumes are So Cool!

The cast pieces I made during this time were beautiful. Interpretation of the absurd and the sublime is often where I excel.

Although I found the 'scene' pretty disturbing, the people were all a delight to visit with when encountered in a daytime venue. The fact that they have an outlet for their 'unusual' sexual proclivities is amazing. Especially at this level. Added into the mix is that the endorphin high for masochists is the same feeling experienced and sought after by any hardcore athlete. It's a good thing that they can get what they want and need, in a safe environment.

Dn'A

Sometimes vanilla is not enough. Sometimes you want mint chocolate chip … or Rocky Road.

As it turns out fetishists are cheap. Plus, they don't want the world knowing their private kinks. Toys and ropes can be safely secured in a lockbox under their bed, away from the prying eyes of their children. A body casting laced up in flesh-bulging rope designs over the fireplace is generally not something you're going to see when you bring muffins to a neighborhood social. Despite the fact that my casting style captured B&D in a most delicious way, it was simply not an art form that most folks would/could have in their homes.

We turned away from bondage-casting as a possible road to fame and fortune, taking with us sufficient tales to share with friends and gentle readers alike.

PART 10

Life in the Country

Although I still shed tears for my mother, who passed away in 1983, I do not think of myself as one who eternally mourns death.

I just miss being able to share with her the things she inspired in me.

Such as this property that Derek and I live on.

Nestled on the edge of the Texas Hill Country, this 27 acres has everything she always wanted. Bluffs a hundred feet tall, two of them, split by springs that join together in a 20 foot fern covered water drop into a box canyon. The water goes underground here, ultimately feeding into our babbling creek that winds through the property. Two swimming holes provide us with respite during the months of intense Texas heat. The sound of the flowing water is our 'white noise', the Milky Way, our 'television'.

Bluebonnets and cactus flowers aren't the classic antique flora I grew up with. Peonies, jack-in-the-pulpits and hollyhocks don't grow well in this soil. Nonetheless, Mom would've loved it here. Fairy life abounds. You can feel it. As our little valley fills in with humans, the sprites retreat, but mostly the folks that have moved here encourage their existence.

The monarch butterflies come through in fall, thickly filling our box canyon with orange and black whisperings. The locals named this canyon area "Ghost Hollow", called such due to all the wildlife that comes for the springs and seeps. The waterfall here lures the hummingbirds that fly in to quench their thirst and to bathe, flinging it over their backs with a flick of their wings. A sight to see!

When the rains fall and the waters rise, Ghost Hollow fills with a rushing roar. Our little creek becomes a raging torrent, 90 feet across, or more.

The Spanish oaks turn rich hues in the fall. Colors to rival a Connecticut countryside in October. In spring these trees produce a gold and peridot tassel reminiscent of a jeweled Japanese tiara.

No New York blizzards, but just enough ice and snow most years to get a taste of winterland delight. The seeps off the bluffs can produce giant 30 foot icicles where springs ooze out, creating a crystalline hush that echos down the creek and through the valley.

Armadillos, black rock squirrels, and ringtail cats abound. Monogamous Mexican vultures lay their eggs in dirt nests in the hollow. The babies look like fuzzy white duckies - with black plague masks on. Exotic spotted Axis deer that have escaped the dude ranches now propagate this area of the Hill

Country. Their strange call sounds like a large bird with a sore throat. The Great Blue Heron comes here yearly to live on our creek along with the kingfishers and ducks.

Yes. Mom would've loved it here.

When Dad passed two years after Mom in the late 1980s, the three of us kids each inherited some cash. I got $60,000. Derek and I began looking at land. The economic downturn of the Savings and Loan failures from this era made it possible for us to get a fabulous deal on this property.

Derek had turned me on to a book called, "Finding and Buying Your Land in the Country" by Les Scher. It was instrumental in learning how to play the real estate game.

My sweetie's mom, Diane, who was living in Houston, Texas, had been dabbling in real estate. She had found a place she thought looked good about two hours from San Antonio. Further from a main city than we wanted to go, we nevertheless decided to take the trek and employ some of the new tricks we had learned from the book.

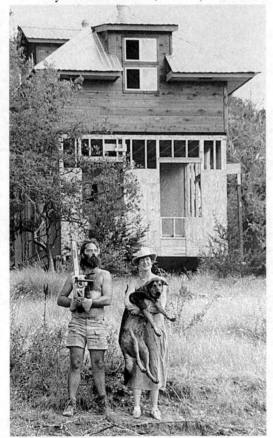

American Gothic, Dn'A & Cactus Brown

The property was amazing! We returned to look at it several times over the next seven months. In the interims, we discovered that we both had been having "flying dreams" off the 100 foot bluff and down into the meadow.

During these months, we worked the land developer/Realtor right down to where we wanted him. We popped the final surprise by offering cash. He got that 'lizard lidded' eye

thing and told us he'd make more money from financing us. We knew cash was king and that he'd go down in price yet again. He met the goal we had in mind and we all agreed. It was half of the original asking price!

While he went off to draw up the papers, I went out to the trunk of the car and got two handmade wine goblets and a bottle of Dom Perignon that I'd kept hidden for just this occasion.

The look on Derek's face was only eclipsed by the Realtor when he brought in our contract. Seeing two exquisite handmade bronze dragon wrapped blown-glass goblets being filled with pricey champagne by two dusty hippies must've tweaked his little mind! We'd played the game well, and had won.

As I signed over the money for this commitment to a life together, Derek said, "With this check I do thee wed." Derek was in it for half, and he made regular payments to me until it was finalized.

Once the house was well underway (a project that continues to this day), Derek would go off with his chainsaw to whatever area he deemed worthy for a tank of gas that day. He would create berms for erosion, built stairways to the bluffs and cleared pathways and sites for potential campers.

Every year, for over 15 years, we would have weekend long parties that took over the land. Anywhere from 30 to 75 festive campers would converge. There was always a 'Quest', a treasure hunt that involved two groups sent off with maps. Manned stations about the property would offer up more clues as the revelers traversed from creekland to rocky bluff. The group that won got gifts

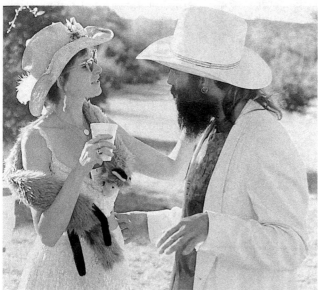

Rattlesnake Croquet at the Dn'A Ranch, 1989

(Clockwise from Top Left)
Deann, Ann, Diane - Mom & Gail (1990); Tracy & Lauren (1996); Lauren, Steve, Laura & Ann (1996); Kids with Piñata candy, Ozaray, Zeke, Emily, Sam & Little Lilly (1995)

galore!

There was a sweat lodge, swimming in the creek and potluck feasting. Piñatas, croquet, volleyball, and musical chairs, were always part of the fun-time weekend. A live band offered wild dance music and the annual roaring bonfire gave the pounding feet a vivid backdrop.

Neighbors that might choose to visit their cabins here (we were the only full-time residents at this point) were always warned in advance. The quiet they sought in their country retreat would be visually and audibly interrupted for 3 full days ... or longer.

Mom would be proud. I do so wish she could've met my dear Derek and seen this property where we now reside. She had a passion for nature

and art and a vivid imagination that she imparted to me.

If my current adult lifestyle scared her, it was only because she herself had come so close to that edge, only to be scolded away by the era she grew up in. Female Artists and Actors were considered Sluts and Whores. Loose women who gave themselves for their craft. And, although it would appear I was the proof in the pudding, it was no longer the orthodox 1930s, but the upshot of the wild and free years of the '60s through the '80s. Rock and Roll got the pelvis moving in the 1950s with Hugh Hefner pushing it along the way. Then Larry Flint took over. "Free Love" became random lewd sex. Although drugs did not replace alcohol, they offered an increasingly available alternative to heightening your escapism. Armed with the pseudo-spiritualism from the '60s (and "the pill"), we charged into the '70s, spawning an ultra-conservative reaction - and AIDS.

I was one of the lucky ones. I came away with only a greater understanding of color - and herpes.

Ann's 50th Birthday Party, with a gaggle of girls, *(Top from Left)* Lynne, Ginny, Bebin, Tracy, Brenda, Tamara, Ann, Sandy, Tamie & Janine *(Bottom from Left)* Ginger, Mary, Dian, Susan, Debi & Kat

PART 11

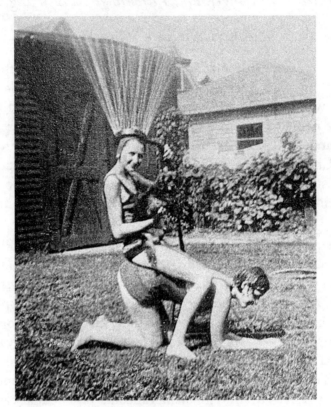

Adventures in the Universal Sandbox.

Chapter 1

"...I dreamed that my soul rose unexpectedly
and looking back down at me,
smiled reassuringly, and I dreamed I was flying..."

– "American Tune" Paul Simon

On my mother's side, my family dates back to the Elder Brewster who gathered the protestant rebels in an alleyway in Leiden, Holland, to catch the Mayflower over to the New Land. I stumbled on this tiny alleyway on the last night of our visit there with Derek's sis and her hubby who were teaching "At Abroad' college classes in Leiden. What a treat! A small plaque in English caught my eye and alerted me to this astounding bit of personal history. As the years have gone by, I appear to now be the last of the remaining Curtis/Ward relatives who cares anything about the family history.

A passion for photos has followed me throughout my life. Photographic albums grace my walls. I keep them in order with fastidious attention to dates and places. I was lucky enough to get all the family foto albums, some dating back to the mid-1800's. Daguerreotypes and tintypes. Silver spoons which a young teacher in the 1870s had made from the five silver coins garnered from her wages, are a part of this. There's even a complete family tree that my sister Dayna made from years of research. There were also Civil War letters, but Dayna's creep of a husband covertly sold them out from under his own son after my sister's death. Abraham Lincoln's presidential campaign pin was another treasure my sis had left in her will for her son which his father decided would be better spent on a Puerto Rican honeymoon with his new wife. Thankfully, the vintage photos and some of the other treasures from the family had come into my possession prior to her demise.

My sister had joined the DAR (Daughter's of the American Revolution) just as my father's mother had. I remember my grandmother would always stand and put her hand over her heart any time the National Anthem played on the radio or the TV.

Dad was born to this patriotic woman in 1914. He started college in

1933. My father met my mother at the Rochester Institute of Technology (RIT) two years later.

My mother's name was Hazel Ellen Ward. At least that was her Christian name. At age 7, she informed her family and friends that she would no longer respond to Hazel, a name she disliked. From now on she would only answer to Ellen. My mother's mother was known to be a harsh taskmistress, so I imagine this rebellion didn't go over too well. Grandmother Ward was a strict English teacher. Her two daughters were punished for using slang words like, "Okay" and "Stuff".

My mother grew up on a farm in Bath, N.Y., with her older sister Catherine. Ellen had a pet chicken that would follow her everywhere. It would sit on her lap. It knew commands. They were tight.

When the family went away on a brief vacation one summer, the neighbors were asked to caretake the Ward farm. Upon her return,

Ellen immediately went looking for her beloved chicken. This is when her mother informed her that her pet had been given to the neighbor's stew pot in thanks for their kindly assistance.

She still got a tear in her eye, even lo, these many years later in the telling.

My father, Daniel Fredrick Curtis, grew up in the neighboring town of Cortland with his sister Marion. In college, he focused on becoming an electrical engineer, a musician, and a photographer. Due to his love of the

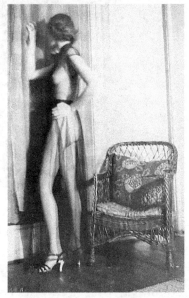

Dad's photo of Mom

142

silver emulsion process, there is vast photo documentation of my parents in their early years.

Co-ed dormitories during this period were non-existent. Dorms had curfews and resident elders that would monitor all the comings and goings.

My dad's roommate was involved in music and photography as well. The two became fast friends.

The boys got good

Dad with a little man in his hand

at trick photography. They also discovered a burgeoning curiosity for the occult. Curiosity led to research and experimentation. Soon they began to play with astral projection.

Astral Projection is an out of body experience that has been reported in cultures all over the world. Another way of describing it is 'lucid dreaming'.

From the time I was a child, I remember 'flying'. Vivid dream states of soaring over the treetops in the neighborhood where I grew up. I used to be able to induce it with some planning and concentration. It's been a while. Maybe I need to try again …

Both my siblings confirm my parents telling this same story. My folks were emphatic that this happened:

Ellen was aware of Dan and his roommate's forays into the astral world. To what degree, I'm unsure. That is, until the night that my father decided to attempt an astral projected image of himself from his dorm into my mother's room on the same campus.

Waiting until an evening when Ellen's roommate was due to be gone for an extended period, plans were made and a time was set. However, the roommate didn't leave as planned. No telephones in dorms at this time. You were lucky if there was one in the hall. Ellen had no way to reach Dan to warn him she wasn't alone.

When my future father's disembodied hand appeared and reached around a door jam, Mom's roommate let out a

Dad on trombone Dad & Mom at R.I.T.

blood-curdling scream! Dad zapped back into his body. After that night, he and his roommate decided this was a dangerous game to play, and thus moved on to other endeavors.

Eventually, my father's love of photography dwindled. By the time I came into the world, the basement darkroom had become an electronics workshop.

Chapter 2

Discovering my muse

As a young girl, I was encouraged musically. Besides being an electrician at his day job, my father was a Big Band musician, playing sax and trombone every weekend. He also arranged music on the piano. My older sister was a vocal prodigy. So, I tried voice lessons. I also attempted to discover possible hidden talents on the cello, piano, clarinet, guitar, and then piano again. I would leave my lessons and go draw. I presumed this artistic bent stemmed from my older brother's similar abilities, and my desire to emulate him.

At 16, while trolling through attic treasures, I discovered a fanciful

watercolor illustration. It looked to be right out of one of my vintage children's books. Turns out that my mother had painted it when she was my age. It was a fantasy rendition created freehand of her first boyfriend named Jack that she had lost her virginity to (scandal!)

Superior to anything I had done thus far, I now became inspired.

Due to my father's dominant influence, I'd been musically pushed. Now, I was able to let that go. I'd discovered my muse.

Mom told me she always wanted to be an artist or, more preferably still, an actress. Thwarted by her parents who threatened to disown her for such tawdry desires, she went to college, found a man, and got married instead. According to her parents, actresses were loose women. Female artists no better. The man she married controlled her every move. She was not allowed to hold a job and her friends were vetted through my father. Mom bought craft kits and made pretty wall art for the home. She got to have children, although my dad didn't really want any. He was jealous of the time they took away from him.

I was her offering to the world. I was going to be the actress, the artist. I was going to be what Ellen would have become, but never could be.

Age sixteen was a big year for me. I'd discovered a desire to push myself harder in the arts. Life Drawing classes happened and I made leaps and bounds in my illustration skills.

When I found my mom's artwork in the attic, I also found her vintage eyeglasses. John Lennon frames were popular then. These were just a nose piece and temples, with the lenses screwed in. I loved them! Mom had my 'script put into these eyeglass frames. It gave me an edge of 'cool'.

I lost my virginity. I began smoking dope and drinking on the sly. I tried cigarettes, but they were gross. Getting involved in extracurricular activities

at school widened my horizons. An avid penchant for photography gave a different view of the world around me. The year was 1971. I made my life a constant flow of activity. I could not learn and have experiences fast enough.

My girlfriends were steadfast. I had Lynne and Lori as my mainstays. Debbie and Donna, Mary, and Sue. We were all boy crazy. All starting our sexual experimentations and discovering the depths and pain of love, jealously and the meaning of friendship.

I remember sleep-overs in junior high before we knew much about kissing boys. We would pair up and kiss each other to 'practice', so that we would be good at it by the time we got our first real Boy Kiss. Some girls just pressed lips - hard. Others played with tongues, thrusting quick jabs into the mouth, saying this was the way the French did it. Small gropings were experimented with, to see what it would feel like. So much giggling!

Chapter 3

Blood

At 14, I got my first ever menstrual period while Lori and I were playing "Prince and the Princess". My parents had gone out to a restaurant, leaving us to our own devices. T.V. dinners finished, Lori and I dove into a treasure trunk of costumes. This cache produced any number of fabulous choices in attire for whatever characters we wanted to create. Our role-playing led to gales of laughter. This led to leaking a little, as we were laughing so hard. The Prince (me), presented himself to the Princess (Lori) with a flourish, whereupon I slipped in a pool of pee and splatted on the floor! This forever after would now be referred to as the "Prince of Whoop-Boom!"

We went to the bathroom to clean me up. That's when we noticed blood between my legs.

Oh Shit! (we would never have said that aloud in front of the folks, as it would get your mouth washed out with a bar of soap)

Lori hadn't gotten her menstrual cycle yet, and although we knew the basic tenants of the contraption that needed to be applied, we found ourselves hilariously confused. Searching the medicine cabinet, we located the skinny tangled elastic "Sanitary Napkin Belt" and the thick pads with

Lori & Ann playing dress up

the long gauze tails at either end. Tampons were considered to be improper at this tender age as they emulated sex. Whatever.

The medieval torture device we now had to engineer caused more peels of laughter. A thin elastic loop strapped around the waist with a latch in back. Two more strands of elastic hung front and back with vicious little metal teeth at their ends. It was through these teeth that the gauze flaps at either end of the pad were to be inserted and secured. Riiiight ... The insertion into the teeth failed, the pad flipped, a bloody mess ensued. More hilarity! Finally, we felt like we'd figured it out. I put on pants and tried to walk. The giant wedgie turned into a crumpled wad.

By the time my folks returned from their night out, the upstairs bathroom was littered with pad debris that had shredded in the "Teeth of Despair". There were also discarded costumes and random spots of red blood on the black and white tile floor.

Mom showed us the proper way to cinch and secure, a process that took days to learn. It was NEVER comfortable.

Blood Sister's Vow

Lynne and I became Blood Sisters. We sat in the crook of a big tree with a sewing needle and a promise. Poking our thumbs 'til the blood ran, we twisted our fingers into each other, knowing that this coursing would pass through into a forever future. And it has, despite the fact that she has always followed her own path. I was often jealous and wanted to spend more time with her. She showed me how to live freely without needing to always have

Lynne posing for my
photography class project

other people to depend upon. How to hold my head up and ignore assholes. How to love unconditionally. Part of the rules of our blood bond was to never stay with a man who hit us.

Her mom thought I was a bad influence, (oh! If she had only known it was the other way around!) - so Lynne and I didn't see each other as much as I wanted. I often had to go to her house so we could be under Lois's watchful eye. They loved all things nature at Lynne's house. Skulls, cocoons, and vacated wasp's nests decorated the windowsills and shelves. She called one day, breathless, saying, "If you wanna see what came out of that weird cocoon, you better come fast, mom's killing 'em!" I got there to find zillions of the tiniest, most perfectly formed baby praying mantis crawling everywhere, with Lois hot on their trail. Lynne was scooping up all she could find and releasing them outside. These half-inch green imps were elusive and running fast!

We often played badminton in the back yard, with bats flying in to capture bugs for their dinner. We'd play well past dark, until Lois called us in.

There was a creek off the back of their property, and when we could escape the all-seeing eye, we'd go there and hang out for hours. Playing in the water, finding unusual bugs and plants, talking about boys, and what would become of us when we got out of high school.

The yard at my house was a quarter-acre of cleared and mowed play space with flower gardens running down both sides. My mother's pride and joy. At the very back of the lot was another quarter acre of wooded area that was mostly 'fort'. Old tables and chairs, stumps, and dishes, all of which became a palace, a dungeon, or Snow White's dwarves' cottage. This area led out through the back of the next-door neighbor's unused portion of

their property, and thus became a continuation of my play space. Opening through there onto one of the two connected dead-end streets that made up our neighborhood, we had random visitations from other neighborhood kids. Some unwanted.

Numerous adventures played out here.

One time my older brother and sister took one of mom's empty candy boxes and filled it with rolled dog turds covered in powdered sugar. They encouraged me to offer some to one of the neighborhood bullies. The boy had wandered into our backyard, as he often did, trying to taunt and tease me. I showed him the box of 'candy', and he gladly grabbed several pieces, scarfing them down. It was that last swallow that made him burble and spit wads of poo. I ran!

His parents came and lodged a complaint to my folks. Mom and Dad agreed this was an unsanitary way of dealing with an issue of relentless bullying, but now perhaps this older boy would stop harassing their daughter.

He didn't come in from the edge of the road any longer, but his comments could be heard from the ditch by the edge of the trees.

Another problem was the new neighbors that flanked the very back of our property. Their place was the first home off of the perpendicular road after the undeveloped acreage belonging to the folks next door. Mom and Dad decided that a good fence made better neighbors. Now the wooded easement to the road through the adjacent lot was closed off. Despite less play area, I had greater freedom from fear of the local ruffians - that is until the backyard neighbors turned out to be assholes.

Our dogs were a border collie mix as well as a chihuahua that had been bought to heal my sister's asthma (for real!) They would run to the end of the lot and bark at the fence. The neighbor's kids, instead of becoming friends with these dogs, would agitate them by shouting and throwing things at them. One winter, an ice ball with a rock inside was thrown at the larger dog by the husband of the family. It landed our pup at the veterinarian's clinic. This almost erupted into a legal battle.

Their kids became juvenile delinquents. The younger one stole a car that crashed, causing monetary dilemmas for the parents. The older one was always a trouble-maker. Lynne and I both hated him. After I left home, mom sent a newspaper clipping about how the boy had died in a jail incident, in which dope stashed in a plastic bag up his anus had broken open. Nasty

demise. Mom reminded me not to bother with hate. Karma is real.

Lynne liked dating the 'bad boys'. I chose odd fellows. Or maybe they chose me and I was just happy to have someone to date.

I remember her and a boyfriend going to church so they could take money from the collection plate for a movie that night, (although she denies this ever happened.)

She was the first to do acid (LSD). It took me years before I made that leap. Lynne dyed her hair black, so she'd look more Puerto Rican. She smoked cigarettes outside the back of the school. She snuck out of the house at night.

I was always too timid to do any of the wild things she did. And her mom thought I was a bad influence! I'm now thinking Lynne planned it that way, so she had a scapegoat!

After I left home at 18 with a man 25 years my senior (bad influence now firmly in place), Lynne went on to college, got married, and had a kid. One night while I was back home visiting, she and I went out partying. A couple of guys were flirting with us and buying us drinks. It was like old times. The pre-dawn hour of 4 a.m. found us weaving up her driveway, laughing. Her husband glared out the door at us, slammed and locked it. I guess the hour was deemed unsuitable for his wife, now that they were married.

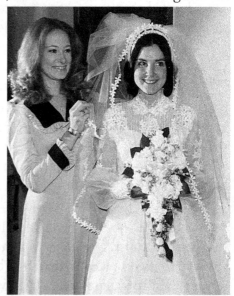

A fight ensued. He let us in and the shouting got louder. He punched her. I saw red. I took off my heeled shoe and went after him with the spike. I was aiming for his eyeball. Lynne grabbed me and we left. We went and spent the night with my sister and her family. Lynne left her husband.

Bond of the Blood Sisters.

Her house got sold. I had just finished painting the baby's bedroom walls with Disney characters.

Ann, Maid-of-Honor at Lynne's Wedding

Chapter 4

Eggshells

Booze was legal when I turned 18. Vietnam vets had been coming home from killing, being maimed, doing drugs and other things we don't wanna think about. They had grown up before they could even reach age 19. These young men came back home and were told they couldn't drink. So the laws got changed. I could and did drink as soon as I became of age. Six Black Russians a night were easy. I often drank so much that I would black out, but still function. Friends would tell me stories of my antics later.

Pot was rare and other drugs weren't considered. (At least not until after age twenty-two.)

A few years fast-forward, and I was living in Texas. I became friends with a couple of students at San Antonio College that were instrumental in changing how I viewed art. Kat became my roommate and Jose', my boyfriend. I was modeling for their painting class when we three became buds.

We started private drawing sessions with other art students in the large empty dining room of the house Kat and I lived in. Having trouble understanding the use of color, my roomie encouraged me to try getting stoned and drawing.

- The eggshell cracked open -

One night at a gallery opening of José's art (before we got together as a couple) I was admiring his work and asked if he could instruct me in the use of color. His two word reply was, "Do Acid." So I did.

- The eggshell shattered and yolk went everywhere -

Photo by Ian McKinney

Barely posing

Anne Curtis, sophomore, poses nude for Jose Campos, a sophomore art major, in an art class Campos is taking. Curtis said she has posed nude for such assignments for eight years. She poses nude with three other students here. The four earn $6 per hour.

My first 'trip' was down on the Gulf Coast of Texas. Kat and I made the journey with a group of friends. One gave me guidelines regarding how to avoid having a bad trip. If you see something that looks disturbing, change your point of view. As the LSD came on, the first thing I saw was a BIG black spider on the wall. Expressing concern, I was told that it was a thumbtack.

I got the drift. Later that day, while listening to a story a friend was telling, my eyes and my mind went wandering, taking in all the vivid changes happening around me. I found myself looking at her bare thigh below her shorts, and it began to bubble and pop. I remembered the guidelines and looked away. Despite the alternate reality, I'd been given a tool I could use to 'adjust'. It was up to me.

I had an amazing time!

Kat, Jasper & Ann

Down in the dunes, Kat and I began playing with the sand. Pouring sparkling "gemstones" in every color of the rainbow through our fingers, we laughed and rolled in the glittering jewels for what felt like hours. As a soft evening began to set, the dunes were outlined in running lights of shimmery neon. Someone had plugged in the stars along the horizon's edge. Our friends came and found us and we all headed giggling back to the house in town for a feast that was awaiting us.

Kat and I had many trips together. So did José and I. Each was a fabulous journey into and out of the mind.

These two friends were such astounding and

inspirational artists. José, however, began to make his artwork too 'precious'. These pieces then became more valuable and each one 'unique in all the world'. He stopped producing. Instead, he was now pondering his worth.

Kat insisted we must MAKE ART! Get it out there! Stop doing only school projects and start our personal CREATION PROCESS. Keep an art journal, draw on the bus, in class, in the john. She encouraged me to give art away. Get it into people's homes so that I would be known and recognized. So I did. I still do. It was an incredibly valuable lesson, for which I will thank her eternally.

Kat also taught me to masturbate. Not, like, literally, but yeah. She was amazed at how I could have sex and not get attached. When she had sex with someone, she fell in love. I merely had to decide if it was worth going back for a second round. Kat always said I was 'just like a guy' when it came to how I treated my partners … and why didn't I just masturbate anyway? I told her I never had - at least not as successfully as what having sex with a partner could be.

One day she sent me out to pick up a book for her. Anais Nin's "Delta of Venus". She knew I would read it. This darling friend changed my life again!

- And the egg yolk now dripped down my inner thigh -

José became more and more controlling. One night, he came out to where I was standing in the yard, enjoying the sunset, and informed me that I shouldn't be out there without him and that I needed to get inside and make his dinner. A little bell went off.

A few nights later when he tried to strangle me, in an unexpected rage, I left him.

My Blood Sister's Vow held strong!

Another vow from the day of the Blood Bond was that Lynne and I would always meet for at least our high school reunions, no matter where we were in the world. And we have.

The first reunion was in five years. Old girlfriends and ex-boyfriends were there as well as old enemies. When she saw me visiting with the girls who'd ditched me at age 12, Lynne became furious. She didn't know how I

could even speak to them. Many of these women disappeared as the years went by. Who knows if they moved to other cities, or perhaps they just no longer desired to have anything to do with a reunion of folks for which they had no use. Some of the other 'cool' kids from high school remained. Year after year, they were always (still) too perfect to want to have anything to do with the likes of us. In August of 2003, Derek came with us to a 'formal' reunion. We dressed up. Us girls in gorgeous form-fitting gowns, Derek in his Versace purple linen coat, with one of my Bettie Page nudes painted on his necktie. When the requisite photo team asked us if we wanted to pose for an R.L. Thomas Reunion booklet, we said, "Sure!" All three of us posed together, girls on Derek's lap. Boy Howdy! Did heads turn!!

Lynne's always loved being able to rub their noses in the fact that she's still, after all these years, a total babe! Me? This dweeb wanted them to imagine the biggest bestest scandal ever.

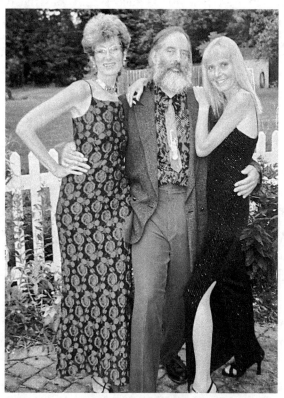

Ann, Derek & Lynne, 2003 High School Reunion

PART 12

Gail

"Though I know I'll never lose affection
For people and things that went before
I know I'll often stop and think about them
In my life, I'll love you more."

- Lennon & McCartney

While working at River Square Galleries in San Antonio, I developed a friendship with another couple whose jewelry shop was next door to my art gallery. Over time, Gail left her husband Kevin for another man who offered her the exciting life of being a drug dealer's assistant. We remained friends, but her secretarial stance in her new lover's life made her coarse and hard to be around. Gail moved to California with Clark. She and I wrote many letters during this time, which I still have to this day. It was through Clark that I got hooked up with the California magazine that wanted to do the photo spread of topless nudes in front of famous Texas landmarks (as per the cover of this book). The 'zine died before that concept could come to fruition. I did get some fun fotos tho!

Gail came back to SA when she and Clark split up.

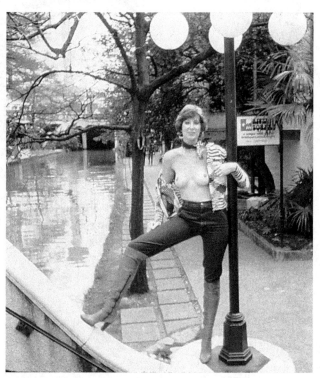

On the Riverwalk, San Antonio, 1980

(Clark died a number of years back after a gun he had cocked and stuck in the waistband of his pants blew off one of his balls during a routine drug money collection. A dog jumped on him, firing the weapon. He subsequently

died from a heart attack.)

While Gail was still off with Clark, I went on a cruise with her ex-husband. Kevin was a large man. The effects of sunbathing on the deck for too long in the Caribbean sun blistered mass quantities of him. Thankfully, that put an end to sex for the remainder of the trip. Like Clark, he also died of a heart attack a while back, but as far as I know, he still had both balls when it happened.

It was through Gail that I met Tom, my first love relationship since Dan Fuller. Tom and I lived together for 2 years. It was while I was with him that we both began college courses in Corpus Christi. He was daunted by my scholastic leaps and bounds. HE was the Mensa brain - how did I rate a 4.0 average? As his pre-med college courses pulled him down (classes far harder than mine,) Tom sought frivolity with another woman, thus ending my first serious foray into monogamy. We separated and I took up with an ex clown from the Ringling Brothers Barnum and Bailey Circus who was living in a derelict ice box outside a favorite crab shack under the bridge over the inter-coastal canal. This fellow and I ended up moving to Illinois together where he reintegrated instantly with his fabulous family there. I loved his relatives and sex with this guy was unparalleled, but he wanted to reign me in and have me become a mother and leave art behind.

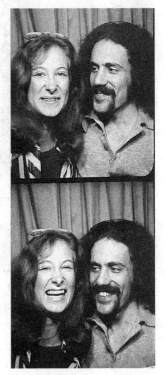

Art is my life.

I returned to SA and my whore-dog ways.

Ann & Tom, 1978

Gail and I shared lovers. Randy Wilson was one of them. She ended up living with him for a couple of years. During the end of this relationship, she met another lover of mine and fell in lust. Then she fell in love.

I wanted to get away from John. He seemed a little spooky for my tastes, however John wouldn't let me go. I convinced him to go play with Gail. He would, and then he'd persuade me back into his bed again.

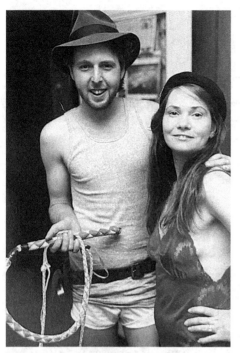
Randy & Gail, '83

John was a glider pilot. Gliders were one of my earliest passions.

My 16th birthday request to my parents was to go up in a one of these free-flight non-engine aircrafts. They agreed. It was amazing! I was hooked.

John also did stunt flying. I loved going up with him! It was the first of many lures he would entice me with.

He got a great gig in Colorado as a glider pilot and temporarily relocated there. Gail moved into his apartment in SA to take care of it while he was gone. She'd do anything for him. I was pleased he was out of my immediate focus. Sexually, he was intense and I felt driven by his energy when I was around him, but he was dark. We'd have arguments all the time. His metal abuses were demeaning.

John invited Gail and I to visit him in Colorado. It was a magical time. The three of us became lovers and it was perfect. We took a cabin on the Poudre River where we had a hot tub outside to lounge in while snowflakes fell around us. We made love together in the back of John's van in a snow forest. We flew over the Rockies in a B-52 he had access to. Two glorious weeks. Gail and I returned to Texas.

Then John came home.

Once returning to SA after our trip to Colorado, Gail and I had kept up our end of the relationship and I had decided I didn't really want John involved. But Gail was in love with him, and when he was around, I succumbed. So we continued our 3-way. He and I wrote beautiful letters and poetry to each other during the times when we couldn't stand to be around one another.

I wanted Gail, Gail wanted him, he wanted me, I couldn't resist. Vicious cycle.

I was oddly tethered to him. I'd leave him, only to return to his dark brooding eyes - and his bed.

Gail began telling me stories about his nights out with ladies of the evening when he couldn't have me.

Other dark tales emerged. Vile stories of his blacker side that I only saw glimpses of during our fights.

He never hit me - but his mental abuse bordered on physical. My Blood Bond with Lynne regarding leaving any man that would inflict injury surfaced in my mind repeatedly.

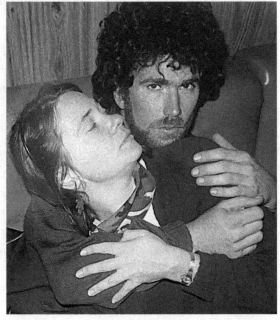

It was during the time I was with him that I chose to get my tubes tied. I realized that my tastes in men weren't conducive to EVER having babies, along with the fact that as an artist, kids in my life would never be a fit.

- Art IS my life -

Tom was now a medical student in San Antonio, Tx. and had become a dear friend. He brought me flowers as I was coming out of anesthesia from the tubal ligation. John

Gail & John, '84

showed up and became very jealous. As soon as I was functional he brought me back to his house where I had erroneously presumed he'd take care of me while I was recuperating. He demanded I make him a sandwich. What?!? I'd just had surgery. I needed to go lay down. Realizing this could easily go from bad to worse, I sent him out for lunchmeat … and escaped to my friend Kat's house across town. I drove there, despite having been warned not to operate heavy equipment for the next 24 hours. John called all over SA trying to find me and landed on Kat's with a vengeance. She kept insisting I wasn't there. I remained with her for a week with John calling multiple times each day, until I finally felt strong enough to deal with this questionable lover again.

I was living at 105 Madison while this love affair rollercoastered. Holly and Sandy begged me to quit him. They had both pulled me from the abyss so many times over the past two years during this tumultuous relationship.

Finally I left him. Gail was there for him, but he was torn up over losing me. Gail was distraught at not being able to get his full love and attention.

At random moments, I would call just to hear his voice, and then hang up. I'd heard of women that had done this and always thought them weak and absurd. Now I was one of them.

I would find flowers on my windshield after coming out of a grocery store.

Other girlfriends at hearing we had split, went to his bed. In time, I forgave them.

Over the years, John would come to me in dreams. These were aggressively sexual in nature. Vivid. I would wake agitated.

When I got with Derek, these random forays into my dreamstate were still happening. It made me feel unclean, unfaithful.

My friend Lauren was a practicing Shaman and she offered to 'go in' to ask his astral self to refrain from these nocturnal assaults. I gave her the required info of his particulars - and then didn't hear from her for 2 weeks.

She told me she hadn't set up anywhere near the necessary protections. Not realizing the intensity of this dire entity, he slammed her. She had horrible headaches for 10 days.

Meanwhile, the dark dreams left me.

Years later at a party a friend was having in SA, I ran into John. He was back visiting from his current residence in California. My heart went to my throat and I decided to address this. I approached him and we visited, even laughed. Simple closure. I walked away.

Gail succumbed many times over the years to his mental manipulations. Ultimately she knew he was nothing more than a narcissist that was trying to wheedle something from her for his own gain. Only recently did she tell him never to call her again.

She and I can laugh about this now. We love each other and have a

huge respect for everything life offers, no matter what it's twists and turns. Gail and I both appreciate a good story. Being a part of one together makes us very happy.

Ann & Gail, 1993

PART 13

The Side Show:
wherein you don't make money,
but you work hard for the fun.

Chapter 1

Being a Kerrvert- "Welcome Home"

1996-2007, Derek and I worked as volunteers managing the Wine Booth at the Kerrville Folk Festival. Started by a megalomaniac with a vision, this 18-day event has given singers and songwriters a place to showcase, play music and gain notoriety since 1972. The main stage performers have ranged from Peter, Paul, and Mary to David Crosby, Lyle Lovett, and Willie Nelson.

Those who choose to camp often don't even leave the campground area to enter the main theatre. They have been known to spend the entire event playing music night after night, wandering from campsite to campfire. Memorial Day weekend through the 2nd weekend of June, all week there are music jams and parties, every weekend there's Big music and Bigger parties.

1982 was my first time to ever go there, on the back of a girlfriend's Honda 200 rice burner, an hour plus ride from San Antonio. Talk about a vibrating sore butt! Enamored from first sight, I returned two years later with my own craft booth, selling odds and ends of art and doing face painting.

The crappy shed-style craft booths created a half-circle around the perimeter of the main theater. Not much money to be made, but the fee balanced out camping cost and the full run of entertainment, so it was worth it.

As an artist there in 1984, I met folks who would become a part of my Ren-World just a few years down the line. Donna Murray and Ken Carns were selling "Satyr Horns" that you would tie onto your head. In with my other craft items, I had crystal pendants set in "Dragon's Claws" that I'd made from the same oven-baked plastic clay that their horns were. They told me I should really start making the horns. That was where the money was. If only I'd listened, I could be one of the rich moguls that took over that business!

Donna went off to make "Cute Poop" with ribbons and lace and potpourri. She was also the original innovator of the "Monday Morning Bizarre Bazaar" at Scarborough Faire right around this same year. This fantastic phenomenon immediately spread to Ren Faires across the country.

Ken Carns became one of the more unique characters to ever grace the faire circuit with his bent wire "Fobs" (roach clips) and a walk through "Museum of Unnatural History", with vivid creatures created from that same plastic clay. Set in bell jars with viscous liquids, these fantasy images from your more dire dreams were displayed in a darkened maze with spooky music.

The next time I saw Ken after the Folk Festival was at a Renaissance Faire. He was sitting inside the belly of a giant green and yellow dragon he'd constructed, selling his fobs.

"There ya are …!" He drawled. The shirt he wore was all holes. It showcased his nipple rings. I'd never

Ken Carns in the belly of the dragon

seen one of these before. As I touched my breast at the nipple, feeling ghost pain, I asked why he would do that. "To watch women grab their titties and ask me that question", he said, grinning.

In 1997, Derek and I were part of the volunteer crew that built the new wine booth. One woman was audibly wielding her art degree as a means of showing she was the best possible person to make the signs and decor, informing me that because I wasn't a college art graduate, I was nowhere near as capable. Sure! This just meant I didn't have to work as hard. The next year, however, she was gone and I had to tear all the dilapidating gee-gaws apart and make new signs and decor - that would last. The previous year's booth was basically a lean-to. The new one was a better shack with a nice lift-gate counter-door, too heavy and cumbersome to raise, so we'd hop over it. When he went to build, Derek was given used boards with nails. He was supposed to pull the nails out and straighten them. Uh — no. As Derek had his own supply of nails that came pre-straightened, he chose to use them.

This row of food and drink booths was a hippie consortium that lined

Ann, Derek, Coffee Dude, Pat, Janine, Mary Beth & Chuck at the Wine Booth

the back wall of the main theatre. Our neighboring booths included fresh fruit smoothies, stir-fry dishes, and popcorn with garlic salt and nutritional yeast. There was also home made chai tea, beer, and the perpetually entertaining Coffee Dudes next door. Most were private operators that paid a fee to be there. The Wine Booth was owned by the Folk Festival, so we made no money working it. We'd slip into the festival's walk-in wine cooler behind our booth for some AC and a toke, and a swig on whatever bottle we'd decided to open that night. The wine was generally awful. The festival would buy whatever quantity deal was the cheapest. When asked what the wine would best pair with, Derek was known to say, "A little olive oil and some fresh greens".

The Wine Booth and the people that worked there had a blast. Occasionally, we might get a light reprimand for the 'fun' we'd have, but as we did all our work and kept the booth looking more festive than any of the others (note: I'm patting myself on the back here) they let us slide.

WINE BOOTH QUESTIONNAIRE
(written by Dn'A, - of course)

**To help us better understand you Kerrverts,
please utilize this questionnaire to offer
serious insight into your character and motivations.**

WHAT I'M LOOKING FOR
IN MY KERRVILLE FOLK FESTIVAL WINE

**1. My idea of 'fruity overtones' comes in 5 flavors
from the Boone Family Farms**

() Yes!Yes! () I think so... () Huh? () Are you Nuts?! () Them's fightin' words!

2. My wines don't breathe, I keep them on life support.

() Yes!Yes! () I think so... () Huh? () Are you Nuts?! () Them's fightin' words!

3. This ish better than Nashcar!

() Yes!Yes! () I think so... () Huh? () Are you Nuts?! () Them's fightin' words!

4. I clear my palette with Listerine.

() Yes!Yes! () I think so... () Huh? () Are you Nuts?! () Them's fightin' words!

5. I prefer my legs on Blondes!

() Yes!Yes! () I think so... () Huh? () Are you Nuts?! () Them's fightin' words!

Peter Yarrow (of Peter, Paul and Mary fame) was on the Kerrville Folk Festival board and would visit the wine booth frequently. I got to where I'd give him his requisite free glass of wine for a kiss.

Many lasting friendships were made there, but most notable was my confidant, Janine. She and her husband Chuck co-managed the booth with us. I'd become friends with this blonde bombshell when she was dating another fellow I was acquainted with. Known for her rapid-fire non-stop exchange, this woman is witty and wise. Janine is a real life corporate state agency employee, unlike most of the rennie/artist types I know. We have the Kerrville Folk Festival to thank for stoking the fires of our improbable lifelong friendship.

Most volunteers tried to camp on the grounds for the duration of the

festival. The music in the campground was often better than what was being performed on the main stage, and camping was fun. There were food camps, and entertainment camps, the tee-pee camps, and the drunk camps, and, most of all, music camps.

As mentioned previously, parties abounded.

The one that stands out for me was Erik's Surprise 40th Birthday Party. His bride to be, Tamie, had planned a circus-themed event, replete with costumes. Tamie was a spirited friend I'd met back at the Michigan Ren Fest. Erik was her high school beau.

Derek dressed as the 'Duct Tape Master', wearing red rope in a fancy bondage style down his torso, (we'd just done BondCon) and a pair of chaps over flame undies. He

Freak Show Queen

created a fabulous black duct tape costume for Tamie. Really skimpy. I was the 'FreakShow Queen', carrying 3 mysterious boxes and a creepy creature who laughed manically when you pulled his hair. The cardboard boxes were created Gom Jabbar style; one would reach blindly in through the top, past fluffed out black plastic to feel the contents of each mystery container. As I brought the individual boxes around, I would say, "This is the Clown's Head, now he's dead."; "These are the Clown's eyes, they draw flies"; and "This is the Clown's Brain, he was insane". The boxes held respectively; a peeled and carved cantaloupe, two cored strawberries, and cooked ramen noodles.

A downpour happened (as it did every Kerrville Folk Festival, at least once, and always with great vigor.) About 30 of us piled into a large a zip-down tent. Perfect for a great surprise! Erik came wandering in, unsuspecting, and we all whooped and yelled. I thought the poor boy was gonna plotz!

The rains passed, the tent was opened, the festivities began! Tamie had planned it all well, with wonderful events and good food.

Later, when the drinking began in earnest, Derek and I slipped away.

However, there was one small unattended detail - we had forgotten to tell Tamie how to get out of her duct-tape costume. Apparently bathroom relief was rather difficult.

On the way home to Harper, still in Circus attire, we encountered a zebra, (yes! really!) running down the road in front of us! The whole thing smacked of surrealism. We slowed and allowed the creature to create its own pace, and also to watch the beauty of a truly rare spectacle.

We live far out in the country, with many "Dude Ranches" around us. These are places that raise exotic animals for rich Big City hunters to come with their bazookas and blast away for a hefty fee. Valuable beasts like the one now trotting down the road in front of us are normally kept behind tall fences. If you manage to find one in your yard, it's yours to do with what you will. It's always open season on exotic game hunting.

Derek suggested we prod it toward our place. We were almost there, when it veered toward a ranch on the right, attempted to jump the low fence, didn't make it, and fell sideways over it instead. As it got up and stumbled off, we marveled at nature and our own good luck at not having to figure out what to do with a zebra.

"Kerrverts" were those who became so fond of the Folk Festival that they would return year after year. Kerrville-converts or Kerrville-perverts, your choice. These folks loved this event, despite the unsanitary conditions, tornadoes, all night music jams outside your thin tent walls, and sleep deprivation for any number of reasons.

"Welcome Home" was part of the hug-fest that would happen anytime you arrived. It was also their greeting sign when you entered after paying. I repainted that sign for them several times over the years.

The crowds at the festival could go from respectable proper sit down folk to wild and unruly. Robert Earl Keen tended to draw the latter. Frat boy and bikers filled the theater one night when Robert Earl was playing, backing the crowds all the way up to the Wine Booth. There was more than one scuffle. At one point, security came by, requesting to be alerted right away if anybody happened to turn in an ear. Some girl found it down at the stir-fry booth, just as her food came up. Take that as you will …

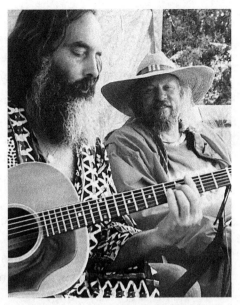

Derek & camp mate Rick Wright

"Winerita" machines. The festival rented one in the early years. It broke down. All. The. Time. It was dispensed with by the end of that season. Left behind were approximately 45 cases of the crap with which one makes wine-a-ritas. Derek, to mitigate space, made a 'wall' of these boxes inside the walk-in cooler. When the yearly "Volunteer Party" would happen, he would give them away. Meanwhile, the cases served as insulation in the off season. We heard that the gifted case that last year, had gone really, really bad.

Ann, Janine & Derek at the KFF Wine Booth

The late shift job included closing the Wine Booth down around midnight. Whoever was there had to tally up, pay up, put all leftover booze into the cooler as well as any cups/glasses so they wouldn't get stolen. We'd

wipe down the counters to stave off fire ants and make sure no food was left anywhere so the 'coons wouldn't get in and wreak havoc. If it was Derek and I, we'd get home by 1:30 a.m., if we were lucky. It could be a drudge. We weren't called the "Whine" Booth for nuthin'.

In '07 they tried Wine-a-Ritas again. Derek had just gotten rid of the last case of the aforementioned dreck, and now there was more! The Folk Festival had actually bought this new machine, so the 'rita gig was more precious than ever. The wretched sticky liquid was frosty and cold and contained booze, so it was an instant hit. It also made more income than bottled wine.

Derek and I had been alerted to a 'new' event on Memorial Day weekend; Burning Flipside. One of many "Burning Man" regional events, springing up around the country, this one was due west of Austin. A 'gifting' society of radical self-reliance and temporal art, this event sounded too good to be true. It was 4 days long.

That next year, Derek and I bowed out of the Kerrville Folk Festival for that Memorial Day weekend, giving up our manager status.

When we got to Flipside, everyone said "Welcome Home". It was a tad disconcerting …

Returning to volunteer at the Folk Fest that following weekend, still high as kites, we raved about the real vision, performance art, camaraderie, and the true hippie shift towards the new millennium we had just experienced. Looking around us, we saw a dingy dusty event clinging to a concept that once lifted original music up and out front. Now they all seemed to be singing the same hackneyed chord progressions and cliche'-soaked lyrics. As the crowd gathered in the main theatre for the final song of the evening, standing with locked arms and swaying to the soggy old standard, Derek and I closed down the booth and gathered our things for the drive home. That's when one of the festival board members (also a volunteer) told us we had to stay and learn how to dismantle and clean the sticky 'rita machine, or else we might not get to come back the next year.

What're ya gonna do? Fire us?

And homeward we went.

Chapter 2

Burning FlipSide: The Sacred and Propane

We made a seamless transition into this alternate universe.

Was there still inclement weather and sleep deprivation? You bet! Music that could keep you up all night long? Absolutely! Did we care? Hell No!

Understanding the basic tenants for this Art and Music Event, we went in with good intentions and came away with even better ones.

Participation is a key precept for this community. Selfless giving of one's own unique talents is encouraged, as it is a 'gift economy' in practice.

Simple Rules. No Spectating. Creativity examples included experimental and interactive sculptures, buildings, performances, offerings and art cars. Heavy on the propane/fire. All volunteer.

No concession stands. No cash transactions. Except for Ice. $2 a bag. Ice goes quickly in this heat and we all needed ice for food coolers and beverages. I loved volunteering at Ice. It was a wonderful way to stay cool for a few hours every day.

We ultimately learned to work the special entrance Wednesday night Zone Greeter Parking shift. This got us in a day earlier than most and we were able to set up our 'Offering' tent without the Thursday kerfuffle of a zillion people loading in.

The first year was our trial run. We went in with the thought that doing free LifeCasting molds would be a good idea. This was our 'gift' offering to the community. As we entered the 4th hour of non-stop casting in the blistering heat, Derek put a halt to the line and told them to come back the

next day.

The music was all canned and it came from every quadrant. Loud techno-bop. All different levels of beat. Discordant at first, by the end of the event, our bodies were no longer jerking to this twisted cadence, but slid in and out to the constant erratic pulse.

Getting back to our country home, the quiet was oddly disturbing.

I had borrowed a 'Fuck' dress to wear as one of my costumes. Strappy and skin tight, this long black jersey had "FUCK" written all over it in various sizes/styles of white lettering. For the "Miss Flipside" talent show, Derek had carved a carrot into a penis. As the music played, I strutted back and forth across the stage during my intro, showing off the "dress of foreshadowing suggestion". My hat had two small yellow fabric ducks with velcro sealed hidee-holes inside each. This made the perfect space for carrying a joint and lighter when there were no pockets. I don't think my electric co-op had this in mind when they gave away these fuzzy animals with secret velcro sealed stash containers the previous Xmas.

This then is when I became the "Divine Miss Ducky", a tag that stayed with me throughout the 10 years we attended this amazing venue.

Derek came up on stage, proffering the orange penis, showing it around to the audience. I dropped the top half of the dress to my waist, turned to expose my naked back, - and popped out my shoulder blades. I'd honed this particular talent in grade school after my friend Donna impressed me with her ability for creating these flipped out shoulder 'wings'. Discovering that I was likewise double-jointed, I began to play around with all my various appendages and limbs. I'm quite sure some day this will all result in arthritis.

At any rate, Derek walked over and placed the carved orange dick flush against my back. I pushed my shoulder blades out further, then folded them over the carrot stick phallus, locking it firmly in place, with the head of the 'penis' poking out the top of my scapula.

MILF and Cookies
Wonderlounge (start point) – Ellen
(Burdizzo)

At popular request, the hot mamas of MILF and Cookies will be once again returning to Pyropolis. this year to the good, hardworking moms' of Pyropolis. Interested moms or moms-to-be, please join us! Bring a plate of cookies and an apron, we'll stroll around topless and put the MILF back in Milk and Cookies. Meet up at 2:30pm Friday May 25 at the Wonderlounge, we'll wander until we're out of milk or cookies or both.

☆ The Burn

The Effigy – D.A.F.T.

The focal point of Flipside, the Effigy, the Conductor will go up in Flames on Sunday Night.
In the event of inclement weather, the LLC has reserved the right to burn the Effigy on Saturday Night instead of Sunday Night, but only as a last resort. Hopefully this will not occur. Still, keep an open mind and open ears. The time of the burn is highly dependent on weather conditions as well, so listen for details on Saturday and Sunday.

The crowd went wild! I won a handmade beaded tiara.

Derek won me. XXOO.

More free events than could possibly be attended happened every day. There were flapjack breakfasts and four-course dinners; hula hoop making classes and a Rootbeer Camp with ice cream-made from real MILF's milk! (MILF: Mothers I'd Like to Fuck)

The Lick and Suck Saloon had a pie eating competition and a naked ass chaps contest (Fuzzy Fanny Derek won!) Bars and dance parties, bondage classes, and yoga, tie-dye, bingo, massage, and pastie making. Next door to us was "Camp Smack That Ass". Five Spank-Masters were in attendance here. Their religious attention to recruiting converts was truly inspirational. Plus you got a totally cool hand-printed wooden paddle with every spanking! I've never been one to like pain - but I really wanted one of those paddles! I bent over the rack and made Devlyn Angel promise to go light. She said 3 whacks was the minimum for the prize. The first smack was light, the second a little harder, the third - I popped off the table!!! She had smacked her own hand with the paddle making a LOUD noise right next to my ear!! They all rolled around in peals of laughter ... but I got my paddle!

Culminating each Flipside was the burning of the Effigy. Built on the main "Playa", a wooden

The Texas Two-Step Effigy created fire tornadoes when it was burned

sculpture was started the week before, it's design epitomizing the theme of each Burn. The Playa is where the more elaborate structures go. The ones with the most lights and whizz-boom. The Effigy is the epicenter. This is an interactive structure that can be crawled all over, played on, drawn on, and decorated. This particular year it was a giant copper mother goddess of suspended parts topping a massive wooden base that housed steps leading waaay up to a slide that whooshed you back down to the cogs and wheels that turned the various bits of toy-like parts surrounding the structure.

On Sunday when it got torched at midnight, there was a fabulous parade show of poi dancers juggling and spinning flame, both naked and costumed, some on stilts. "The Men In Hats" came next with wildly colored fireworks shooting out their chapeaus. A HUGE light-show of pyrotechnics then commenced - fireworks to blow your mind! Especially if your mind is already enhanced and primed to be blown! Blasting overhead, the vivid illuminations crescendoed into the explosive BURN of the Effigy!

Burning Man Flipside 2008 saw the addition of two friends who wanted to introduce a TeaHouse to our camp. Made from scratch chai and "Go Juice" (matté).

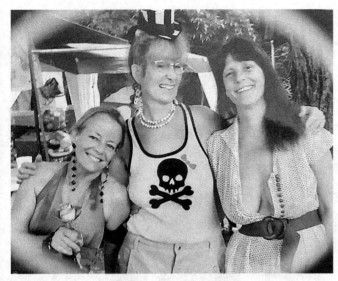

Cinder, Ann & Marilyn

A delicious attraction, this changed the face of our camp.

Heat was often overwhelming. The camp creek was a perfect place to hang out any time of day. One had to be alert for leeches.

My festive frock this year won "Most Smashing" at the Glam Fashion Show. Again with the yellow duckies in yet another bit of hair wear. My costume colors were orange and yellow, with green furry bits around the cut-out nipple/breast area of the violet dress. I used some temporary tattoos from a "Lord of the Rings" promo which fit perfectly around my areola. These declared, in elvish; "One Ring to Rule Them All". I'd obtained a slew of these from a publicity

tent one year at the Maryland Ren Faire. I probably still have enough to last the rest of my life. (I'm betting they didn't intend their tats to enhance titties, but then again, we are talking about Hollywood …)

The 'Smack That Ass' contingent brought over food treats every day as thank yous for the tea they consumed. We liked their camp best for the aural input. Giggling, screaming, thwacking, and howling came wafting through the air at all hours.

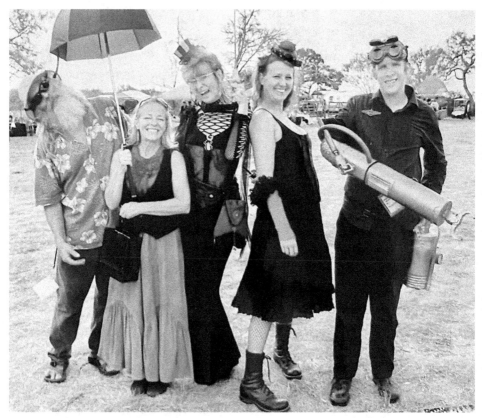
Derek, Cinder, Ann, Devlyn & a friendly stranger

Due to last year's THUMPA-THUMPA canned rave music, the local neighbors' complaints squelched the level of noise. This led to a wider variety of live music expression everywhere.

The most favorite sound experience was the 'electrical resonant transformer circuit'! Two 6-foot Tesla coils shot lightning bolts up into and around a 10-foot metal grid. The sound intensity of the high frequency sparking was part of the music, from a low-base hum to a high pitched squeal. Truly, music of the spheres!

There was glow-in-the-dark croquet, A Monkey Pope Confessional and a "Sing and Strip" Scary-okie. A black-light saloon tent with balloons beckoned you to wade through it. You could hobble on over to the "Geriatric Ravers" camp: "I've fallen and I can't find my glow-stick", or go get hooch and dance at the "Illuminaughty". Also available was the optimistically titled "Sacred Sex Temple".

Bars were everywhere. The best was constructed from 4 sheets of plywood creating a very small structure serving airline-sized bottles of booze. It's proprietors named their bar the "Tiny Anus" - "where there's always room for one more to come on in - okay, two!"

My beloved friends, Sandy and Paul, our intrepid travel buddies down through the years, decided to join this retinue of reprobates and came to revel with us over the following years. Sandy always brought the addition of sugary ginger scones to the TeaHouse. Yum!

We ultimately quit doing lifecasting and focused on a better lounge

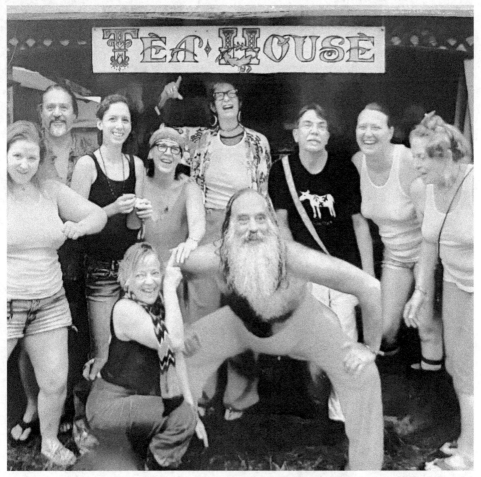

Back row: Kristin, Maka, Cara, Glenna, Ann, Paul, Devlyn & Sandy
with Cinder & Derek, front and center

scene. Couches and comfy chairs on nice rugs under an old craft tent ... with fly swatters- "reincarnating the Buddha - one fly at a time"

Another addition was "Sushi Body Shots" with Cinder and the Sushi-Master, Maka. Camp was growing quickly.

Cinder had become a friend when her sister Tamie (remember her from Erik's Circus party?) brought her to visit our property one day and we all went for a long walk. At the top of the second bluff, Cinder overlooked the valley below and said she'd never seen anything so beautiful in all her life. I've loved her ever since.

Sushi-Master Maka & Cinder

When a couple of spare tickets to Flipside became available, I called her. She had recently said that someday she might like to go.

Having been nearly agoraphobic over the last year after the motorcycle death of her son, Cinder was beginning to entertain thoughts of venturing out. She enthusiastically said,"Yes!" to the tickets and we hung up. A moment

later she called back and asked if I thought she'd be 'safe' there. Well now, people are in various states of undress all about, but there's never been an issue with aggressive nature. Even when there's booze or drugs, one of the Rules is "No Means No". Respect is a huge part of this event. When men came up to speak with me, they didn't address my boobs. So - yeah, I figured she'd be safe.

And with that cautious beginning, Cinder and her husband Maka brought "Body Sushi" to the Camp. Body Sushi became food performance art at its finest. For approximately 2 hours each evening, freshly made vegetarian sushi would be

Me with Scott, my brother from another mother

placed on cleaned 'human plates'. These were walk-up volunteers that were mostly or all naked. Lying on a flattened inversion table, the human dining surface would offer up sushi that was placed strategically on their flesh. Hungry attendees would then avail themselves of a choice treat. No hands allowed.

"The Aloeverium" was another a camp option started by Derek. Sliming burnt flesh, slathering aloe on those in need.

The "TeaHouse" was now open 24/7. Once you knew how to help yourself and clean up after, you could enjoy iced tea and a place to sit, rest, visit, play music, and tell stories any time, even if we weren't in attendance.

We'd become enamored of the "Glam" camp that sponsored the Fashion Show.

Their gifting focus was free and fabulous clothing. Flipizens flocked there to augment their costumes. I found the most awesome attire there over the years and developed a lasting relationship with the two owners; Jade and Sparky. Love of life and attention to humorous detail has drawn us into each other's spheres. I became a sub-Glammer and spent long hours dressing people to the best version of themselves - that is, whenever I wasn't on staff at the TeaHouse. Glam Camp was never too far from our TeaHouse Camp now. We made sure of it.

Like all quintessential small

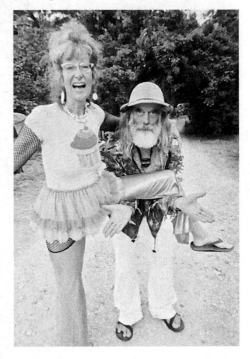

communities, Burning Flipside hosted a local pageant. The Miss Flipside Contest became one of my most memorable achievements. Donning a size 6XL pink cupcake tutu dress from the kid's section at Costco, I added a rhinestone tiara, (with the duckies!) and glow-in-the-dark pearls. Derek reminded me to invoke my inner 4 year old.

Up on stage, in a helium voice, the Divine Miss Ducky sang "I Wanna Marry a Lighthouse Keeper". Whatever I did, I did it right - I WON! Another fab 15 minutes of fame!! My awards included a "Miss Flipside"

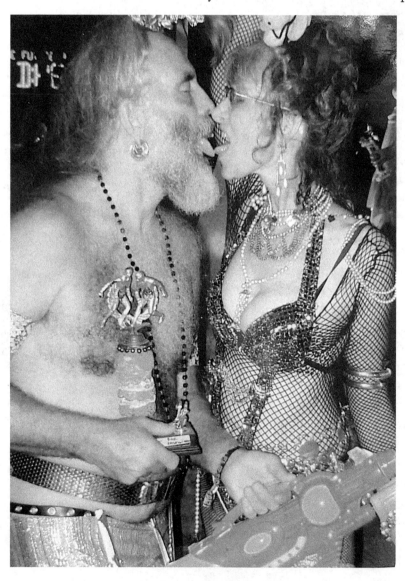

sash and a flight over the site in a Cessna. Soaring over the cornfields the next day, little did I know that among the tiny human ants scurrying about the Playa, Derek was rallying folks to moon me. 15 asses all in a row.

The Burning Glam Fashion Show was always a big favorite. Derek and I would plan months in advance for costumes to fit that year's theme. For the "Freeky Deeky Time Machine", we decided to go as "Babe-A-Rella" and "Cock Rodgers". I'd found an awesome gold sequined skimpy thong and boob cover from the "Lingerie Shoppe" Camp that gave out chocolate and wine while you chose from their free offerings. Tricking this out with other costume pieces, I was ready to go! And of course, there were fuzzy duckies on my head. Derek had a long, orange stretchy spiked kid's toy dangling from under a gold lame' mini skirt. He'd yank on it occasionally. It was a "Trouble with Tribbles" version of a flaccid French tickler. We both had futuristic Space Blasters (water guns). Augmenting the thruster on mine with a rubber penis, I did a pump-action and soaked the audience. This added bit of phallic creativity won us an extra special trophy that year!

'Kay, everyone! In order to bring more folks in to the flock, were gonna change that bread and wine thing to birthday cake and gin. OK, go!

Privies were important. Everyone helped to keep them clean and fluffy. You'd use different ones daily to see how they were decorated.

There was the "Cake with Bacon and Creepy Hug Breakfast" and the Russian Camp had homemade vodka tasting. Cinder got totally toasted there one night.

Nice to see her get so frisky!

There were Sex Camps. These had lots of toys and 'sex furniture'. Some were visible and you could see people using them. They also had classes. Neither Derek nor I ever attended, but we would wander by occasionally, deft voyeurs that we were.

ACCESSORIZE OR DIE
YOU LAZY FUCK.
Pyropolis DEPARTMENT of BAD IDEAS

SEX CAMPS AHEAD
Pyropolis DEPARTMENT of BAD IDEAS

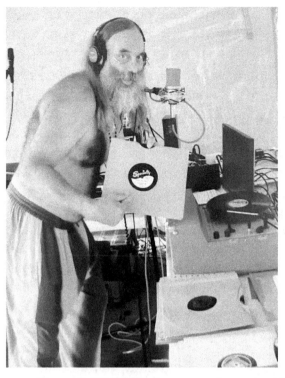

Jade invited me along to give out Fashion Citations. We'd drive around in her golf cart creatively torturing those whose costumes were lacking, and encourage them to come 'shop' at Glam.

KFLIP was a pirate radio station specifically set up for FlipSide. Derek spun 78s for a couple hours most every event. This meant bringing in at least two of our vintage phonographs and lots of the old 78 records we'd collected. It made tent space a premium, especially when you also consider all the costumes we brought.

The year KFLIP was across from the TeaHouse, a spontaneous Flash Crowd happened during a Gloria Gaynor set. The entire roadway suddenly filled with people dancing in sync!

Sure there was drama - sunburn, overdoses, break-ups, snakes, floods,

and leeches, but factions were always there to address and facilitate helping and healing. We worked together toward the good of all.

Jade, the Queen of Burning Glam, told us she had just attended the original Big Burn in Nevada. We figured we'd lost her. Instead, she said that she'd never go back. Yes, the sculptures and pyrotechnics were astounding - but there was no sense of community. It was too big. Flipside was a loving and fun gathering of family.

What Flipside did for my heart will stay with me forever.

Jade & Sparky

Rules for Being Human

1. You will receive a body. You may like it or hate it; but it will be yours for the entire period this time around.

2. You will learn lessons. You are enrolled in a full-time informal school called life. Each day in this school you will have the opportunity to learn lessons. You may like the lessons, or think them irrelevant and stupid.

3. There are no mistakes; only lessons. Growth is a process of trial and error and experimentation. The "failed" experiments are as much a part of the process as the experiments that ultimately "work".

4. A lesson is repeated until learned. A lesson will be presented to you in various forms until you have learned it. When you have learned it, you can then go on to the next lesson.

5. Learning lessons does not end. There is no part of life that does not contain its lessons. If you are alive, there are lessons to be learned.

6. "There" is no better place than "here". When your "there" has become "here", you will simply obtain another "there", that will again look better than "here".

7. Others are merely mirrors of you. You cannot love or hate something about another person, unless it reflects to you something you love or hate about yourself.

8. What you make of your life is upon to you. You have all the tools and resources you need. What you do with them is up to you. The choice is yours.

9. Your answers lie inside you. The answers to life's questions lie inside you. All you need to do is look, listed, and trust.

10. You will forget all this.

Author unknown.

"Learning lessons does not end. There is no part of life that does not contain lessons. If you're alive, there are lessons to be learned."

- from a billboard at a FlipSide bar

After ten years, I had to finally make the executive decision to quit attending Burning Flipside. Heat this time of year and my decreasing ability to function in this challenging environment were getting increasingly difficult. No longer would I be able to engage in the type of frolic required to fully enjoy the event. It was a hard choice. Derek stood by me and we moved on to the next part of our journey.

Sandy, Ann & Cinder at the Effigy

PART 14

the **R**OGUES Renaissance
ALTERNATIVE
we won't repeat **G**AZETTE
rumor, innuendo or gossip,
so get it right the first time!

vol. 1, issue 1

priceless, (but to you 2 dollars!)

HAVE YOU SEEN THIS COW?

The Source of All Conflict;
Thwarted Expectations

"Minitus cantorum
Minitus ballorum
Minitus carbonata descendum pantorum"

Chapter 1

Tell your children over dinner,
"Due to the economy we are going to
have to let one of you go."

Albert Landa left us in 2002. Cancer. He was our next door neighbor at the Maryland Ren Fest. A rarer sense of humor has seldom been born on this planet. Although I can't say that everyone felt that way. His employee's wife, Eve, would tell her husband, Aaron, to 'please leave Albert at the door' upon coming home from a day's work at the Faire. Caustic and carefree, Albert had wit and wisdom, often leaving the latter for others to figure out for themselves.

Albert Landa

Aaron & Eve

Albert was a mediator for the State of Colorado during his weekdays and a weekend Renaissance jeweler for his passion. A prankster and rabble-rouser, he drank to excess and had less than subtle ways of getting revenge. I have photos of him pissing on the neighbor's roof at a Ren Faire. An act he considered a social commentary and one that he made with regularity. When Derek decided to create an 'in-house art and literary news magazine', Albert and Aaron were his muses.

Aaron and his entire family are MENSA - and somehow, despite this, they manage to still all be functioning human beings. Brains combined with a radical shrewdness made Aaron the perfect counterpoint to Derek's political bent and willingness to spend the time it takes to put together a magazine while trying to run a business at the faire.

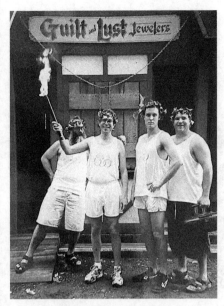

Albert's 2000 Olympic Torch Relay through the MD Ren Fest, Derek, Albert, Aaron & John

The R.A.G., "Renaissance Rogues Alternative Gazette" started in 1999 and lasted for 10 years. It was only published in Maryland at the Ren Faire.

I was one of the regular contributors. Drawing comix and writing stories, I also did interviews, and added photos. The first issue featured a nude of me on the cover. I was sitting on top of the life-size concrete cow that graces the front of the Maryland Department of Agricultural on Truman Parkway, near the faire site. Not an easy feat, as cars kept zooming by.

The 'zine grew over time from 16 to 38 two-sided pages. It was a tabloid filled with stories, humor, games, and advertisements - both real and faked. Rennies left their 'nocturnal submissions' in a mailbox outside the back door of our booth in hopes of being published. Each issue sold for the outrageous price of $2.

On the inside cover, the "Substandard Disclaimer" stated: "If anything printed here is construed to be libelous and/or of slanderous intention, or if we offend and/or misrepresent you and/or the truth … oh well. We'll try harder next time!"

It's important you remember this for a story that'll be coming up here soon.

Ren Faire through the eyes of a news reporter:

"Looking around I see not a Renaissance Faire, but a Science Fiction/ Fantasy Festival. Imagine, if you will, breastplates, chain mail armor, and a kilt on an overweight, out of shape 55-year-old white woman in Nikes with red socks. How about the buff black guy in silver lamé plaid wearing sunglasses, an animal tail and a giant wooden sword slung across his back. Or the anorexic post adolescent in a teeninesy blue and purple leather outfit gyrating, lap-top style, to bag-pipe music. Nipples showing through garb are

(Top Left) Gabriel Quirk as the "Queen of Hearts" *(Right)* Just another playtron and his friend
(Bottom Left) Ren-Dudes: Shane, Frank, Derek & Stephen *(Bottom Right)* Playtrons in garb (wearing one of my bone crowns)

(Top) Ren-Kids: Danielle, Cory & Eve
(Bottom Left) Ann & Patch Adams
mining for gold

(Bottom Right) Gabriel as "Baby"

Playtrons
(Top) Teenage girls as the
"Knights Who Say Ni"
(Bottom Left) Storm Trooper
in a kilt
(Right) Little Darlings

(Right) "Miguel" of Don Juan & Miguel Comedy Troop, aka Doug Kondziolka

(Bottom Left) Playtron styling with one of my bone crowns

(Right) My Fairy Gawd-daughter, Ellawyn

de rigor as are 'wings' cellphones, piercings, and tattoos."

PLAYTRON: A patron that comes (almost) every weekend to the Ren Faire always dressed in garb, sometimes theme appropriate, with a twist.

Chapter 2

Rabbit hole: *"Curses, Foiled Again!"*

This will take you down another path, but ultimately come out right where we left off, sort of ...

On Sept. 10th, 2001, I got filmed in Baltimore for a TV spot due to be aired the next day. Note the date.

The previous year I had made a fabulous connection with CBS through a customer. We lined up a weekday on-site live life-casting of a reporter for the 'This Morning' show! Spending several hours to make it perfect, we set up the booth for ease of filming and dressed in our best costumes. Having done this many times at the Michigan Renaissance Festival and for the Xmas show we did in Austin each December, we were news show pros.

Unbeknownst to us, the festival management had been informed of the TV crew coming in and stopped them at the gate. Somehow, they convinced them that filming jousters (Jousting is the official Maryland state sport) would give better coverage with greater flair.

A parade of newspeople and crew headed our way, then suddenly veered right. I ran up to them, letting them know we were ready. Avoiding eye contact, the spokesperson said the newsman had decided not to have his face cast. I saw the MDRF Entertainment Director coming up the rear and knew what had happened. I had brought a prime time television connection to the festival and not only didn't I get TV coverage, but I never even got any credit for bringing them in. I was later told the switch in subject matter "was best for the Faire" and that "when the tide comes in, all ships rise". I was personally crushed by the festival management's actions and attitude.

Not to be thwarted, we pursued other local television coverage.

One feature segment was taped on September 10, 2001. The next morning, the event that became euphemistically known as 9/11 occurred.

That filmed segment never aired. The world around us changed forever.

The paradigm of the U.S. of A. shifted.

Stock markets tanked all over the world. American flags went up all over the Maryland/Virginia area and beyond, on cars, homes, and businesses. Every overpass had at least 2. (Do I need to mention these flags were mostly made in China?)

On the 'outskirts' of DC, there in Annapolis, we felt a blow-back of extreme measure.

At first, when this happened and we'd be out driving, people would talk to each other from their cars at stoplights, laughing and being overtly friendly ... then the following week found our fellow motorists angry and reckless.

The skies went eerily quiet. Planes were grounded.

On the 13th, a small engine prop plane flew over the faire site. The suddenly foreign sound had us all outside looking up at it. Mere seconds later, three fighter jets surrounded it and guided it back to ground level in an undisclosed location. It turned out to be an elderly gentleman who was out for a joy ride, not some rabid terrorist intent on malevolence.

That next weekend at Faire (after deliberating opening, the management decided it would be a good idea) everyone was so glad to be alive.

But by the following weekend, everyone seemed savage - ready to go to war, wearing Renaissance camo, with American flags on their Pirate and Princess hats.

We had an Armageddon Party at the White Hart Tavern down from where our booth sits on the faire site. Derek spun 78s and everybody brought food for a pot-luck and assuaged their panic with alcohol. We all got drunk.

The world had concerns and opinions. Derek and I bought gold, - more comprehensible and currently more reliable than stocks and bonds. Derek's sis, Connie was thinking about never flying again and was spending all her time in terror in the basement. Albert and Aaron reminded me to see the humor in daily life. We worked on finishing that season's R.A.G.

In early October, we drove up to see Connie and her husband Alan in Pennsylvania. She was feeling better, a little less fearful. Garage sales and dinner out made the few days there extra fun.

On the way back to the faire site, a truckload of live missiles had an accident on the highway. Traffic was at a standstill for 5 hours. Meanwhile,

BUY THE RAG ... OR THE FURRY GETS IT

BUY IT FROM THE PAPERBOY, ON THE RUN.

AFTER CANNON

AT THE

LIFE CASTING

BOOTH

ONLY

3 DOLLARS

in other parts of the world, a plane filled with Israelis was shot down over Russia, a man in Florida died from exposure to Anthrax (the first case in a frightening series) and buses across the country were put to a halt because a guy slit another guy's throat on a Greyhound.

That week, I was painting signs for a few of the Rennie businesses when my dog Toona alerted me, "Look! Something's happening!!"

I turned, and there was Frank with his two giant elephants. "Essex! Sussex!" he commanded. "Salute Ann!" In unison, they each lifted their trunks and their left foot - right there in my front yard!! Toona was beside herself - so was I.

Fantasy and wonderment abound even in times of dire fates. You only have to look for them, and be properly amazed.

That issue of the R.A.G. was said to be the best yet.

Chapter 3

Out of the Rabbit hole and into the Briar Patch

"Live never to be ashamed
if anything you say or do is published around the world -
even if what is published is not true" – R. Bach

Johnny Fox was a sword swallower extraordinaire. He'd begun with sleight-of-hand, magic, and comedy acts in the 1970s. He could swallow up to 22 inches of steel and make an audience gag and laugh at the same time.

Johnny had the outward appearance of no fear and would take chances and push the envelope whenever and wherever he could, always watching out of the corner of his eye to see what the reactions were. Johnny was a great entertainer.

MDRF never once had a contract with him (it's true!), yet Johnny never missed a show! He was there for 37 seasons and more than 3,500 scheduled performances. A consummate professional.

Derek and Johnny Fox were friends. They re-bonded over tequila during a rainy street show in Tempe, Arizona, in 1986. I was not along on that trip, but by all accounts, a fine time was had.

Johnny couldn't safely swallow swords, nor do magic in the rain, so his show was canceled. Derek continued selling bubble wands to the customers who'd braved the weather. Bubbles do amazingly well in humidity. My sweetie had gone and gotten a fifth of Cuervo at 8 that morning, just because he could. Arizona sells hard liquor at 7-11 stores. Derek was well into it when Johnny came by. He could see that Derek was getting too toasted, so he began to help him out by drinking along with him, and doing comedy in the rain. Later that

night when Derek called, he told me the story of the day, in a bad German accent, interspersed with "I Love Youuuu". Worried about alcohol poisoning, I called him back every few hours. He had a vicious headache the next day - but he'd made money! ... And he still had two days to go.

Johnny had 'perks' at the Maryland Ren Faire: 'Nut Booths', t-shirt sales, and the "Test of Strength", Mystic Bears - all of which contributed to a plethora of anecdotes about Johnny Fox. ("Eat Johnny's Nuts", etc.)

One of the sugar-coated nut booths and the Test of Strength were back to back, catty-corner across from my booth. Bees came with the former, clanging and shouting with the latter. An old carnival mid-way game, the Test of Strength is 17-feet tall with a bell at the top. Various levels on the painted panel mock those who can't quite strike the clanger to the bell.

Right around Y2K, Johnny had begun to imbibe in the 'pickle juice' more than ever before. He would often get so drunk, he'd leave bits of his costume in whatever rennie pub he ended his Saturday or Sunday night at.

We began to poke fun at him in the R.A.G.

Now, he wasn't the only one. Many likely suspects were 'roasted' on the skewer of this satire 'zine. But entertainers always see themselves when they look in the mirror of the world. And if they are getting drunk all the time, they'll get pissy/angry when someone sees them in anything but a glorious light.

One Saturday night, Derek and I found Mr. Fox's 'famous' hat at the White Hart Tavern while we were out walking the dog after faire closed.

Sunday at opening, a would-be strong man hit the bell on the first try, but it only thudded. Looking up, there was Johnny's hat, perched high atop the Test of Strength! A tall ladder was found (non faire theme appropriate) and while festival patrons watched, the hat was brought down, - and returned to its owner.

Later in the week, Johnny came over while Derek was up on our extension ladder staining the fascia of the booth. He said he was sure that Derek had something to do with putting his hat on the bell. From his perch, Derek replied, "Now, how would I have gotten up there??" Johnny said he didn't know, but he was pretty sure Derek was involved. (Doh!)

On Saturday, Oct. 15th, 2001 the second issue of the R.A.G. came out for sale. There was a photo of Johnny on the inside back page.

It was an edited snapshot I'd taken at "Darts From Hell" a number of years back. "Darts From Hell" was a yearly post-midnight party on the last Sunday of faire held at the pottery booth across from us. A raucous affair, the participants would whoop and holler. Loud shouts of, "DARTS FROM HELLLLL!!!" would finally wake us. So we'd put on our robes and wander over to see who was winning. Approximately 10-20 folks would enter the contest, but many more were always there to encourage the entrants and imbibe. Those who lost a round of darts, created an infraction of the rules, or said a bad word, would be given a squirt from Judge Jeannie's penis gun, or have to take a slug of whiskey, or both.

I'd brought a camera one year and was about to take a photo when Johnny stopped me. Rightly so. He said the flash could throw off a dart shot. I should wait till break time. Once that round of darts was over, Johnny grabbed the penis gun and stuck it out of his unzipped pants, saying,

"Here, take a photo of this!" In the background, Albert, Derek, and other revelers were looking on.

Derek edited the background out.

The caption on the photo in the RAG said, "Here's Johnny!" over a profile picture of Johnny Fox with what appeared to be a penis sticking out of his pants.

Derek's RAG was selling like hotcakes that Saturday morning!

Two of Johnny's ex-wives were sitting at the Henna Tattoo booth nearby. As it was still an hour before opening, I went over to say hi.

Johnny had numerous exes at this point. There was a joke at the festival that the surefire way to get a booth at MDRF was to marry Johnny Fox- (another festival perk.)

The women wanted to know if that was his finger sticking out of his pants. I replied it was not. Then they wanted to know if it was his 'Addadicktome'.

Whaa?

It would seem that the sword swallower thought himself not particularly well endowed and had a strap-on that he called an 'Add-a-dick-to-me'.

Woo-boy. I could suddenly see where this particular spot of humor might not go over so well with the intended victim.

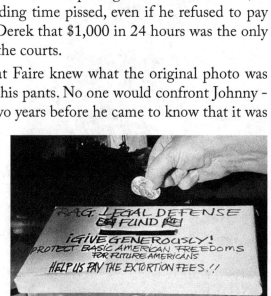

Heeeere's

JOHNNY!

Johnny Fox was PISSED. Derek went to see him the next day with the unedited photo I'd taken three years before. Johnny wouldn't even look at it. He said he knew what it was; a photo taken while he was inebriated and pissing in the bushes. Well, at least he knew that he was spending time pissed, even if he refused to pay attention to the truth. He told Derek that $1,000 in 24 hours was the only thing that would keep it out of the courts.

Within a week, everyone at Faire knew what the original photo was and that it was a water pistol in his pants. No one would confront Johnny - who was livid. I believe it was two years before he came to know that it was a snapshot taken at Darts From Hell that he didn't remember posing for because he was too schnockered at the time.

Derek approached the festival manager, Jules Smith, and showed him the original snapshot and explained that he'd done his best to apologize

to Johnny. Jules told him that he would do what he could to resolve this by Faire's end so that Derek wouldn't be brought back from Texas for a court date.

Much behind the scenes humor happened in the following weeks; I have photos of

various friends as well as Johnny's exes posing with plastic penises on their heads, in their pants, and as guns.

At the Monday Morning Breakfast Bazaar, Derek put out a "Legal Defense Fund" collection box (help us pay the extortion fees.) Albert helped Derek draft an aggressively humorous legal letter - which, sadly, was never used.

Chapter 4

"The world is full of magic things,
patiently waiting for our senses to grow sharper"
– W.B. Yeats

Years passed and Johnny would not forgive, nor forget. We were informed by random strangers that Johnny would exact revenge. It had been suggested that we never eat dinner at the same place as the magician/comedian. His sense of humor had not

yet returned. We dodged him and stayed clear of being in the same places.

As time went by, Johnny got healthy and quit drinking. He ultimately learned what had happened and (maybe?) figured out that it was all meant in jest.

Derek quit the R.A.G. as of 2009. His mom's failing health and the family drama surrounding it was all-consuming. Albert was long gone and Aaron left the Faire scene in 2006.

No one else at the festival had the 'zing' to make the 'zine happy and fun.

Jules taunted Derek, trying to get him to pick up his pen, but the work that the R.A.G. took to publish was simply beyond us at this point. The only place we could see to make humor happen was a limited yearly knock-off of the Festival's "Herald", a weekly newsletter Jules would write and post in a glass-enclosed lock-box. Derek called his version "the Harold" - and still, people thought Jules had written it. Especially when it slandered the likes of us and others at faire that had caused infractions against the norm. Once we figured out how to open the lockbox, the rest was easy.

Meanwhile, Lifecasting was waning and we were struggling to make ends meet. I was regularly making signs for rennie businesses as well as painting pin-ups on neckties and teaching lifecast workshops. I tried colored pencil portraits and hand-made tiles, to little avail. Lifecasting plugged along, but with the advent of selfies, having one's face cast had again become an archaic art form.

Johnny slowly allowed us back into his life. We never discussed the drama from the past. We merely went forward. In 2016, he showed up at MDRF with a dynamite babe 11 years his senior that changed his whole way of looking at things.

She was all about unconditional love.

Johnny Fox died the following December from his years of excess, beset with Hepatitis C and cirrhosis of the liver, ultimately ending in cancer, which he fought valiantly.

We were gifted airline tickets to fly up and attend Johnny's memorial in Annapolis, Md., January 2018. My cousin Bob gave us his free air miles so we could go be part of a proper goodbye. He felt we needed to do this.

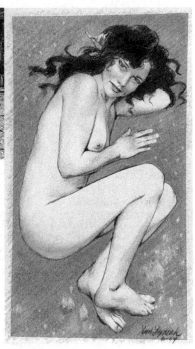

~ Art works by Ann ~
(Top) Adventure Armoury's Dragon, approx. 5'x3'
(Right) Prisma Color pencil drawing of a patron
(Bottom Left) Body casting
(Bottom Right) Juice Bar sign, approx. 4'x3'

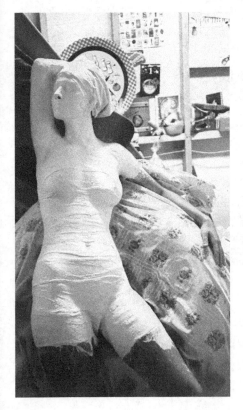

Voluminous Two w/ Issues

THE NUMBERS

We are now halfway through the festival with a total participation of 100% for patrons through the gate to tickets scanned prior to entering the fair grounds. Levels like this haven't been seen since the late 1990's when Bill Clinton was running roughshod over the economy. If these trends keep continuing we should have completed the festival by Oct. 20th with a 25% rise in facebook "likes" year over year to complaints about authenticity, not withstanding.

Beer sales as a reflection of loose wallets can be calculated by those inclined with a handy equation such as:

$$D\ (oz + iQ) \pm T\{vis\} = \cent$$

or in layman's terms, number of teeth showing times the amount of beer drank plus intelligence quotient, plus or minus the number of tattoos visible, offers a general amount of what you can fleece them for and how much you might go home with after this weekend.

THE WHETHER

The lack of mold is on everyone's mind these days, but only because of the amount of dust we have inhaled. Dust mitigation is an on going project, with the importation of the Asian Hornet to distract you from the black nasal cavity powder particulate build up, that is only compounded by the copious quantities of straw blown in your general direction.

As long as this holds out, and the amount of hurricanes stays in the containable range, we should round out this year with a full season of dust and bees unseen since the first issue of the RAG was published.

These was the goodle'daze!

PETS

Many of those reading this do not understand that contractually your furry friends are persona non grata. A simple contractual rider clause is necessary to alleviate this short coming.

While dog poop is nominal, your cats have been enjoying Michael Valentine's new rock kitty litter playground to the exclusion of our food booths.

If this trend continues we will have to reevaluate our interest in your participation.

BOOTH SALES

OMyGawd, this year has shown that the amount you people will try to squeeze from your structures is far beyond the serviceable nature of your building capabilities, and the upkeep you have supplied to both the booth and it's façade.

What Are You Thinking ! ? !

We have tried to supply an environment in which you are able to create an income that is commiserate to your worth here as an artisan, but then you attempt to plunder the naive with prices that are equivalent to a home value in Mangum, Oklahoma, are you delusional?

To those of you who have squandered your lives in this retail environment, may we offer the sage advice, "so long and thanks for all the fish!"

MISCELLANEOUS FLUFF

A look forward into what to expect on our parts; you can expect us to continue to work ourselves into an early grave supplying the artisans and entertainers of MdRF a venue that is unlike any other of the festival genres in this country. As owners and operators of the Festival™ we have blisters on our fingers from trying to win the battle against encroaching decay.

This is our part, yours is to supply a friendly and well presented public presentation, throwing in a few "good days" and "fare thee wells" to add spice for the general public.

As long as we both do our parts, we will all come out better for it.

ERRATUM

As we enter the party season on site we would like to remind those who are inclined to excess that moderation is the key to success. A word to the wise, it's better to hit the hay after killing two birds with one stone, there is no reason to beat around the bush, when it takes two to tango.

Now go out and have a great time & blow hay while the sun shines !

He was right.

Derek and I stayed with our friend Adam Smith, on his 87-foot yacht. It was one of the coldest winters Annapolis had seen in years. Even the brackish waters of the bay froze solid, - and the boat didn't have enough heat.

Adam is the most creative of the Smith brothers.

There are four of them that run the Maryland Renaissance Festival; Jules is renowned as the most honest and revered General Director throughout the industry, nationwide. Justin is the muscle, Mark is the one who drives around on the tractor, and Adam makes the giant 15 foot fabric banners and designs and builds all the really cool stages. They all work the grounds, making them safe and beautiful.

This faire is the most desirable of all Ren Faires. Rarely do booths come available, and when they do, they're snapped up in a jiffy. The brothers are part of the desirability. They actually care.

This Smith brother had become a dear friend. Adam loved Johnny Fox, so staying with him was the very best for the time at hand. While huddling around five space heaters on the main deck of his yacht, in a winter so cold the harbor froze the boat in place, we swapped stories about the man whose life had just ended. I found that I wished we'd made it back into Johnny's life sooner.

"I address you all tonight for who you truly are:
wizards, mermaids, travelers, adventurers, and magicians.
You are the true dreamers."– Brian Selznick

The memorial was an amazing event. There were magicians, musicians, and jugglers. Storytellers, puppets, and tears. There was a "21 Sword Swallowing Salute", by sword swallowers that had come in from all over the United States. A sight I expect may never be seen again.

Afterward, a select gathering was invited to the Yacht Club, where Adam paid for an open bar and had catered in exotic foods. Derek and I helped Adam with the small bouquets to be placed on all the tables. As we put the yellow roses and little white posies into each of 20 tiny vases, Derek

The Fabulous Smith Family:
Justin, Mark, Jules, Big Daddy Jules Sr., Ann & Adam

had an idea. He dashed off. An hour later, he finally returned. He'd had to go to one grocery and three liquor stores before he found a sufficient quantity of those toy plastic swords used to stab fruit for alcoholic beverages. He put one in each rose.

The crowd was a gathering of the people closest to Johnny. I felt our presence there was near sacrilege. It was by virtue of being Adam's guests that we were invited along. There were entertainers from the faire as well as from other parts of Johnny's life. Women and men who'd loved and admired him.

One of the fellows who was there when Johnny died had photos he'd taken after his death. I, of course, wanted to see them. Being who am I, I was

Joe Coleman & Ann at Johnny's Memorial

fascinated.

Listening in on conversations, I heard so many tales of fond remembrances and amazing stories.

One of the highlights from that evening was getting to spend time with Joe Coleman, an artist whose work I'd long been enamored of.

Coleman's early circus-themed paintings had been on display during our first visit to the American Visionary Arts Museum (AVAM) in Baltimore - art so disturbing that even the guard on duty avoided that room. Coleman's visionary graphics caused delicious nightmares for weeks. I fell in love.

In the year 1999, Johnny's wife number 3 and Johnny were featured in two of Joe's pieces due to be in a museum show of Coleman's work in Hartford, Connecticut. Rani Fox knew of my admiration for this outsider artist's work and invited me to go along to the opening.

I went on a train ride with her to NYC. Once we got there, we taxied over to visit Rani's previous employer, the musician, Rosanne Cash. I was more than a little speechless.

After this, we hooked up with a slew of Freaks and Dominatrixes at a local shop that sold erotic dancer fashions. There was a contortionist in pigtails and a magician whose latest claim to fame was being buried alive underground for a week. Numerous strippers in revealing garb, a housewife, a cartoonist, and us. We all piled into a bus and headed to Connecticut.

The lavishly adorned society elite were already seated when the

"Auto Autopsy", Joe Coleman ©1992

bizarrely attired bus-load that had come in from NYC was directed into a crowded theatre side room off the museum. Once everyone was settled, Joe Coleman came sweeping in on wires from overhead. Successfully landing on stage, this character of a man wearing Civil War garb, talked about his life as an artist whose work focuses on the pathological and psychological, the sacred and the profane - much of it done with single-hair brushes. A video of Joe conducting a human autopsy on an elderly woman ran on a screen behind him while he spoke. Led by a doctor in this autopsy process, it was something Joe told us he had always wanted to do. When the lecture was done, we were all allowed gallery access.

The paintings were, of course, disturbing and amazing.

During the evening's festivities, Johnny Fox swallowed swords and did magic. It was all rather fabulous.

On the bus ride back to NYC, a short movie was shown on fuzzy video screens that were staggered throughout the backs of the bus seats. The video was about a Hispanic woman who enjoyed squishing earthworms between her toes until they were totally squashed. Later, the 2 girls in the seat in front of me had sex.

We didn't arrive back in NYC until after 3 a.m.

The "Freakatorium", Johnny's home and museum was on the lower east side of Manhattan. Barely the width of a standard living room and five times as long, it was filled with sideshow curiosities. Among the wonders there were vintage circus art, Sammy Davis Jr's glass eye, the Fiji Mermaid, a two-

207

headed turtle, Admiral Perry's narwhal tusk - and a very large live python. Under the glass case that housed the gigantic creature was where I was given a pallet to sleep upon. This, after the wife told me the tale of the day the serpent had escaped and trapped she and her Shih Tzu in the bathroom at the back of the museum for two hours. It seemed that Johnny had been experimenting with how long the 8-foot snake could go without food. Wife and canine waited until the bell finally went off at the front door, indicating a visitor. She hollered at them to get out - and call Johnny!!

They both promised me the python had been fed recently.

PART 15

PLAYLAND PARK
San Antonio Tex.

*"Life is the best party
I've ever been invited to"* - A. Francis

Chapter 1

"Hi Diddle Dee Dee, A Rennie Life For Me!"

My love of Ren Faires started with the SCA. Yes indeedy-do, I was an avid member of the "Society for Creative Anachronism".

It all began with a Renaissance themed birthday party for my brother Danny, who was visiting San Antonio, Tx. from Phoenix, Az.

Brackenridge Park in San Antonio has the most fanciful WPA pavilions. The whole park is filled with magical concrete structures created during Roosevelt's 'Works Project Administration'. Stuff no one has time to re-create to that level of artistic ability anymore. Leastways, not for the mere tuppence paid then. (Funny what you can get starving people to accomplish.)

Brother Danny and I roasted mutton and put together a veritable feast for about fifteen friends. I rented one of these charming park structures and we had music, dancing, and costumed "Renaissance" revelry for hours!

The SCA was an obvious next step. The "Duct Tape Warriors" as they are known, were an odd bunch, all looking for a fantasy escape from their cubicle jobs. Delightfully creative folk, they could capture vivid

Ann, Roberta, Rick, Dan & Ellie at an SCA Event

moments of fantasy and make them real through their play-acting. In a land where 'dragons' fly overhead in a constant flow of traffic patterns, their make-believe world spun out tales from another era in the land below. They were good at it!

During one of my favorite events, my friend Ellie met her husband.

Ellie was Richard when I first met her down on the Riverwalk in downtown San Antonio. We worked waiting tables at the same restaurant there and became good friends. I got to hear all the tales of the then revolutionary and groundbreaking operation that would change this hunk of a man I knew into the beautiful woman he became.

(we now interrupt your regularly scheduled program)

Carey and the Crabs

A brief side step takes us to Ellie and I working together at the 'San Francisco Steak House' a couple years after her operation. This San Antonio establishment was known for its delicious food, great bar, and the 'Girl on the Swing', who would soar over the heads of the diners below. Ellie was thrilled to become this illustrious girl on several occasions!

Ellie was living nearby the restaurant with a really great young man named Mark. His boss Carey and I had met, became intrigued, and decided on a date after my shift one night.

I was dating (and sleeping with) many men at this point. There was currently a delightfully well built pentathlete 4 years younger than I, as well as an older stogy lawyer who lived in LA but had frequent business in San Antonio.

Carey seemed like a lot of fun! All four of us had gathered at Mark and Ellie's for a little toke before she and I went off to work.

I'd been 'itching' the past few days (ever since my last over-night with the young pentathlete ...), so I called El into the bathroom to inquire if she saw anything down there. She put on her glasses, took a pair of tweezers, moved into my crotch area, and plucked out one of the suspects. "Yessss, ... You have crabs." She stated quite matter-of-factly.

Horrified, I whispered frantically to her my concerns regarding to how to deal with this dilemma - as well as my imminent date with her sweetie's boss!! ... who was in the other room!!! Yikes! She calmed me with the facts of life as she had known them and said the truth is always best. We walked into the living room where the boys were getting toasted, and I fessed up.

They started laughing! Then they started in on the jokes:

"Gotta stop 'em now, before they build lakefront condominiums!"

"How do you get rid of crabs? Shave one side of your crotch then light the other side on fire and stab 'em with an ice pick as they come fleeing out." Etc.

Carey, seeing my tears, pulled me to him and told me not to worry. I should go to work, try not to scratch, and he would pick up some 'Krab-Be-Gone', which he would show me how to use after my shift.

Strange date, but hey - I'm always up for new adventures.

He arrived at the bar about 1/2 an hour before I was due to be off work. Apparently, when he brought the sack of "Nix" medicine out of the car back at the apartment, the bottle fell and broke. So - he went and picked up another bottle. When the same clerk saw the same man with the same lice product for a second time, she 'shoved' it at him across the counter, and gingerly took the cash, eyeballing him sideways! Hah!

Having gone to my place across town, we got into the bath together. Again, a very odd first date: to get totally naked in a tub with a man you barely know, and start combing for lice in the pubic region. Once sure we'd succeeded in removing

Ellie, a friend & Ann on Halloween

all the offending critters, we had a delightful evening of sex.

However, it's not that easy. You must wash or burn and exterminate EVERYTHING you've come in contact with.

I gave the vile little biters to the lawyer

He stopped calling after that.

Mark and Ellie and I continued to have many adventures. (Mark was the one who showed me how to best navigate my first acid trip.) We'd travel down to the coast often. The 3 of us hosted an awesome Halloween party one year. We hung out together whenever we could.

And then word came down that the feds were closing in. It seems this gentle sweet soul was wanted for murder. Mark had been on the lam with a changed name and now had to move on, never to be in contact again. I was bereft. Ellie was totally devastated.

(we now return you to your regularly s c h e d u l e d program...)

When Ellie and Ed met, it was love at first sight. I'd invited her to join me at an outdoor SCA gathering. The event had everything a good George Martin novel has; Magical Creatures, Beautiful Maidens, Sword Fights, Treasure,

Brother Dan considering a little bloodletting

213

Athena, Simon & Rick

a Quest, and Sex. For me, it was a delicious playground.

The 'Bar Scene' that was set up that night maintained a perfect combination of character development and reality. A Viking style pub had been erected, with large soft pillows, draped flowing curtains, and plenty of booze.

Contests and role-playing were rampant. As I'd been sketching on and off all day long during the event, it was suggested I auction up a drawing. The treasury got $37 for my offer of a portrait. I drew the couple who won the bid, nude, in their tent later the next day.

Athena and I won a tie in a competition for the 'most seductive wench'. Athena was exquisite. Thick waves of blonde tresses and built like a Frazetta Amazon Queen. $45 won the bid of a joint kiss by the Two Most Seductive Wenches! The winner was more Grendel than Lancelot, but Athena and I enjoyed each other immensely. So did the watching throngs. As a gift of thanks for that evening, Athena made me a 24K gold crescent moon necklace that remains a sweet part of my treasure chest.

Ellie and Ed ultimately wed. I was one of the bridesmaids. They remain happily married to this day.

Fantasy, fun, and role-playing - and earning a living doing it, sounded like the way to go. Plus, at Ren Faires, one's craft display is set up for 6-9 weeks, instead of the 'set-up/make sales/break-down/repeat,' that had to be done for street shows. Now I was going to play dress-up for a living! Halloween costume fun and the SCA disappeared in the smoke and haze, and Ren Faires rose from the ashes.

Parties gave those of us that lived on site added amusement! Some rennies live in their booths, some in tents or travel trailers in a designated

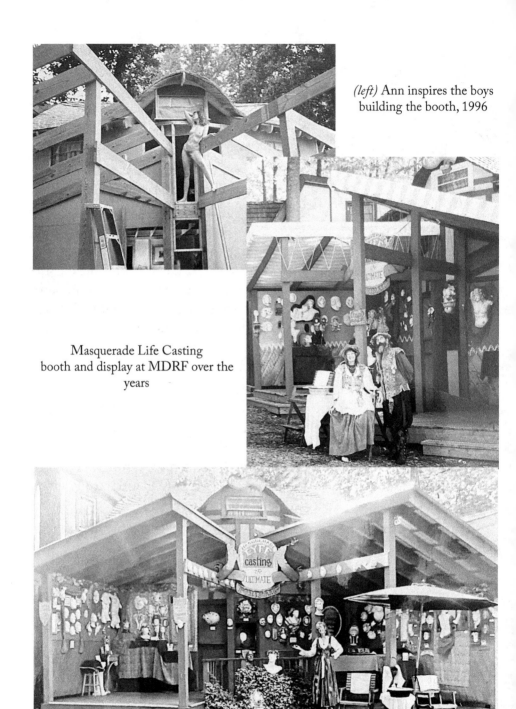

(left) Ann inspires the boys
building the booth, 1996

Masquerade Life Casting
booth and display at MDRF over the
years

The Jezzard's Beach Party: Debi, Derek, Roger, Ron, Frank & Sharon

campground. Maryland didn't have as much of a party scene as Scarborough or Michigan. Derek and I added to the few existing events by bringing in the "Champagne Croquet Formal and Erotic Food Contest", as well as "Che' Dereek", the "Subterranean Thursday Night Cafe". Micheal Valentine, the "Junk Yard Dog" for the Maryland Faire site, always swore that part of the reason Jules Smith let us into the faire was because of the fun functions we brought with us. I can't say for sure that this is true, but we did manage to get away with almost anything.

The Thursday night 'Che' Dereek' didn't have quite the same general appeal to the site-dwellers as it did in Michigan, where everyone accepted it as a great gathering with food and entertainment for a mere $6-

$10. In Michigan, we could make any meal plan and they'd come, knowing if there was something they didn't like, they could get more of another dish. If the tables were booked, they'd make sure to get a reservation in early for the following week. In Md., they wanted to know every ingredient and what the entertainment was before they'd even consider paying for this unique feasting option to an off-site restaurant. Greedy bastards.

More greediness ensued when folks decided they deserved to get in after an evening was already booked. More than once we were threatened for not 'assuming' to reserve a place for certain "friends". A woman who

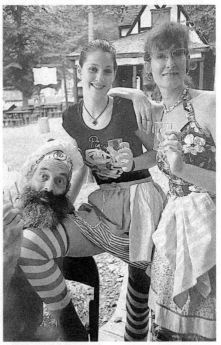

Derek & Ann with waitrix, Lil' Alice

216

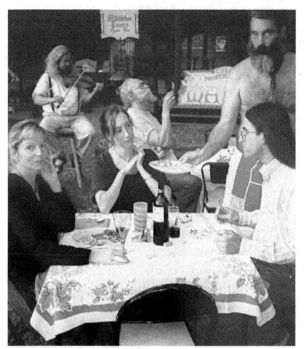

Derek serves food to Katie, Trish & John,
as Dan Mehn inspects the cleanliness of our flatware
while Jim Nelson fiddles around

will remain nameless, pressured both of us with blackmail to try to get in late for a fully booked Thursday night that had several folks already on the wait-list. She had discovered that someone she wanted to schmooze with would be there. This, after informing us that she and her husband would never eat at Che' Dereek. Why would they, when the meals they made at home surpassed anything we might possibly create?!

Another unnamed assailant became furious when an entertainer he wanted to see was going to be there and all the tables were booked for the evening. We should have known he'd want to be there! He stood at our back door and loudly berated us until we made him go away.

Food was purchased and planned for a limited number. Tables and chairs were also finite. Being blackmailed and screamed at was NEVER going to sway us.

Despite unwarranted drama, the Thursday Night Subterranean Café' in Maryland had numerous fun adventures. Such was the night of Hurricane Floyd. Many had

217

Michael V. lends a helping hand

chosen to flee the site to safer havens inland. We maintained we would stay and serve Che' Dereek. Clearing our upstairs bedroom, we put in a table for six there; four folks in the kitchen, five in the back room. With the help of our cohort, groundskeeper Micheal Valentine, we slung a tarp between the back of Albert's booth next door and ours. As we had Albert's key, we let ourselves in and set up tables for another ten people in front of his jewelry counters. (He was not thrilled when he found this out later). Everyone arrived wearing mukluks and slickers. Big rains were drowning the site. Our booth was on a hill, muddy, but free from flooding. We brewed the last pot of coffee right before the electricity went down. Candles in every room. Dereek's grilled salmon arrived hot and the salad and veggies chilled. John Jacobo, our musician for the night, had a portable, battery powered Pig Nose amp. He went from room to room playing guitar and singing.

It was FABulous!

Trees went down all over the site, crashing cars, stages, booths, and tents ... but missed us.

Another evening, we had our friend, the potter, Stephen Bennett, entertain the diners as the "Little Professor" - in the guise of a chin puppet. A chin puppet is created by laying on your back and turning your head upside down and facing thus towards the audience. Covering the nose, eyes, and hair with a costume - (in this instance a silly tiny professor costume) - you then create eyes and a nose on the chin. A common smile becomes a grimace, and a frown is a smile. Using the display window for the initial life castings, we were able to hide Stephen's body, laid

out on a table behind, into the interior of our booth, with a drape at the neck outside. He had chosen to recite Lewis Carroll's "Jabberwocky". Stephen's already exaggerated rubbery features were hilarious on this bizarre creature. From one of the tables, someone kept drunkenly proclaiming, "The teeth look so Real!!"...

This type of restaurant work was difficult, especially when we had no running water and had to walk the dishes to the festival kitchens behind us in order to wash them. Shopping in Md. was more expensive than in Michigan. The people here wanted meat. Cost for a meal went up.

It was becoming tedious. There was no real money in it. It was all for the love of the game. We were offering a plate with second helpings for ten dollars, with a prep of up to 3 days to produce the menu items.

When one of our waitresses decided she wouldn't share tips, we'd had it. We cooked and cleaned as well as waited tables. To make sure everything ran smoothly, we'd 'hire' one waitperson (different every week) who got paid with free food, fun and a third of the tips. Everyone we'd ever had was always thrilled to be there. It was a sought after position. Clearly stated up front was the fact that we all shared tips.

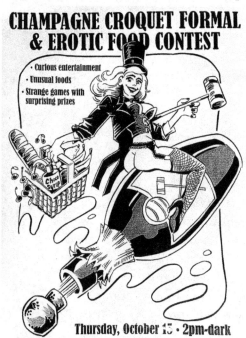

CHAMPAGNE CROQUET FORMAL & EROTIC FOOD CONTEST

· Curious entertainment
· Unusual foods
· Strange games with surprising prizes

Thursday, October 15 · 2pm-dark

Poster art by Sean Bieri

It was the straw that broke the camel's back.

We quit before the end of the faire that year and discovered all the cool stuff that could be done with the free time we now had!

"The Champagne Croquet Formal and Erotic Food Contest" was another festive event we brought to the faire. It started in Michigan and easily segued to Maryland, where everyone loved the games and contests. There was the "Banana Peeling Contest", in which one partner holds a banana while the other

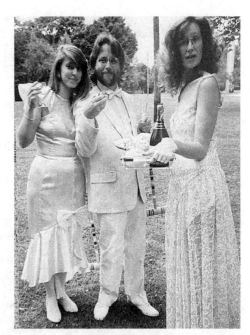

(top right) Ann serving champagne to Bob Bielefeld & Leslie
(bottom) A Bevy of Babes: Cathy, Tamara, Ann, Tracy Lynn Tucker, unknown blonde, Kathy, Laurel, Jeanne Jeanne the Tattoo Queen (seated) & Noodlehead

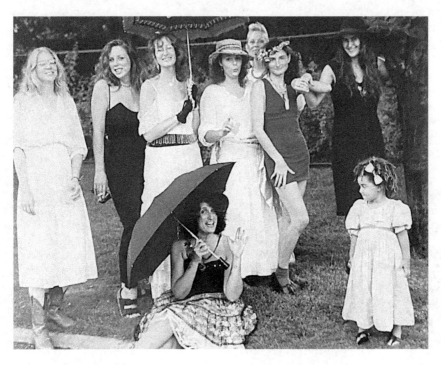

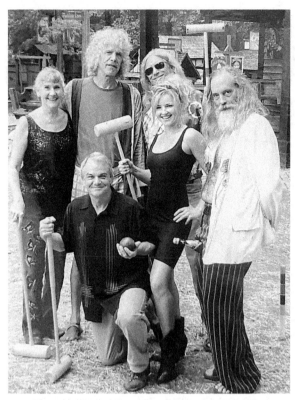

(top left) Zenobia, Stephen Bennett
(who still needs a facelift), Steve Exley, Lauryn
Murray, Derek & Clark Orwick (with one ball),

(top right) Margaret Barry with her trophy
(bottom left) Fondant Japanese Pillow Book
(bottom right) Ann & female dish

peels it, with anything but their hands. Hilarity ensues!

The "Cherry Stem Tying Contest", which I'd perfected back during the Riverwalk bar scene decades earlier, likewise created visual comedy. The best win in both these competitions would get a well ornamented trophy.

Croquet could be quite vicious. I always cheated. Cheating is, after all, in the official rule books. Badminton and bocci were also on the playing field.

There were the Erotic Foods, which generally all got prizes, with the Grand Prize going to the best.

Since the entries were usually made by artists and creative types, the erotic foods were sometimes difficult to judge. Memorable entries included a life-sized chocolate sculpture depicting part of a woman's face with red lips and a red-fingernailed hand on a phallus. Colored fondant 'paintings' on cakes were a fav. There were penis-carved cucumbers in cream sauce and a capon whose chicken legs were lashed to 4 posts that was

(top) Kristi BigSmiles wins a trophy

(bottom) Leah questions Derek's banana

Ann & Jeanne share a treat

being impaled through its rosemary encrusted opening by a sausage. Peaches and apricots flattened and folded seductively with an appropriately placed cherry and oozing cream cheese made for a more feminine entry. Other arguably charming little tidbits featured cocktail onions on dental floss with spaces in-between, three on a strand, and two cheesball gerbils with raisen turds ...

Entertainment ranged from spinning 78s (records made from 1898 to the late 1950s) on vintage turntables, to baton twirling entertainment from Deb Harkness, wearing the same outfit she donned when she won national champion at age 19. One year Jeannie Gibbons performed Madeline Kahn's, "I'm Tired" from 'Blazing Saddles'. Derek and I did a duo with the "Scrotum Song". Bawdy acts and silly songs were prepared and performed here much as one would for a talent show.

We inherited the 'Dawg Party'. This was a Dice and Revenge game. It had nothing to do with dogs. A nicely wrapped gift, with no tag, was brought by each entrant and placed in the center of the floor. The goal for this gift was to have it be both tacky and desirable. Derek and I normally made ours. The voodoo doll I crafted with various "human limbs" dangling from her hoopskirt might've been one of my best. I gifted a large dildo the night I wanted to make it clear that kids under the age of 17 were not allowed. When the attending 5 year expressed curiosity regarding the vibrator, I achieved my goal. One year everyone secretly decided that I should receive Jesus art. A group went thrifting and gathered up everything Christ.

When the dice go around, if you

223

roll a 7 or 11, you pick a gift. Once all the gifts are gone from the center of the floor, they get opened and described; desired, or repulsed. Now it really gets going; A secret timer is set for an undisclosed time (usually about 20 minutes) and now two sets of dice are set in play. Again, 7 or 11 and you can now grab anyone's gift or give away a gift that you don't want to keep. This goes round and round, with some gifts being highly coveted. The year of the Jesus's, they all kept being given to me - no matter how many times I kept trying to give them away!

"The Bobbitt" was perhaps one of the most coveted items of all time. A carver who makes knives and other treasures, had a short Damascus blade with faults no one but him would ever see. He also had purple heart from a deer antler that was the perfect size for a small penis carving. This became the handle for the dagger which was then engraved with "The Bobbitt" - after the infamous true story of a woman who cut off her husband's dick when she found out he'd been unfaithful. The couple's real-life last name was Bobbitt. On the night of the dagger, I had control of the timer and could have cheated. Instead, I lost it to another. Years later I won a cock ring carved from a whale's baculum, made by the same artist. I didn't cheat then either. Only ever at croquet. I swear.

The "Black and White" Funky Formal: Kristi, Marina, Joe & Jeanne

(top left) Wonder Woman & Harley Quinn flank Julius Smith
(top right) Cersei (Lee) & Septa Unella (Malynda) "SHAME!"
(bottom left) Popeye & Olive (the Spurlocks)
(bottom right) Gabriel doing what he does best …

Funky Formal dance parties have been around the ren faires forever. Most all faires have them. These are fabulous themed events held on-site, normally in one of the festival pubs. There's food, drink, and a DJ, and of course, awesomely fabulous funky 'formal' costumes. Our faire went from funk to foul when purportedly somebody decided to fuck in the mud pit during the dance.

"What's a mud pit?", you might ask.

Mudbeggars are a troupe of actors who perform Shakespeare and other such witty acts - in the mud. Audiences

Mudbeggars

in the front row often get splattered. Mudbeggars would eat the mud as part of the performance - or at least, it went into their mouths and then they spit it out.

The 'pit' got covered weekly so that nothing unseemly would go into a mouth or any other orifice.

Finding used condoms in an uncovered mud pit the Friday before a show weekend caused a gag reflex. It also meant the mud pit had to be emptied, cleaned and re-filled post haste.

The Funkies on the Maryland festival site were terminated forthwith.

Some folks tried to host a Funky Formal happening off-site at a bar, where the locals found our antics and attire worthy of staring at, slack-jawed. When a well known stilt walker got too

Frank & Gayle Murray

Cruella meets The Joker, (Ann & Jonesy)

toasted and blistered the crap out of her mouth, while fire breathing inside the bar, (bad idea,) that Funky experiment also shut down.

It was a number of years before Frank Murray came to faire with his "Elephant Ride". When he realized (aghast!) that MDRF had no Funky Formal, he approached the management and promised to oversee the event and hold fast by their rules.

Remembering my long-ago venture at Scarborough Faire with my painted back-drop and polaroid, I approached Frank with the idea of a photo booth set up.

I would have my camera on a tripod with bright lights and a theme-worthy scenario set up with props. Revelers could come and have their snapshot taken by this would-be professional as many times as they wanted to get in front of the camera. Everyone knew me and I was able to lure the shyest into my web and get them to pose.

I really got into the role of photographer. Of course, having hours of play in which these costumed rennies would proceed to get 'loose' (and drunk), made the photos a delightful observation in human performance art.

I sold the CD of edited photos for $12. It was enough to make it worthwhile. Hell, the experience alone made it fabulous!!

I did this for nine years. Towards the end, Derek was

helping me full time. I could no longer set up the backdrop alone, and hauling all the props and lights from the booth to the pub was getting harder for both of us.

Ahh - age and gravity. It does take its toll.

'Che Dereek' went first, then we quit the 'Champagne Croquet Formal and Erotic Food Fest'. Others attempted to take up the torch, but the commitment to the event loses something in translation. The 'Dawg Party' came next. We passed this on to someone who has stepped up well and I'm quite sure it will continue on into the future.

Giving up the photo booth at the Funky was the last, and perhaps the hardest. I just loved making these performing monkeys do what they do best: play to the camera! Derek didn't want to be the schlepper for this anymore. He had to do ALL my lifting and toting at this point, so I couldn't blame him.

Next to go was my life in the Ren Faire - but here I am getting ahead of myself again.

A meeting of great minds (Nicky & Roger)

PART 16

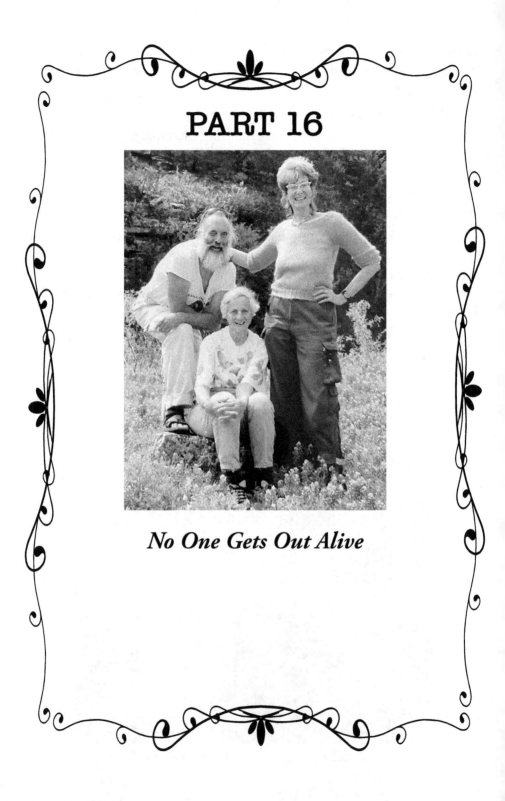

No One Gets Out Alive

Chapter 1

"Grey woman thin skin
sharp wit softened by age
black dog watches her"

(Haiku for Diane Weaver by Ann, January 2006)

While Rennie life was happening in our make-believe whirled, all around us was real life.

Derek's dad, Clyde, was in a nursing home, asking for his gun. Derek's mom, Diane, was fading into the confusing abyss of Alzheimer's. His sister Connie had a husband who was also in some phase of a mental meltdown not unlike dementia, while Derek and Connie's other sibling was traveling a manipulative path of treachery. I was going through menopause.

Diane had sworn she would walk into the ocean if she ever got Alzheimer's like her own mother had. Of course, once the mind starts going, you spend every minute trying to recapture those happy thoughts from the past, until they all swirl into a constant theme of Neverland.

Clyde hadn't had much to do with anyone in the family for years. He lived in Corpus Christi, Texas. Alcoholism had alienated him from everyone, although he had quit drinking a decade ago. When he was discovered on the floor of his seaside shack, suffering from pneumonia, we were alerted. It was leukemia that ultimately took him out. Clyde was one side of Derek, and Diane was the other. One a snarly curmudgeon, the other, sweet as pie. Both smart as whips.

Somewhere in recent years, a question about child abuse changed the

family dynamics. It was known that Clyde liked to pat little girl's butts, especially when he was drunk. But when the 'other' sister decided to have a 'massage memory' about being poked by her father, things went wonky. Her claims that her mother, older sister, and younger brother knew about it when it happened were never substantiated. To begin with, Derek was a baby at the alleged time.

Poor Diane was tortured by the prospect that this might've happened on her watch. Despite all attempts at reviving any memories around this, neither she nor Connie had any recollection.

This obviously tortured sibling got weird(er). She would show up at her mother's house in Houston, ask for antiques and heirlooms, get them, and proceed to leave whilst viciously letting Diane know what a bad and evil mother she was. Wait a year, Repeat.

As Diane's illness worsened, her youngest daughter was known to scoop her up and take her places, away from the in-home care Derek and Connie had implemented. She once took her mother to the beach where she sat her down in the sand and walked away, returning hours later - after Diane had gotten burned and blistered. Due to increasing raids on family valuables, items were pulled from the house so she wouldn't steal them.

Suffice to say everything went increasingly off-kilter.

Diane had worked for lawyers. She knew the law. In the initial stages of her increasingly compromised condition, she knew something needed to be done to safeguard herself from her twisted off-spring. She implemented a Declaration of Guardianship in the case of her own incapacitation.

A "guardianship" is a protectorship. It's aspects suck. Emotionally speaking, you never want to do this, unless you absolutely HAVE to.

The only way we could legally protect Diane was to set this in place.

Connie being the eldest, was the first choice, but due to the increasing health issues with her husband, as well as her residency in Pennsylvania, she could not handle the responsibility. Derek took up the banner.

Many dramas ensued.

Finding a woman who could be a full-time live-in caregiver for Diane in Houston was a blessing! Her last name was Santarchangelo - the Archangel

Saint. She bathed and fed Diane and cooked good food for her. She took her to church and festive activities. She truly loved her. Ms. S. kept mom's mind as active as it could be. She also trained Diane's championship black lab to take her for walks around the neighborhood. We didn't believe it until we saw it! Smart dog. Ms. S. also kept the bad daughter at bay.

Connie's husband had contracted his illness around the same time as Diane. Alan was an 'academic criminal investigator'. Look in any book on

criminology from the 1970s and you'll find him there. He was working for Penn State teaching Criminology. (Alan also taught at the FBI). He and Connie taught 'At Abroad' classes in Germany and Holland. Derek and I joined them one year while they were in Leiden, and discovered what a civilized country Holland is. Open minded, the jails are not full and the crime rate is low.

Alan & Connie

Connie and Alan brought a class to a church in Rotterdam while Derek and I were visiting. The pastor was working with heroin addicts. A panel of addicts spoke to the class - in English, - and answered our questions intelligently. One was the chosen dealer, someone the general populace agreed dealt clean drugs. Afterward, we went with the class into the basement where a controlled dispensary gave out heroin and clean needles. We could stay and watch them shoot up if we wanted to. I left, nonetheless amazed at this civil way of dealing with a very real issue.

Alan was always researching various gangsters, mobsters, and criminals wherever they went. In Amsterdam, they were interviewing a New Jersey gangster that had been the one responsible for bringing pornography to Holland.

232

The investigations these two would do often had them fleeing for their lives. There were times when I would hear that they'd had to hide out as they were moved from place to place to get free of a country.

One of my favorite tales Alan told was secondhand from a friend within the security detail for the Clintons. The story goes that allegedly a fight between the future Secretary of State and her hubby was in full flame at the top of the Grand Staircase when she suddenly pushed him down the stairs! Getting to the bottom, she shouted at her splayed out husband, "Now getcher lard-ass up and get back to work!"

I believe it was the inquiries into the Bank of New York and the Russian mob that finally took Alan down. He was keeping a baseball bat by the front door at this point and, as he put it, he would "let Constance start the car".

When we asked our friend who worked for the NSA if illnesses can be created to appear natural, he confirmed that, yes, all illness can be manufactured. Alan's never quite fit the total Alzheimer's profile. I've always believed he was being somehow drugged to keep both he and Connie from further research. His illness shut down any investigative studies for Connie as well, as she took care of him at home for his last 13 years.

Diane's maiden name was "Arras". Castle Arras in the Alsace-Lorraine region of Germany was a 'family' castle out of history. Now a B&B, Derek booked it as a surprise for her. Diane was very aware that her brain was going. She wasn't planning on walking into the ocean - not just yet. She wanted to see the family castle and the Louvre Museum in Paris. So, we took a two week European Vacation - and proceeded to do just that and more.

Germany turned out to be far more colorful than Paris - which was gray in comparison. The museums in France were stunning, however! Diane loved them. Couldn't remember them day to day, but knew she'd been and was grateful.

In Germany we rented a Mercedes

Derek & Diane in Paris

and drove down the Mosel River and up the Rhine, going to castles and wineries. Mom got to the point where she'd say, "ANOTHER castle?!!?" These magnificently maintained fortresses were all mere miles apart.

The staff at Castle Arras had been alerted to her mental 'status' and greeted her as tho she was a bonded royal member. She was thrilled to find out she would stay the night in 'her' castle!

Then she accidentally locked herself in her room and lost the key.

This, then, became the battle theme over the next number of months back in Texas. Having not implemented a full-time caregiver yet, Derek would call from our home, five hours away to Diane's house in Houston where she was still living on her own, to make sure she had taken her pills. She would set down the phone and walk away. Derek would spend the next 15 minutes or longer, calling out, hoping she'd hear his tinny voice shouting through the phone line. When she finally did, she'd be thrilled, yet again, to know her son had called her.

Tales of her dog's antics were her favorites, and she'd tell us the same ones, in the same phone call, over and over. Babies and puppies were also a huge source of entertainment for her. And fat people. If we went out with her in public and she saw a large person, she'd loudly exclaim, "That [man's] SO FAT!"

Her car keys had been taken away, as had her brain cells.

Bringing in a caregiver was imperative. It was the perfect answer. For two years. Then she fell and broke her femur.

You know how this story goes …

It was ultimately decided that she be settled into a nursing home nearer to us after discovering that the one we'd placed her at in Houston was virtually ignoring her. Our previous loving caregiver, Ms. Santarcangelo would check in on her and alert us. After finding her freezing in a thin nightgown and falling out of her wheelchair with her broken leg twisted at a bad angle - and no one caring, Ms. S. called Derek. We drove there and brought her to Kerrville, close to where we live. Not all nursing homes are the same. No indeedy. We'd found this out when we tried to find a decent home for Clyde the year before. Many margaritas ensued at the end of long daze of searching for a decent nursing home and ultimately being appalled.

We'd researched facilities in nearby towns and chose one that wasn't as pretty but seemed to have an amazing staff. Speaking with the manager

on our initial visit, I mentioned something about Dr. Kervorkian. He said, "Kervorkian was a saint." That one sentence and we were in!

Chapter 2

"Here is a test to find out whether your mission on earth is finished; If you're alive, it isn't" – R. Bach

Here, I have to say, I'm so glad my parents went quickly.

Early photos of Mom & Dad circa 1936

Mom died from choking. She had an inherited form of Muscular Dystrophy that caused this, called OPMD. She'd choked many times before, to the point of being hospitalized, and had recently told me that the next time she wasn't going to save herself. She was a woman of her word.

A couple of years later, my dad died in his girlfriend's car on the way to the hospital. "Blood in the bowels and failure of the respiratory system" were the causes. His doc had told him to quit drinking and smoking or it would kill him - and it did.

When my sister Dayna and I got there to clear out the house in Florida, Cleo, my dad's girlfriend, came and joined us.

Cleo was my mom's best friend. My oldest memory of her was from around age 8 or 9. She and her husband drove up to our house on rumbling black Harleys, dressed in black leather with black helmets. I was impressed! These cool people were my folk's friends!

In later years, as my mom and I became closer, she confided in me that before any of us kids were born, she and dad had separated. His fits of rage scared her and she decided if he couldn't calm down, she was leaving him for good.

During this time, my mother had an affair with Cleo's handsome husband. With rakish good looks and a compelling personality, this man had a way with women. Cleo was used to it - as much as anyone ever can be who decides to stay in a relationship with infidelity.

Mom told me that sex with the man was electric. Dad never did that for her. This, then, was why she was telling me now that choosing one man, and only one ever, might be the best way to go, so you'd never know disappointment.

I went the exact opposite route, searching through many to see what might suit me to the fullest. Don't settle.

Cleo supposedly never knew about my mother and her husband. After mom died at age 83, Cleo and my Dad became lovers. The Universe winks.

The three of us, Cleo, Dayna, and I, cleaned the house. The walls had to be thoroughly scrubbed. Years of cigarette smoke had yellowed everything.

Hidden in every nook and cranny were bottles of booze. Under

Dad & Cleo

the kitchen sink; in the recesses of the clothes closet, in the hamper, under the bed. The open ones we emptied out. Some 20 or so. Dayna started getting twitchy around the fifteenth barely opened bottle of spirits, saying that maybe we could save this one? Nope. We had agreed on this 'purging ritual' and I was sticking to it.

Sideways Story:

After mom died, us three siblings gathered in Florida to help dad dispense with her ashes. They'd been in the garage sitting on a shelf in a box next to the paint cans for a year now. We were to assist dad in the formal releasing of mom's ashes into the gulf. When we got to the seawater, he abruptly and unceremoniously dumped his wife's crispy remains into the froth of the incoming tide. I was offended at the rudeness, but chose to let it go.

The four of us then went to a bar to 'toast' my mother. Brother Danny's drunken traits had already put a thick wedge between the two of us. My very last conversation with my mother was that I was 'divorcing' my brother due to his inappropriate nature when he was inebriated - which was all the time. My father's proclivity for alcohol was no better, leading him to start imbibing every morning by 10 a.m. My sis, well, she was along for the ride and just happy to be there.

I decided that toasting my mom with a Shirley Temple was best for me. Suddenly berated and insulted, the three of them began attacking me for not having alcohol as a celebratory nod to a woman whose drinking habits later in life made any conversation with her after 10:30 a.m. a futile endeavor. Their antagonism escalated with loud incivility. I up and walked out on what remained of my immediate family, ditching them in the bar. Tears streaming, I was headed down a nearby beach contemplating how to get into my folk's house to retrieve my return airline ticket so I could fly out early, when my brother came running up behind me. He apologized and said everyone wanted me to come back.

The rest of my time there was awkward. I quit drinking altogether for about 3 years after that.

Sideways return:

Dayna Curtis, circa 1964

Dayna and I took Dad's unopened bottles of booze and put them into two wicker baskets. Going door to door, we visited my folk's neighborhood friends. We told them we were giving away two bottles to each neighbor. Their reactions were sort of creepy. One man grabbed a couple of bottles and quickly and slammed the door. No one invited us in. Some asked for three.

Danny now joined us to help go through the valuables. Everything of worth got moved into the center of the living room floor. All the family treasures, as well as Mom's jewelry and Dad's musical instruments. We made personal piles. If there was contention around an item, it went into a separate pile. Then we'd go through that one. Soon there was only a trio of items remaining that we all wanted: A Civil War cut-glass pen and ink desk set; a turn of the century mouth organ with paper reels; and the three first edition "Princess of Mars" books by Edger Rice Burroughs.

Ultimately, due to fate, I got everything.

Our mates joined us the following week. Derek never did get to meet my dad. We'd planned for that following spring …

Disneyland and Epcot Center were diversions we employed regularly over the following two weeks. Unbeknownst to any but me, Derek had

Ann & Derek, Dayna, her son Scotty & his sweetie Anduril

238

decided to take acid during one of the trips to Disneyland. Dayna's husband decided he really liked Derek that day. (This was short lived - maybe Derek should have done LSD every time he had to see this guy?)

When it was time to toss dad's ashes into the Big Blue Water, we had chosen a Florida peninsula. One side was too windy, so we went to the other side. Same thing. In a version reminiscent of the famous scene from "The Big Lebowski", (before the movie was even a twinkle in the writer's eye), we threw the box of bone chunks and dust skyward, - it landed squarely back in our faces. The Universe giggled...

We all went home and bathed.

Dayna was the next to go.

Apparently, Dayna and my father worked together on how to spell my middle name - Lyneah - when I was born. (I didn't know this until after her demise when my friend Jeannie Gibbons told me that my sister had imparted this bit of trivia to her when the two of them met at the ren-faire a couple of years before.) It was the name of my father's first girlfriend. My mother loved the name and had decided to give it to me. I find that charming.

I called mid-November, 2009, to see if Dayna might want to have my help coming up in January due to a questionable illness she was battling. Her creepazoid husband answered saying, "Ann E. Bopper! ... I guaran-gawd-damn-tee you Dayna won't be around in January!" Beyond shocked and hurt, I scrambled for answers.

I made it north to upstate N.Y. in time to enjoy a wonderful end game with my sis. Her son Scotty and his family were there as well. If it hadn't been for them and the joy of seeing my sister in these last moments, I would've left the minute that her idiot husband made a pass at me.

Dayna had stage 4 ovarian cancer, complicated by OPMD. The weakened muscles of her pelvic floor due to this rare form of Muscular Dystrophy made it impossible to even consider removing the cancer. She died the day after I left.

She was 64, and still lovely.

When it came to the memorial the following August, the moron she had married refused to even pony up for coffee for a reception at the church afterward. When asked if he was going to speak at the service, he said, "What? … and bitch about 42 years that sucked?" Very little personal info was given to the minister, so the entire service was geared around baby Jesus.

Derek and I hadn't been invited to the small post-memorial gathering back at my brother-in-law's house because we had our beloved elderly cousin Ralph with us. Ralph was considered to be gay, although no proof was ever forthcoming. Homosexuality was not condoned by my sister's husband, so Ralph was shunned. Having returned to retrieve our belongings that were still at the house, we discovered that no one had arrived yet. A grocery store cake had been purchased for the 'solemn' occasion. I cut a huge chunk out of it and packed it into one of my mom's vintage glass refrigerator containers that was down in a kitchen cabinet. I refrained from poking finger holes into the rest of what remained. Derek, Ralph and I ate it on the way back to Ralph's house a few towns over. We talked about my beautiful and talented sister all the way there.

My brother, despite his alcoholism, was much healthier due to his active nature.

A decorated track runner, he stayed physically fit his whole life. He still walked daily.

He lasted until age 68. Cause of expiration on the Death Certificate: COPD with complications of OPMD.

His roommate called me during a Monday Morning Bazaar at Scarborough Faire. We were just leaving after doing a couple of guest weekend gigs. The fellow had just enough time to sell or pawn some of the more precious swords and other things he could get quick cash for before we got there.

I'd never been to this apartment, having stopped hanging out with Danny years ago. The place was filled with cigarette smoke and cockroaches. Big ones. Thankfully the kitchen seemed to be their main attraction, as that's where the leftover pizzas sat rotting.

The roommate had been kind enough to clean up Danny's room, i.e., the bed my brother had evacuated on upon his demise and some of my brother's more lewd bits of pornography. Can't even imagine what that would've looked like, considering what

Danny & girlfriend, circa 1965

was left. My brother was a journalism major (who couldn't spell) and an artist. Drawings were everywhere in stacks and sketchbooks. There were also numerous hand-drawn 'novels' - all in pornographic, comic-book style. Simultaneously clever and pretty darn disgusting.

Derek and I cleaned the room and went through Danny's stuff. He had told the roommate that I was to get everything. Digging his way into the further recesses of the bedroom closet, Derek pulled out a vintage black medicine bag. He opened it and screamed like a girl. Out had popped a plethora of penises! Dildos of every neon color known to man.

The roommate said, "OH! So sorry! I thought I got rid of all those things ..."

{Oculopharyngeal muscular dystrophy (OPMD) is a rare genetic condition characterized by muscle weakness that begins in adulthood, typically after age 40. The term "oculopharyngeal" refers to the eyes (oculo-) and a part of the throat called the pharynx (-pharyngeal). Affected individuals usually first experience weakness of the muscles in both eyelids

that causes droopy eyelids (ptosis). Ptosis can worsen over time, causing the eyelid to impair vision, and in some cases, limit eye movement. Along with ptosis, affected individuals develop weakness of the throat muscles that causes difficulty swallowing (dysphagia). Dysphagia can cause saliva to accumulate and a wet-sounding voice. Many people with OPMD also have weakness and wasting (atrophy) of the tongue. Problems with food intake may cause malnutrition, choking, or a bacterial lung infection called aspiration pneumonia.

Individuals with oculopharyngeal muscular dystrophy frequently have weakness in the muscles near the center of the body (proximal muscles), particularly muscles in the shoulders, upper legs, and hips (limb-girdle muscles). The weakness slowly gets worse, and people may need the aid of a cane or a walker.}

In retrospect, this was what my mother had, not the Myasthenia Gravis that her father and his father before him had supposedly died from. Hereditary research now proved otherwise. They all had OPMD.

Mom had her eyelids lifted four times. Her throat muscles constantly failed her.

In his final years, my brother was barely understandable when he spoke. He ate blenderized foods. Danny had made himself a pair of 'lift' glasses for his weakened eye muscles, These had bars installed on the top rim of the glasses that propped up his eyelids so he could see out from under them. In conversations with my dear old cousin Ralph, he remembered my grandfather crafting a pair of these glasses for himself as well.

Mine were made professionally.

Dayna and Danny had convinced me to go to the MDA (Muscular Dystrophy Association) in San Antonio and get tested. In 2005 it was confirmed that I was likewise afflicted with this rare hereditary disease that had been brought to this country through 3 sexually prolific, French Canadian sisters in the late 1600s.

This illness has slowed me down, but it hasn't stopped me yet!

The Universe dances a jig on the head of a pin ...

PART 17

The Lord's Prayer

Chapter 1

"Our Men"

From earliest memory, I would kneel by my bedside and say my prayers. It was a beloved ritual. I got to include special bits for those I loved and ones in need, - and for my two dogs. The most valuable take-aways: "Do unto others as you would have them do unto you" and "Be Good". My parents didn't go to church. Dad didn't like the proselytizing and mom always said that God would hear us no matter whether we were in our house, under a tree, or in a church.

Somewhere here at home I have a cassette recording my brother made of me saying the Lord's Prayer when I was about four. At the end, I clearly say, "Our Men". I knew that they were over there fighting for us. 'Amen' meant nothing to me.

Chapter 2

"Honey"

When I was 12 and Lynne and I were currently on the outs, I had a friend that used to invite me to go to church with her family. It was a curiosity, as I had never attended this conceptual practice that others seemed to flock to. Honey was the only friend I had anywhere near the neighborhood at the time, about a mile away, so I hung out with her whenever I could.

Sunday Church meetings were boring. Even the stuff for the kids was dull. The shining glory was the after-service Sunday dinner that I invariably got invited to at Honey's house! Yum!! The best part was her mom's home-made biscuits, warm from the oven, with butter and honey!

As the months wore on, I got invited to Sunday dinner less and less. Honey's mother had invited my vocally endowed sister to join the chorus, but Dayna's active social life didn't have room for church goings-on. They also tried to get my mother involved. She politely declined. After two years of being friends (and a waning decline in my participation at their house of god), these folks up and moved away.

During the final months of my friendship with Honey, Dayna had gotten sick. I knew it was serious, but no one would talk to me about it.

While at the doctor's one day, my mom, the doc and his wife, (who was also the receptionist,) all went in back, with instructions that I should remain put. No one else was there. Sneaking into the hallway where I could listen in, I came to understand that my sister had something called Hodgkin's Disease and there was only a 40% chance she'd live.

Due to concerns that I would become depressed or act out, the letter that came from "Honey" after she moved away was not shown to me for two years.

Once mom felt stability had re-entered our lives (Dayna was finally on the road to health), she showed me the letter she had intercepted at the mailbox. It didn't look like Honey's handwriting. She didn't trust it. Mom had a second sense. She always said she had 'eyes in the back of her head' - and I believed her. The letter started out kind; "going to miss me and what a good friendship we had", blah, blah, blah ... Then it went into how my sister's illness was caused by spurning God, that if I didn't change my ways, bad things would come to me as well. And then finally, it said my mother was going to Hell! Obviously written by an elder, this vicious letter was an attempt to frighten a youth into a belief system that I now had further reason to question.

There was no return address. I never heard from this childhood friend again.

Chapter 3

"The Giving Tree"

Mark had been held back in high school three times. He wasn't stupid, maybe just lazy. He was the first person I ever met that did heroin. I only knew this by rumor. He was kind and tolerated me, despite the fact that I was probably more geek than desirable female. When I was 16, Mark and his new girlfriend Judy became 'Born Again'.

My curiosity was more mature now and I approached them sincerely. I wanted to know why they decided that "One Way" was the right way. Could I be converted? They welcomed me and followed up with me, telling me stories of their personal journeys and tales of Jesus, etc. One day they brought me "The Giving Tree". This illustrated bit of prose by Shel Silverstein had been embraced by Christians as a parable of selfless love. I found I was

appalled when the story's protagonist cut down a perfectly good tree that had been so important to him.

When the 2 seniors graduated, I dropped my Christian quest and moved on to other visions.

Years later, my theological research led to studies of early Catholicism and how, when moving into 'pagan' lands, they'd rape the sacred forests to build their churches. Encouraged thus to come pray inside where the One God was lord, the local pagans retreated further into the woods and were more often than not, burned, hung, and otherwise tortured.

While touring France, many years ago, Derek and I inquired about the springs we saw coming out from in back of the churches. They seemed to be at most every church we saw, although not in very good condition. A young pastor told us that these were the pagan wells. The church built on sacred pools to lure more flock into the fold. He was disgusted by the condition of the one we were standing near, saying that it was once a pristine water source, now gone pitiful and murky.

I was reminded of the sweet, but sad gift from my good-intentioned friends. Kindness can be found in so many places, as can vicious vengeance. How you dance with it, is up to you.

Buddha with Pink Flamingo & Skeet

PART 18

Menopause

"It's life Jim, but not as we know it"...

*(No reason to dwell long here,
despite it's lasting for an eternity)*

Geh. One of the worst segments of my life. Somehow, Derek decided to stay with me.

At age 47, I jumped out of bed at the booth in Maryland. Running downstairs and outside into cooler air, naked, I tried to remove my skin. Thankfully, it was the middle of the night and no one was up but me.

I knew what was happening. The blood rushing to the vessels nearest the skin can raise the epidermis' temperature 7 degrees, while the body maintains a normal 98.6. Sweating and panic can set in. Sleep patterns are disrupted, causing delirium and nonsense. Wine is not enough. Wine for breakfast helps. Whining is pretty much constant.

*"You still like your husband,
you just like him better with a stake through his heart"*

By age 49 I was having hot flashes every couple of hours. Some would last 20 minutes, some much longer. I kept a book by my bedside so I could read for as long as it took for them to pass during the night. Blanket off, blanket on.

One morning around 8, Derek walked through the living room, having just woken up. Sitting on the couch, awake since 4 a.m., I thought to myself, "If he does that again, I'm gonna kill him!" Instantly realizing, to my horror, what had just passed through my mind, I called a friend who was also going through menopause. We had an agreement. Anytime, day or night. She talked me down.

Derek and I were in a 14 day, 12 hour a day run at the 'Dillo doing lifecasting and selling hand painted neckties. The "Dillo" is what we affectionately called the "Armadillo Christmas Bazaar". One man's vision for a perfect holiday shopping experience in the fabulous state capitol of Austin, Texas, - a megalomaniac control freak's dream.

Derek and I did this show together from 1998-2013.

Not sleeping and having sweat pour out of all my pores every couple of hours or so, drenching my clothes and hair, plus doing 12 hours day ad infinitum, I was ready to kill anyone that came up and wanted to offer Xmas

cheer. Add to this the constant live music over incredibly loud speakers that were RIGHT over our heads, and you can sort of get a feel for what poor Derek was dealing with.

An old rennie friend who was visiting the show came up and cheerily asked how I was doing. I told him, in all its gory detail. He grabbed the purse from the woman he was with and took out a bottle of pills. They were chock full of woman's herbs. He gave me a tight schedule on how many to take and when. In two days I was almost manageable. In two weeks, only wine brought on a hot flash. I can't say it all got instantly better. Internal drama raged and I kept begging the gawds for a psychic hysterectomy.

Fast forward to July of '06, Lynne, Derek, and I had a small celebration with party hats and cake in her back yard in upstate N.Y. We were there for our annual street show selling bubble wands. I had finally gone a full 12 months without bleeding! The Golden Mean.

As far as the 'Dillo goes, we made it through 15 years of doing this grueling event. Every year the restrictions and the booth fees for this tiny show went up and the crowds went down. I finally quit when I felt like punching the owner of the show every time he walked by, -and I was well over menopause by then.

Suzanne, Ann, Bebin, Merry, Cheryl & Derek at the 'Dillo

PART 19

"Ancestral Masking"

Chapter 1

Getting Plastered

Ann, Deb & Derek at Ephesus

Death Masks date back to 5000 BC. They're the oldest form of portraiture on the planet. Derek got to see that particular famed plaster-encased skull from Jericho. It appears to be the first known attempt of figurative sculpture using the skeleton as a point of departure. We were in the Middle East, touring historic sites with our friend Deb Harkness. Our last day in Amman, Jordan, Deb and I were toast. We'd been hiking all over for a couple of weeks now through Turkey and Jordan. Madaba, Wadi Musa, Cappadocia, Ephesus, and the most astounding Petra. You might know Petra for it's Treasury building that was used in the Indiana Jones movie, "The Last Crusade". It deems further research. (Petra - not the movie).

We had gone back to our room to pack for our return to Istanbul the next day. Derek's suitcases were ready and he decided to hike to one last museum we hadn't visited. The National Archaeological Museum. It turned out to be the one that had the Jericho Skull from 5,000 B.C. The oldest evidence we had ever found in our studies on funerary masking.

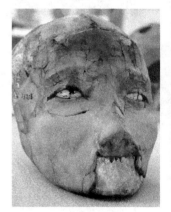

Jericho Skull

Life castings date back easily to Ceninno Cenini who wrote about the process in his arts manual from the 14th Century.

In the 1500's Michelangelo was accused of using castings of the human

251

form to achieve his life-like sculptures. It was heresy at the time to do this. (Gotta love "The Holy See".)

Marie Antoinette's breast was cast to create the champagne glass.

Madame Tussaud was famous for her wax death masks from the French Revolution.

Castings from a man's face and phallus were mounted on graves in ancient Grecian times. This united the vital parts; head and reproductive organ.

Romans encased whole slaves, while still alive. 'Breathing tubes', were inserted for the slave to ensure survival. These portals to life would then be removed once the giant plaster cast had set. The holes would then be used as 'sprues' for the molten metal poured in to make a life-sized burn-out human sculpture.

From the middle ages forward, death masks were used to help create statues and busts of the deceased. A revival of this time-honored craft in the 1800s made the initial castings valued of their own accord.

Every continent and just about every culture on the planet has used death masks as a way of depicting ancestry.

Funeral masks were displayed on the faces of the dead for final rituals, sometimes buried with them. Later in history, castings of eminent persons were placed in libraries, museums, and universities.

As they are to this day.

Chapter 2

Famous Faces

Derek and I had been teaching workshops all over the country, coast to coast for 25 years when we got the chance to work with the Hutton Collection. (Google this for more references should you so desire.)

In 1995 the sweetest middle-aged woman came up during a faire day at the Maryland Ren Fest and invited us to do an evening workshop at a local college where

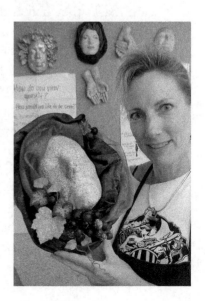

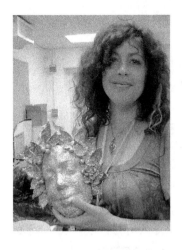

she was Dean of the Art Department. Her familiarity with the large collection of life and death masks owned by the college had piqued her interest in my craft.

We taught workshops for McDaniel College in Westminster, Maryland, one night a year for 15 years.

In 2008 Derek and I were invited to co-teach a week-long lifecasting class for a premier music and arts event that the school puts

on. "Common Ground" is known for the amazing musicians that are brought in from all over the world. It also offers classes from artists and crafters from across the country. The concept is that we all come together on Common Ground. Old age to the very young; all races, all countries, all religions, coming together to celebrate each other. Truly amazing!

I had been watching the slow decline of the stunning collection of life and death masks they had at the college. It seemed no one realized or cared about the incredible worth of these faces from antiquity. Hanging within

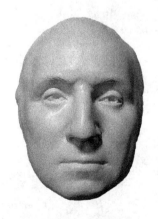

reach was George Washington's lifecast, as well as Lincoln's death mask, Beethoven, Napoleon, Ulysses S. Grant, and so many others.

One day upon taking our workshop class into the sculpture lab to see the 50-plus faces hanging on the wall there, Derek saved the cast of Wagner from being destroyed by a ladder that almost fell over onto a still life a teacher had set up. Included in the display was this astounding composer's death mask! The teacher seemed nonplussed.

I'd spoken to the Dean about recasting

George Washington

some of these faces several years previous. She had declined, saying that if any were damaged in the process, it would be bad.

Seeing these treasures get mistreated was all I needed to proceed in my own right. We arrived early for our week-long session one year and I asked Derek if he could get Washington's face off the wall for me. He reached up and pulled it down with ease. Beethoven and Sir Isaac Newton (death mask 1727!) were next. The following year when we returned, their Beethoven was missing half his chin. Quite certain that he'd met a similar fate to the one from which Wagner was barely saved, we carefully and surreptitiously cast seven more famous faces.

In 2011 one of our students at this workshop had a lightbulb go off over his head. When we showed him the dusty collection of history's heroes and villains and explained their amazing historic and real value, this man 'got it.' Mr. John began to ask questions. Derek and I answered each with as much detail as we knew. Why this treasure trove wasn't being revered, however, was beyond our comprehension.

The pieces housed here at this college were from the same "Hutton Collection" owned by Princeton University. Theirs are kept safely under glass around the campus and are rotated on occasion with others from the archives.

> *"The human face is after all,*
> *nothing more, or less, then a mask" – Agatha Christie*

Laurence Hutton claims to have found half a dozen castings discarded on the streets of New York City in the early 1860s. He grabbed them up and took them home. This led to his 30-year passion for salvaging and procuring life and death castings from all over the world.

There were three copies of this collection. Princeton had one, another was gifted to the Smithsonian in 1955, and that same benefactor gave a third set to what is now McDaniel College.

Mr. John had a family trust that arranged for grants to be given in the arts. In a fortuitous symbol of trust and artistic respect, he believed that the next year's recipients needed to be me and Derek! These Famous Faces had to be preserved before it was too late, and we were the perfect ones to do it.

The three of us started researching and documenting the Hutton Collection. The school archivist wasn't even aware of its existence until we showed it to her.

Knowing already about Princeton's collection, we began to research the set at the Smithsonian. We had questions about some pieces that neither Princeton nor the McDaniel collection seemed to have but which we knew were in the Hutton Collection, according to his book and it's photo documentation. However, we reached a dead-end. They couldn't find their 60-some-odd masks from the Hutton Collection. A two-month long e-mail communication back and forth with the Smithsonian ultimately revealed that their collection, for no known reason, appeared to have also been gifted to McDaniel, somewhere around 1975.

The college had 2 collections?

Wasyl Palijczuk was the Dean of the Art Department back in '75. Although still alive, senility had taken hold. No one could reach him. Had he sold this second collection? Had he gifted it somewhere else? Did he have it in his house?

Mr. John helped Derek and I clean and tag all the masks at the college. Many were now missing, many more were damaged. I had photo proof of the previous existence of Lincoln's death mask having been on the wall, but now it was nowhere to be found. Stories came to light about a teacher that had been fired. They knew he had taken the famed President's mask, but due to circumstances beyond their control, it couldn't be retrieved.

Comparisons with the files found buried in the archives showed 18 premiere pieces were gone. Getting the grant now looked questionable.

The first day of workshop classes for the year was upon us.

At the end of our afternoon session, the current head of the art department came and got Derek and me. Saying nothing, she led us up to the attic above the art studios. There a sweaty and dirty Mr. John met us, grinning. As he stepped aside we saw more than 50 mint-condition Life and Death masks on the floor!!! Robert E. Lee! Keats! Daniel Webster! And LINCOLN! Plus SO many more!

Derek and I both started sobbing.

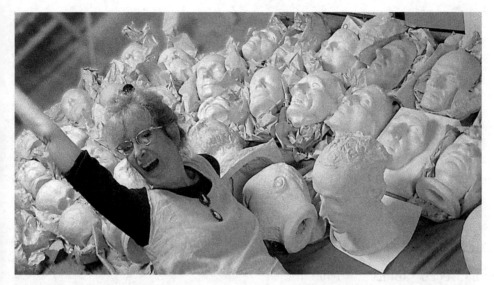

Another teacher came up to see what was going on. He took a closer look at the ancient maker's marks on the back of the bust of Lee and commented, "You know, this could be valuable!"

Duh. (I refrained from smacking my forehead)

We found out that when Wasyl received this collection back in the mid-'70's, he realized that the original set the college had was unappreciated and being mis-treated. In his country, the Ukraine, these treasured relics of history would have been respected. He carefully wrapped and stored this second set, placing them in the far back corner of the storage area, where they sat languishing for three decades. Searching, we found more castings wrapped up in old fish tanks and barrel tins as we pulled ancestral masks from times past out of the annals of the attic.

The original castings had all been made from plaster. Plaster damages easily. In order to make a more substantial casting of some of the more esteemed pieces, Derek and I had decided to work with a gypsum and

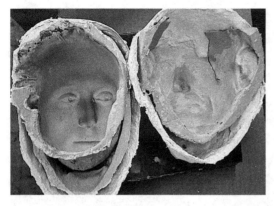

polymer product which will virtually last forever, and not chip. Casting these masks with both alginate and plaster gauze bandages, we were able to reproduce many of the famous faces.

We recast three American presidents: Washington, Lincoln and Grant.

We did Jean-Paul Marat, whose cast had been made after his stabbing death during the French Revolution. This face casting had been molded by Madame Tussaud of Wax Museum fame. His body had been brought to her museum doorstep in a wheelbarrow by the ruling class during this reign of terror. They instructed her to cast this man

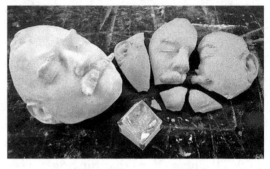

who had been her friend - or die. His distorted features were caused by leprosy.

There was also the Marquis de Lafayette, who fought in both the American and the French Revolution.

John L. Sullivan was the most challenging to make a finished new piece from. This man was the first heavyweight boxing champ from the late 1800s. His face casting was in pieces. Some very small. The archivist insisted that despite the wretched mess that had been wreaked upon this collection

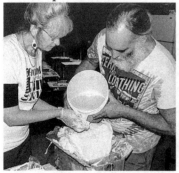

over the years, now that we were doing things 'properly', this man's face could not be glued together for the recasting purpose. The pieces were now archived and had to be returned in the same state from which I borrowed them. Research led us to clay. This being a medium I was quite familiar with, I proceeded with glee. Mounding the clay, I formed the pieces of Sullivan's face together on top, using the

clay as a non-invasive water-soluble 'glue'. I even got his famous handlebar mustache in complete detail! The finished piece was astounding!

Derek and I also cast Dante, Whitman, Napoleon, Robert E. Lee, and others. The entire project was a huge coup for us, not to mention an incredible honor.

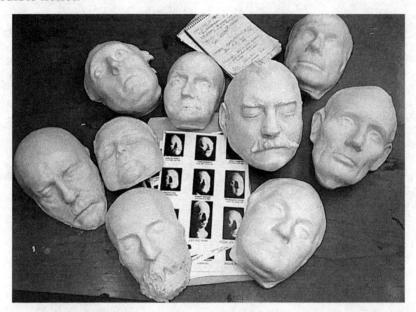

(clockwise from left) Robert E. Lee, Celia Thaxter, Marquis de Lafayette, Aaron Burr, John L. Sullivan, Henry Clay, Abraham Lincoln, George Washington & Walt Whitman

Two glass cases were made to house these pieces that are now on display in the McDaniel College library in Westminster, Md. They are available to travel should museums or institutions want to house them for a (limited) time. The original plasters have all been archived.

Chapter 3

Stroke of Genius

Now having actual permission to own copies of these Famous Faces, we exhibited the dead men in our booth at MDRF. I think they scared people. Especially Beethoven. He REALLY looked dead. We presumed this astounding collection would bring us notoriety and thus more money! Boy, were we wrong.

Don't Dream It.
Be It...

Be Your Fantasy

Masquerade Life Casting

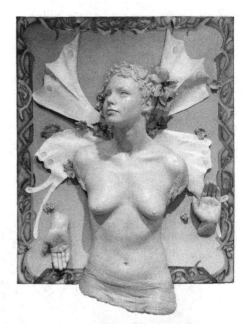

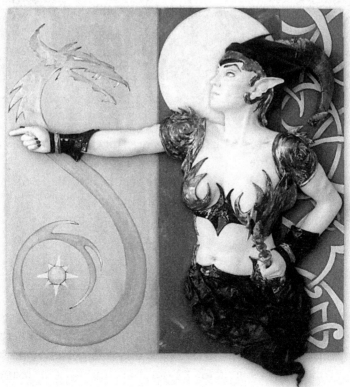

Our previously revered craft was suffering the same fate it had repeatedly undertaken over the eons. Nothing we could do seemed to bring lifecasting back from the dead.

I had what I perceived as a 'Stroke of Genius!' moment during this time with my "Story Book" pieces. These were finished sculptural castings designed to hang on my board-backed painted canvases.

A sure-fire fantasy art form I just knew would appeal to the public. Museum-quality art now filled the walls of my display. These told stories of your choosing. Fairies in a wooded wonderland, genii's, jugglers, and mythical creatures.

Like the B&D (bondage and discipline) castings, these apparently had a limited audience.

It was depressing.

Derek and I searched for another craft to incorporate into our Maryland Ren Faire booth. All foundered.

In 2015, after informing the festival manager that we had to find a new craft or become greeters at Walmart, we landed on the concept of creating art with bones.

The previous year a customer had come up to my sales counter and, shuffling his feet, shyly inquired if I could cast 'anything?' …

That sort of statement came around just about every weekend, normally by some frat boy bo-hunk who would swagger up to me, often on the dare of a friend. My response was always to look them square in the eye and say, "Sure! What did you have in mind?" Only to watch them scurry away!

Because of naked body castings on my walls as well as the panel of nipple magnets for sale, I got lots of titters, family freakouts, and curious inquiries.

This tall good-looking man now standing at my counter was accompanied by his charming diminutive wife. They were serious. What he had in mind was a coat rack - with his penis. To reproduce one cast the requisite 3 times, I now needed to make a silicone mold, something I'd never done before. Undercuts were always a booger bear to deal with. Much in the same way I couldn't cast a hand/arm 'in the round' and expect to remove

the clay piece without cutting the mold, the shape of the penis shaft/head created a similar issue. I needed a mold that could be reproduced without being destroyed. The finished pieces also needed to be made with a sturdy resin, in order to support the weight of winter coats.

Derek and I picked up the supplies we needed from a company in Dallas on our way back through Texas. When we got home, I expressed my concerns to a fellow artist. I was worried about making a mistake with the unfamiliar silicone - and only having one penis cast. A hat maker by trade, my friend Rischa wanted a bird skull for her 'Steampunk' line. One of her pet finches had died recently, and she had saved the skull. The bird head became our test subject. It turned out superbly. Now filled with confidence, we made 3 perfectly formed penises! Incorporating a colorant that the supply company had given us to play with, the flesh-like effect was exceptional!

... and the bird skull cast gave us an idea ...

Chapter 4

"Sucking on the marrow of life
doesn't mean choking on the bone" – Dead Poet's Society

Skulls and bones have always been a part of my life. As a youngster, I would cut the tails off dead animals and keep them in the miniature tiger oak vintage dresser that originally housed clothes for my dolls. Of course, they'd molt. But eventually, I'd end up with a bone tail.

Mom imbued a sense of reality in me. I knew that someday, she and dad would die and that I would as well. Dead things were intriguing, not fearful. Over the years, from childhood forward, I collected various skulls and bones in diverse art forms.

After one of the Dawg Parties in Maryland, I approached a woman who had brought human finger bones as her 'gift'. They had come out of a collection from her roommate's deceased father who had been a doctor. There was also a human skull that they wanted to get rid of. I traded a hand casting for it. I'd wanted one since I was three.

A death-related side-line

Lo, these many years, I'd never done an actual 'death casting.' People had died after I'd done a casting, or were going to die, so they got cast just prior to their demise. I'd cast folks with cerebral palsy, severe attention deficit disorder, and Alzheimer's. We'd done castings at bedside vigils and had gone into nursing homes to work with family members that wanted to have the hands of their loved ones preserved. Although it almost happened a few times, we'd never made an honest to gawd death mask. I had the chance after Derek's mom passed away. I just couldn't do it, and as it turned out, neither could Derek.

Eventually, the opportunity presented itself in a way that I believed was righteous and viable. Found by our website, a young couple who had just lost their 5-month old premature baby wanted to have him cast. Three times. All of him. Whatever we could successfully mold. One set for them and one for each of the grandparents. The tiny little guy had five names, not counting his surname.

He had been left in the nearby town of Kerrville at the funeral home there.

I warned Derek that I might be squeamish. Instead, I found I was fascinated! Such an itty bitty little alien. His feet were only an inch and a half long. To cast them, we had to put them together for more surface space. The hands had to be laid on his body to mold them, due to their diminutive size. We cast the head, body, hands and feet. Even the teeny ears.

The molds turned out perfectly, capturing everything down to his minuscule fingernails and knuckles.

Derek and I turned a wooden cigar box into a velvet-lined display case for the set that the parents got.

I was honored to have created something with as much sentimental value as this.

Returning now to dead animals, who are

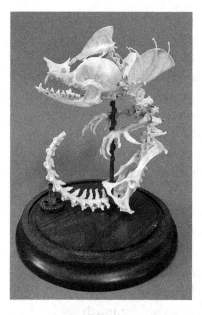

already in progress:

Our home nestled in the hills of Central Texas was filled with random skulls we'd been gifted or had found over the years. As we began to cast these and make wild sculptural wall pieces, friends started bringing us more bones. In no time flat, we had a solid representation of samples to present. MDRF general manager, Jules Smith liked them and told us to go for it.

By the second year, our customer base began to tell us what they wanted from us. The walls and counters of the booth now filled with a wide variety of bone art. One wall retained life castings for the remaining patrons that still saw the value in them.

We discovered local ranchers and their 'bone piles' consisting of deceased livestock, from which we harvested skeletal odds and ends to add to our existing collection of road kill. There is also a rather repulsive event called a 'Varmint Hunt'. Functions like this exist all across the country. These are juried affairs where the entrants pay a fee up front to go hunt on a ranch of their choosing for a slotted 12 to 24 hour time period to kill a specified listing of 'varmints'. Some of the events even use a lie detector to

test the validity of adherence to this timed participation. There will be a list of what varmints (aka: 'predators') the jurors want, and what gets the highest points. The hunter with the most points 'wins'. Derek and I figured that these events weren't going to up and quit just because we were appalled by them, so we attended them instead. The happy hunters are required to take away whatever carcasses they bring, so our offers of carcass disposal were well received.

A shifting of focus is sometimes necessary to continue in life. Much like doing

a death casting or going to a bondage convention, change of perspective will give you lessons otherwise unknown, whether you thought you wanted them, or not.

Our patrons had let us know they wanted real bone art. The cast pieces still sold to those that didn't want dead stuff on their walls or as body ornaments.

Derek experimented with various manners of decomposition and the subsequent, necessary cleaning methods. Different processes for different animals. Always a work in progress.

I learned which critters made the best Bone Crowns and nicest earrings. Wall pieces use all parts.

By the fourth year of "Curious Oddities of Skin & Bones", we were down to selling off the life cast samples and just holding onto a core section for those remaining patrons that still wanted to get plastered.

And that's when my body's inherited genetics caught up with me.

PART 20

Yum, Yuck, and Ouch.

Chapter 1"

Make friends with freedom and uncertainty.
Invite someone dangerous to tea"
- SARK

Derek and I have traveled all over the world. We've been to parts of Italy twice. Holland, Belgium, Mexico many times, Germany, France, and Peru. In

Southeast Asia, we visited Thailand and Cambodia. Most recently we saw the Middle East where we toured Jordan and Turkey. Many places we've been are considered dangerous. Enough so that we followed state department recommendations and in-country suggestions as to places we might consider avoiding. Let me say that people all over this planet are varied and unique. They have different versions of who their gods are, how they dress, eat, speak, and say hello. Across the board, we found them to be generous and kind. Politics suck, as do most of the ruling factions. Holland may have been the most civil, however, they too, have had their issues.

But if you think you want to become an expatriate, think again. Where will you go that you won't ultimately want to make a stand?

The antiquities, historic quarters, and ancient sites that dot this amazing planet are so worth seeing. My mind has exploded so many times, I'm surprised I still have one.

Travel is the one place where Derek and I spend our saved income.

To tell the stories of our shared experiences from these astounding adventures would take another book. Better you should go there yourself.

Due to increasing 'muscle death', my hiking abilities have become more limited. The last trip was freckled by taxi rides, even to just get up a hill.

Chapter 2

"Our state of Health and Happiness depends more upon our perception of life events around us than upon the events themselves" – C. Northrup

My throat and it's increasing recalcitrance was the first to give me problems - but the eyelids demanded more attention. I got professionally made 'crutch glasses' that had bars built inside the frames to lift my eyelids. This in lieu of the more invasive operation. I did that next.

They opened up my eyelids like a pita bread, peeling the skin back from either side of the crease. Here, they insert a fiberoptic-like thread in a triangle; one part runs along the lashes, with the other two meeting under the hair of the eyebrow. That point hooks into the forehead muscles, which for some reason don't tank like the rest of the facial muscles do in this dystrophy. The forehead muscles are now what operate the lift of the eyelids.

For the first week, I had a black thread attached to my eyelids running down over my cheeks, to help pull the lid shut in order to sleep.

Science is freakin' amazing! So is the human body.

I've had my throat stretched three times. I was able to eat popcorn again after that first time.

When my arm muscles began to tank, I decided to relinquish wheel-thrown art and we sold off that piece of pottery equipment.

Muscles that atrophy and 'die' in this disease don't come back. You can try to 'exercise' them, but exercise can set you in arrears. Hence the use of the word 'dystrophy.' Nevertheless, I still have some functioning leg and arm muscles which, inexplicably aren't a part of the system that's failing, and I do what I can to keep them going.

Another side effect is an intolerance to 'extreme' weather temperatures. Think 68ish in sun as a low, 83ish in shade as a high.

Intolerance, for me, is panting delirium in heat or loss of all vocal and mobile ability in the cold.

Doing outdoor art shows was becoming increasingly difficult.

Chapter 3

"Pinning the tail on the reluctant monkey of change"
-from a student paper

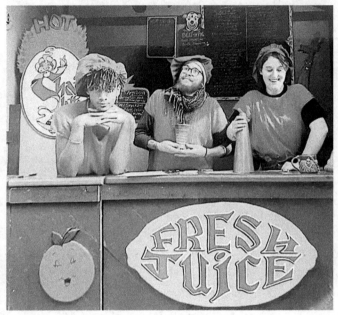

The Carrot Kids: Travis, Seth & Ellawyn

The year after we had gotten the Bone Art going at MDRF, Derek received permission to run a Juice Bar!

We took 1/3rd of our pre-existing booth at the Maryland Ren Faire and walled it off, making a long/skinny full-scale juice stand. The employees were the best! The kids we hired to run it came up with awesome juice recipes. Within four years, the business was going great guns. Derek was very proud of what he had. Clientele became faithful and would return each following year, bringing more and more customers with them.

And now I was asking him to leave it behind.

The stairs that led to our bedroom were like ladder steps. Tall. I'd gotten to where I'd often crawl up them, and scoot down.

There was no AC. We called this our 'cabin in the woods' because it was primitive. No sheet-rock, holes in the walls everywhere. It was, after all, a ren-faire booth. Even if it had AC or heat, on the weekends I had to be outside selling where there was no climate control.

"Selective Sisterhood of the Jaded Renaissance Mavens":
(top row) Sue, Kunji, Ann, Maryann, Suzy,
(bottom row) Nellie, Tammy, Debra, Jeanne, Leslie, Pam & Malynda

By the second weekend of 2019, we had made the decision that this was to be our last year at the Maryland Ren Fest.

Lining up mini-convention hall INDOOR Expos that catered to our new craft, we plotted a path of shows for 2020.

Family and friends began freaking out when they heard we were selling the Maryland Ren Faire booth. They were sure I must be dying. Jules tried to get me to reconsider. Rennies, friends, and patrons alike flocked to us with suggestions on how we could stay.

I cried; Every - Single - Day.

As soon as the booth went up for sale, I had several crafters from across the country inform me that we needed to take it off the market - they were the ones who were going to buy it.

But it's not that easy. You have to be approved before you buy a booth at a Ren Faire.

Brothers Adam & Jules Smith

This foible had already been tested when a person bought a shop and then couldn't get into the show. A clusterfuck ensued. (refer back to "The Harold" in Part 11, Chapter 4)

I wanted someone who would bring something new to the faire - fresh energy and a different point of view. Hard to find in a market glutted by jewelers, clothiers, wooden swords, garlands, and pottery.

One of our final five Monday morning yard sales at the Festival, 2019

Of those who approached me with the proper intentions, a vibrant young potter, suited the place best. The potters at this faire, as well as many other crafters, were all 'aging out'. Her work was different and she had youth on her side.

Jules, despite his reluctance to let us go, agreed.

Would that we could've stayed there 'til ... well, until we got to where we couldn't move anymore, and it would fall to others to pack up this booth.

We had 5 huge yard sales during the Monday Morning Bazaar. This Breakfast Bazaar and weekly participant garage sale was basically in our front yard, so we didn't have to go far. Our booth had 25 years of collected oddities. Every Monday was an adventure in offerings!

My favorite was the day we auctioned off the smashing of a double body casting, providing a sledgehammer to best accomplish the destruction. It had been a great sales attraction for years. Since we were planning to retire lifecasting totally, this piece was now an albatross.

I put it out with a sign that announced the time of demolition. We had an 'auctioneer' and drew quite the crowd. The winner paid a mere $47 to obliterate this fabulous piece of art. From folks picking up shards off the ground, I made a few more bucks from a random nipple and a nose. Some people looked on in worry and concern. That kind of destruction of art freaked them out. I laughed! I'd been doing Burning Flipside for years. Destroying Temporal Art can release the soul.

I'd already suffered the loss of this business - for years. Over it now, I was happy to finally let go.

Letting go of my 'cabin in the woods' booth was much harder.

> The Ren-Faire now is covered with dust,
> but (mostly) sturdy it stands.
> We all forge on as we know we must,
> fashioning wares with our hands.
> Time was when our fingers were nimble
> and our backs were lithe and strong ...
> and that is when we built the faire,
> and planned a future long.
> Now we didn't think of age or change,
> but it happens in the blink of an eye -
> Our wispy ways and sexy days
> have all but passed us by.

And as we were dreaming an age-old song
 awakened our drug addled brain -
Oh the years are many, the years are long
 and now we've found we must strain -
Ay, still faithful to fantasy we hold strong,
 but the call of the dollar is placed.
Awaiting the setting of the wallet on the counter,
 the smile of a happy face.
And I wonder as these short years fly,
 with my creme and my dyes and my stays -
What will become of old rennies
 when like dust we all blow away?

<div align="center">(with apologies to Eugene Field)</div>

Chapter 4

"Why take life seriously? It isn't permanent."

Many of my dearest friends aren't mentioned by name in this story. Who you are is part of the color here, make no mistake! I could add in more chapters, but I'm thinking this about does it for this round. Perhaps someday I'll write another book. Of course, we'd need to have another plague - or have this one continue indefinitely.

Covid 19 is currently raging. During this pandemic, I've had the chance to finally research and write the tales of my history. This then is account of one artist's life.

Derek and I have been beside each other now for over half our lives. When I turned 60, we got hitched. "Informal Marriage" is what Common-law is called in Texas. In order for him to get my higher Social Security should I expire prior to him, we needed to be married for at least 10 years (Yup! It's true) and since we don't know how long I have (or any of us for that matter,) we decided to go retroactive to the year we bought the property when we signed the deed for the land in 1988.

It's a rich tapestry of love and intensity. Derek and I have strong

wills and vivid passions. We laugh a lot. The two of us are always ready for adventure.

Right now we are patiently biding our time.

We've been waiting for Mama Earth to upchuck for a while. You can't have this action of abuse and not have a serious reaction. She's been shouting, "RED!" for a long time, and even now, those holding the whips aren't listening.

Derek and I had art shows lined up and watched them slowly shift and cancel, offering a move to open again 2021 ...

History is being made. This time will be known forever. What it will be called, no one knows yet.

My friends, my family are in flux. Some are in fear, others, like us, are merely watching and waiting.

Here, we have our glorious place in the country. We have beautiful gardens and so do our neighbors. We share. Our neighbors are the best. We struck it rich here in our little valley, and are beyond grateful for all we have.

May all of you be lucky enough to see the abundant blessings that surround us. Breathe deep and smile!

Feed the Temple - and stay safe.

*"I wish it need not have happened in my time," said Frodo.
"So do I," said Gandolf, "and so do all who live
to see such times. But that is not for them to decide.
All we have to decide is what to do with the
time that is given us." -J.R.R. Tolkien*

Acknowledgements:

I wish to thank those who've been of immense help regarding this publication.

My beneficent editors, Janine Hess, J. L. Brooks, Al Craig, and of course my beloved sweetheart, Derek Weaver. Even though at first he queried, "Why in the world are you writing a book?", within no time, he jumped right in. Derek figured out how to install the requisite photos and create the cover design, the typeset, as well as the printing and publishing parts. Whew. Dunno what I would've done without him!

Many friends were there for me when I needed to pick at their memories trying to figure out storylines that have been brain-washed away by the sands of time. Thanks go to: Sandy Dunn, Donna Barnes, Lori Eckenrode, DaveAnn Taylor, Gail Pollock, Mary Lynne Wolfe, Holly Hindt, Elisa Grothues, Adam Smith, and of course, Lynne Parsons.

Assistance and encouragement came from Paul Harford, Connie Colton, Tim Cross, Cindy Wexler, Jennifer Stevens, and all my FaceBook friends who wanted to read this before I ever wrote it. I hope it doesn't disappoint!

The support and love that has come from my faithful clientele over the years has had a HUGE impact on who I am and how I move through my life. Thank you all for your continued support.

And, of course, there's my Mother. Her artistic spirit, encouragement, and love inspire me every day of my life.

I've been blessed by so many wonderful people in my time on this planet. Without the events told within these pages, I may never have known you. Thank you all for your participation!

Photo Credits:

Notes:

Part 3, Chapter 6 "Ritual Disrobement at Mardi Gras Study", Wesley Shrum, Pp. 430 - 431. Social Forces, December 1996.

Part 3, Chapter 6 "Ceremonial Disrobement and Moral Choice: Consumption Rituals at Mardi Gras", Wesley Shrum, Pp. 39 - 58. Contemporary Consumption Rituals: A Research Anthology, 2004.

Part3, Chapter 6 "Beads and Breasts: the Negotiation of Gender and Power at New Orleans Mardi Gras", L.A. Wilkie, Pp.193 - 211. Beads and Bead Makers: Gender, material Culture, and Meaning, 1998.

photo: Derek Weaver

Ann's penchant for art has driven her since she could first hold a pencil. When not roaming the world, she lives under the Milky Way with her husband Derek in the Texas Hill Country.

CPSIA information can be obtained
at www.ICGtesting.com
Printed in the USA
LVHW081330090321
680984LV00032B/510